P9-ELT-571

194

FIRST IMPRESSIONS

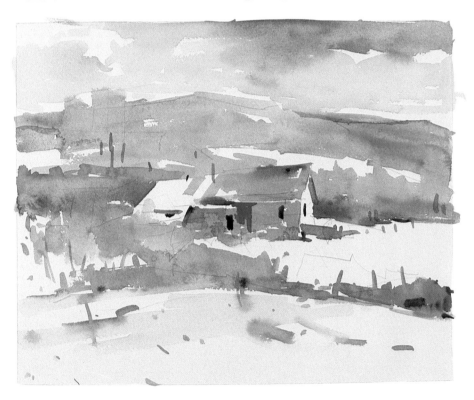

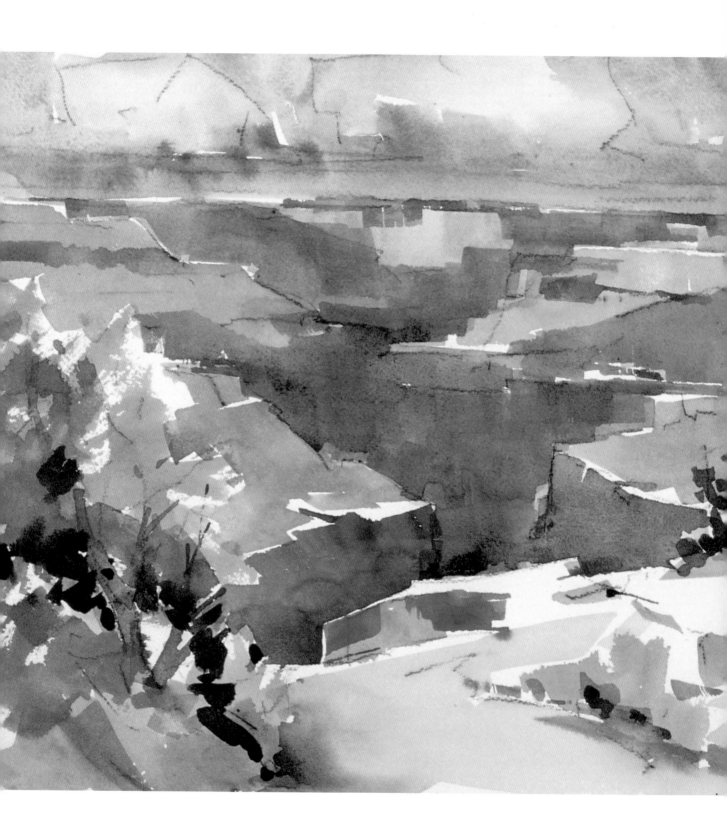

FIRST IMPRESSIONS

SKETCHING NATURE IN WATERCOLOR

BY EDWARD NORTON WARD

WATSON-GUPTILL PUBLICATIONS/NEW YORK

This book is fondly dedicated to my wife, Johanna.

Painting Information

Frontispiece:
On the High Road to Taos

Title page:
Canyon Depths

Page 5:
Morning at Mok Hill

Pages 10–11:
Shadows on the Snow

Pages 76–77:
At Dock, Albion River Harbor

Copyright © 1990 by Edward Norton Ward
First published in 1990 by Watson-Guptill Publications,
a division of Billboard Publications, Inc.,
1515 Broadway, New York, N.Y. 10036

Library of Congress Cataloging in Publication Data

Ward, Edward Norton.
 First impressions: sketching nature in watercolor / by Edward
Norton Ward.
 p. cm.
 Includes bibliographical references.
 1. Watercolor painting—Technique. 2. Nature (Aesthetics)—Themes,
motives. I. Title.
ND2237.W37 1990
751.42′243—dc20 89-27544
ISBN 0-8230-1820-2 CIP

Distributed in the United Kingdom by Phaidon Press Ltd.,
Musterlin House, Jordan Hill Road, Oxford OX2 8DP

Manufactured in Singapore

2 3 4 5 6 7 8 9 10 / 94 93 92

ACKNOWLEDGMENTS

WRITING A BOOK requires the help of a lot of people. I would like to thank Joseph Nordmann, who originated the idea for this book; Dr. Robert White, the owner and skipper of the boat *Seacomber*, whose invitation introduced me to the wonders of southeastern Alaska; Steven L. Rose, good friend, art dealer, and president of the Charlie Russell Riders, who invited me to ride through, see, and paint the Montana wilderness. I would also like to thank Bonnie Silverstein, who encouraged me and guided me through the early days of writing; Candace Raney, who helped me bring my writing to a successful conclusion; Grace McVeigh, my editor, who understood what I wanted to say, for all of her help in pulling the final manuscript together; Bob Fillie, who designed the book; and Hector Campbell, who did the graphic production.

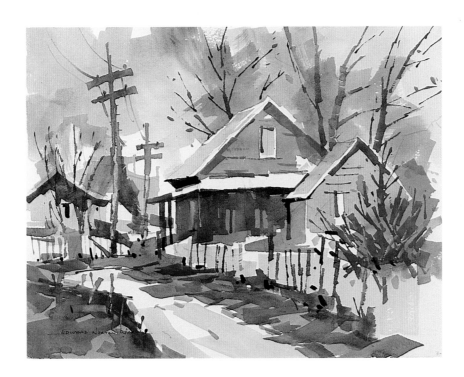

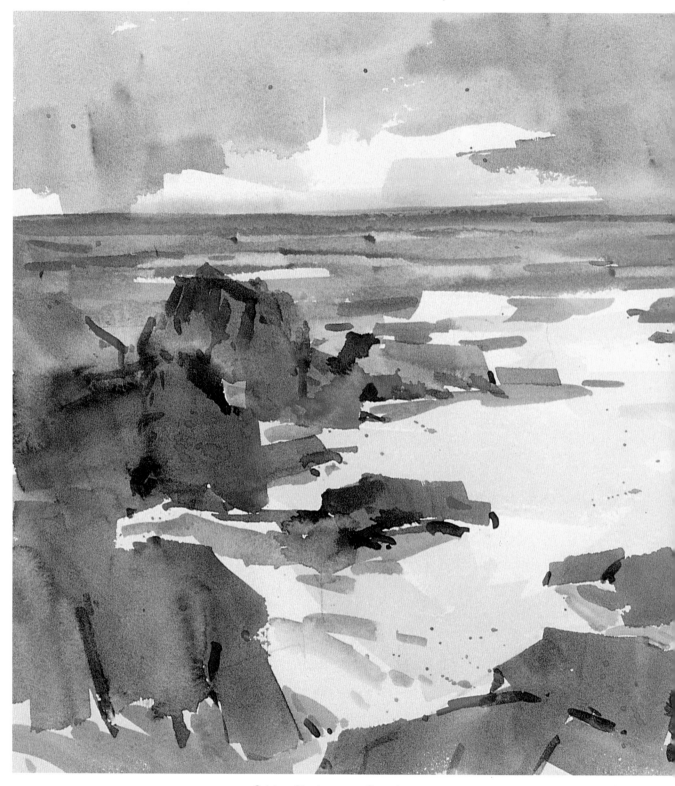

Off Malpaso Creek

Watercolor sketching is a means of
quickly getting down your thoughts on a
subject in changing light and weather.

Contents

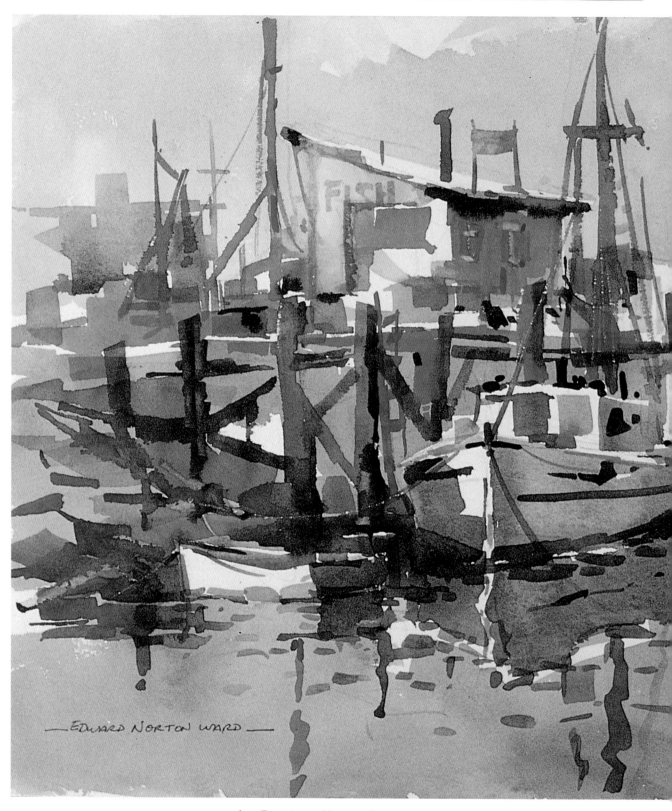

At Dock, Moss Landing

First impressions should be completed quickly, without regard to painting
gallery-quality works of art. Once the subject is committed to paper,
it becomes the germ of an idea for later, larger watercolors.

Preface

I BECAME AWARE of the need for this book while teaching a workshop. A student within view of half a dozen good painting subjects complained that she "couldn't find anything to paint." While pointing out some of the possible subjects, I realized that she didn't understand the process of seeing in the special way the artist sees.

For most of my career as an artist, painting outdoor watercolor sketches has been my way of finding, exploring, and getting my thoughts down on a painting subject. I feel that outdoor watercolor sketching is also an excellent means of showing how an artist sees and what makes a good painting subject. The fluidity of the watercolor medium encourages one to paint the sketch quickly. I look for this spontaneity in my work. While some paintings may come off quite well, I am not after gallery-quality paintings when I paint outdoors. I think it is more important to get the subject on paper for later use as an idea for larger watercolors and oils.

To this end, my technique is the natural result of a need to quickly complete a sketch in changing light and weather. I completed most of the watercolor sketches in this book in less than thirty minutes. Speed of execution allows me to gather quite a few painting ideas in the course of a day's painting. The development of this technique will become evident as the reader proceeds through the book.

In the first part of the book we will sharpen our creative skills and explore the means of finding things to paint, reducing the subject to a few simple parts, and then putting some of those parts back together into an original design of shapes, values, and colors. Once we have seen how some of these ideas work, we will try them outdoors on a variety of different subjects.

From time to time, I will say something about how I developed a particular illustration, just to inform the reader of my thinking during the execution of the sketch. There are many ways to paint a watercolor. My way is only one of them. If you are already skilled in using the watercolor medium, by all means continue in your own way. You will get much more out of trying my suggestions if you are not hampered by having to learn a new technique.

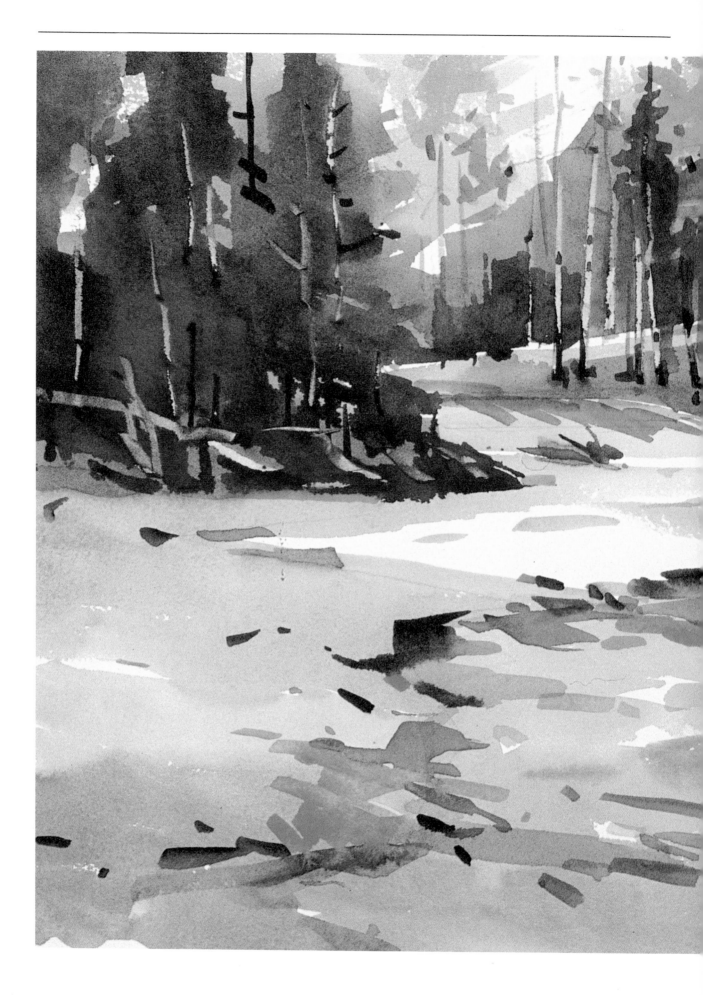

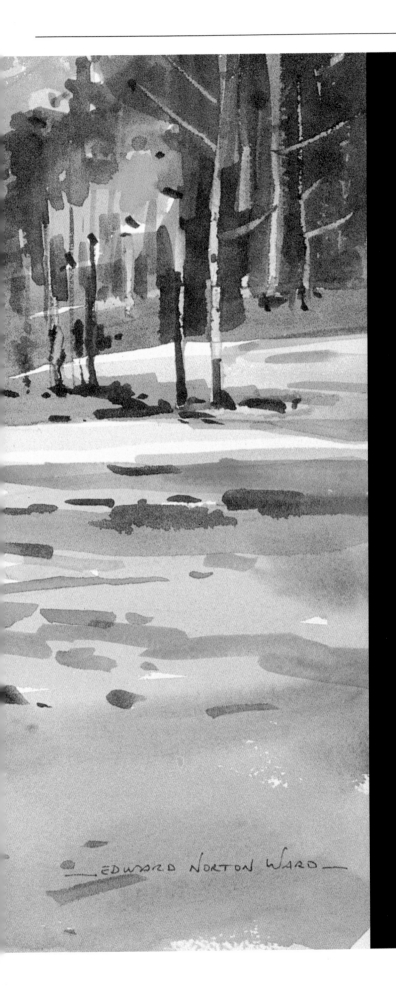

EDWARD NORTON WARD

PART 1

METHODS FOR FOR WORKING IN NATURE

Assembling the Sketching Kit

Morning at Mendocino

Finding scenes like this to paint almost always
requires that you be on foot. I put my painting kit together
with two points in mind—weight and mobility.

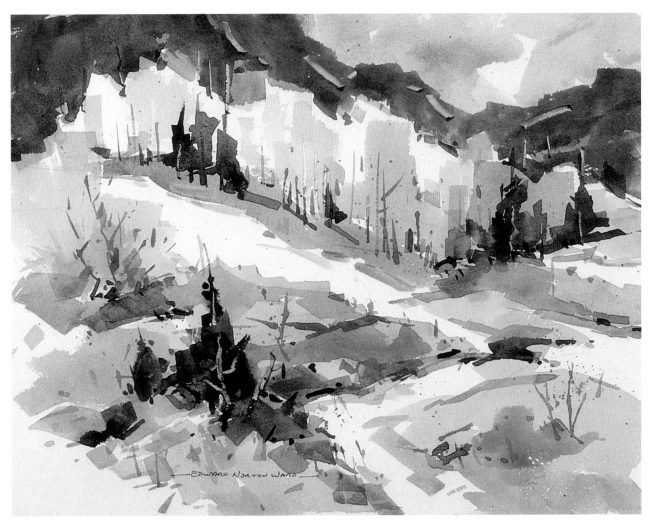

High Country Aspens

Out-of-doors we have to carry everything we use. Each piece of equipment, each
tube of paint must have a right to be in our kit or it has to be discarded.

SUCCESSFUL outdoor watercolor sketching requires the right set of tools. We want a sketching kit that is well stocked yet portable and easy to use outdoors. Since we will not be in a comfortable studio where everything is handy, we will have to carry whatever we need with us. Each piece of equipment, each tube of paint, must have a reason for being in our kit or it has to be left behind.

My painting travels may include flying, cruising on a small boat, or even riding on horseback to reach a favorite painting location. In view of this, I put my outdoor sketching kit together with two points especially in mind—weight and mobility. Often limited in terms of

luggage space, I find it necessary to have all my sketching equipment fit easily into my airline suitcase.

Since I am always moving about in search of subjects to paint, I have no need for a folding stool. I like to make a quick sketch and move on to another subject. A stool would be too much of an encumbrance.

Years ago, I even gave up the use of an easel for my outdoor watercolor sketching. Any level surface that happens to be handy can serve this purpose. I've used rocks, old oil drums, railings of waterfront docks—even the ground when necessary. Sometimes my watercolor palette has been perched a little too precariously, but except for an occasional mishap, I have rarely felt the need for an easel.

One accident I'll never forget took place while I was sailing the inland passage in Alaska on the sixty-foot boat *Seacomber*. We had stopped and sketched at every small fishing village we could find. While we were docking at Elfin Cove after a four-hour run up the coast, I still had the sensation of "sea legs" and the dock seemed as if it were rocking. I had set up my palette, sketch board, and water cup on the dock's rail. An awkward move, a loss of balance—I knocked most of my equipment, brushes, and palette over the side. Luckily, it was low tide and several Tlingit Indian kids, who had gathered to watch me sketch, went bounding down to the beach below and quickly retrieved everything for me.

The Small Knapsack

Assembled, all of my painting equipment fits nicely into a small knapsack that I can carry on my back. This leaves both hands free. The limited capacity of the knapsack ensures that I will carry only what I need. This gives me freedom of movement, which I feel is so necessary for outdoor work.

You can buy this kind of knapsack at stores that cater to hikers and mountain climbers. Some of the knapsacks come fitted with several zippered pockets. Be sure to try on the knapsack for fit. Its straps should be comfortable and adjustable so that they can be fitted to your shoulders and back.

If you are flying and take your knapsack and sketching kit as carry-on luggage through an X-ray security device, be sure to explain to the guards just what you have. I have been asked to open my kit many times. All those gadgets, tubes of paint, brushes, and other art supplies are often unfamiliar to airline security guards. If the guards become suspicious, you have to spend a lot of time explaining all about outdoor watercolor sketching before being allowed to proceed onto the aircraft.

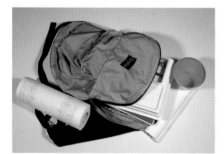

My Watercolor Palette

Since I like to carry my palette in my knapsack or luggage, I use one of the plastic ones with a snap-on lid. A variety of these palettes are available. The one I have chosen is a smaller-sized palette, which fits into my knapsack.

The design of the color wells in the palette is important. In my palette the wells are large enough to hold a generous amount of paint, but they have a shallow ridge to prevent muddy water from being trapped in them. Sometimes freshly placed paint will run out of the wells when the palette is placed on edge, but if you let the pigment set for a few hours or dry it with a hair dryer, it will firm up.

I like to squeeze a pile of paint about the size of a quarter into each well. This amount will last for several sketches. If I am going on a short flying trip, it may be all the paint I need.

Most watercolor palettes have enough wells to carry a fairly wide selection of colors. If I find I am using more colors than there are wells, I eliminate some of them rather than switch to a larger palette. I can always mix extra colors from some of the more basic ones. The main thing is to be able to carry my palette in my knapsack and to keep my hands free.

My palette has a useful compartment in the lid for holding brushes and pencils. I prefer this feature to having the lid molded into more mixing wells because this easy access to my brushes saves me time.

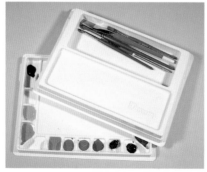

EDWARD Nor

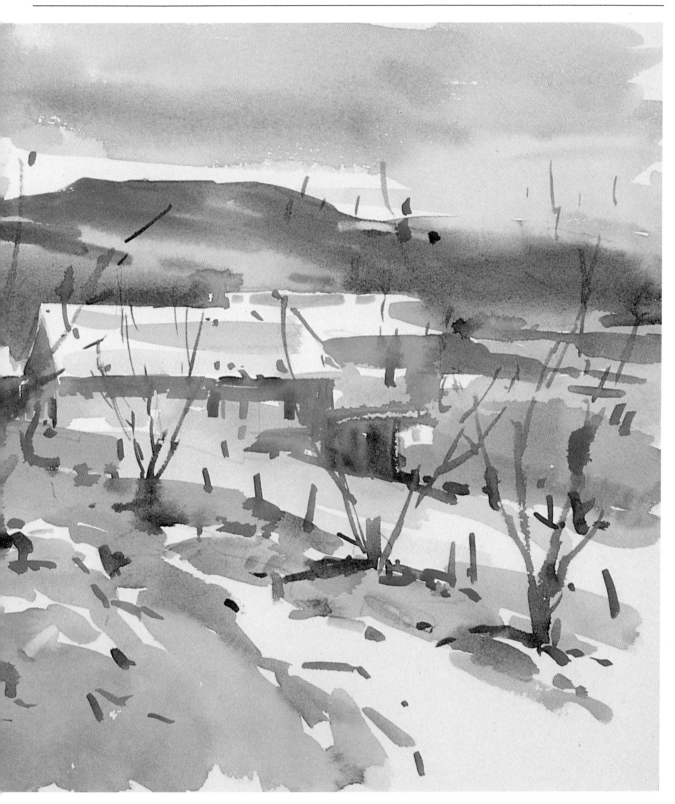

Apple Country
The glow of white paper under a transparent wash is a quality that
is available only with watercolor. Opaque colors do not produce this quality.

MY CHOICE of watercolor pigments is continually changing. I am always experimenting with new colors and discarding those I no longer use. This keeps my watercolor palette exciting to use, and I avoid routinely using the same colors.

With a selection of blues, reds, and yellows, each primary color is present on the palette as a warm and cool variation. I round out my palette with an orange, a violet, and a green. I have given up using earth colors ever since I found that all the earth colors on my palette had dried and cracked from lack of use. That was when I decided I no longer needed them.

I like to use transparent pigments whenever possible. The glow of white paper beneath a transparent wash is an effect available only with watercolors. Opaque colors do not produce this transparent effect. When an opaque color is present on my palette, it is there so that I can exploit its opacity. Cerulean blue is one such opaque color that I like to use for this purpose. Its opaqueness, along with its special hue, can do wonders when I want to introduce a special touch of blue or create a passage that must exude atmosphere.

My palette includes both primary and secondary colors:

THE BLUES
ultramarine blue
cobalt blue
cerulean blue
manganese blue
phthalo blue

THE REDS
scarlet lake
Winsor red
permanent rose

THE YELLOWS
new gamboge
Winsor yellow

THE SECONDARY COLORS
phthalo violet
cadmium orange
phthalo green

Most of these colors mix well together when you are making warmer or cooler variations of the primary or secondary colors. With transparent colors, I find that the fewer used in a mixture the nicer the resulting color. If at all possible, I try to limit my mixtures to no more than two colors. In order to gray a color, I mix it with a complementary hue. To add warmth to a color, I mix in an even warmer hue. To cool a color, I mix in a cooler hue.

Three pigments that are hard to use in mixing are phthalo blue, phthalo violet, and phthalo green. These are strong dye pigments, and they have a habit of overpowering any other pigments they are mixed with. I use them instead of black when I want strong, vibrant darks.

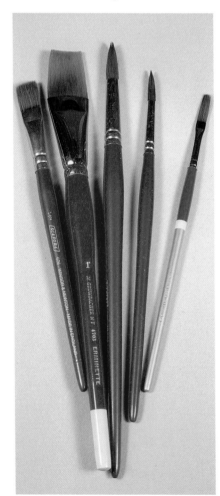

Brushes and Brushwork

When I paint outdoors, I am not as demanding of a brush as I am in my studio. I find that the new synthetic fiber brushes perform just as well as the expensive sables. Every brush maker has a line of synthetic fiber brushes on the market. As a rule, if the manufacturer offers a good sable brush, it probably offers a satisfactory synthetic fiber brush as well—and at a fraction of the cost.

I take only a few brushes with me when I sketch outdoors. In my studio I have a full set of brushes in all sizes and shapes. Outdoors, I paint on 11″ × 15″ quarter sheets. (In fact, all the sketches illustrated in this book are painted on 11″ × 15″ quarter sheets.) I find that two flat brushes and two round brushes in different sizes are sufficient for me. Sometimes, for some special effects, I may also use a small sign painter's brush.

I carry a one-inch and a half-inch-size flat brush. I also take a No. 12 and a No. 8 round brush. The one-inch flat and the No. 12 round are my primary brushes for watercolor sketching, and I use them well into the development of the sketch. You can also use the corner of the flat brush for placing small accents of color. I enjoy the freedom and spontaneity of a brush that is a little too large for the stroke required. When absolutely necessary, however, I'll reach for a smaller brush. This usually happens during the finishing of the sketch.

The half-inch flat or the No. 8 round brushes are used only when I need a stroke I cannot achieve with the larger brushes. The No. 8 round will create a stroke fine enough for most of the lines I need. Working with a light touch, I can create a line of varying strength that is difficult to achieve with the smaller rounds or rigger brushes.

Some subjects require letters and signs as important parts of a sketch. For this effect, I have adopted a sign painter's brush, which is shaped like an eighth-inch flat but has slightly longer fibers that can be

used for painting in the blocky letters of signs that may appear in a scene.

Technique with a brush is unimportant to me. You won't find too much on the "how to" of watercolor technique or style in this book. There are already several good books on the subject by fine watercolorists. Instead, if you follow some of my suggestions, your own style and technique will develop naturally through practice. Practice is what counts. If you paint several watercolor sketches, experience itself will teach you how to handle the medium.

I took no pains to arrive at any special effects in my own work. My technique for watercolor painting is a natural extension of my oil painting. I have never practiced laying down graded washes because I never felt the need for them in my work. I am sure they serve some watercolorists, but you won't find much of that technique here.

In my sketches, I was after painting ideas. I put down the brushstrokes of color as I thought they would best achieve the result I was after. Sometimes I succeeded; at other times I had trouble or failed completely. Whatever the result, what I had done stayed with me, and in later work I either used it or not, depending on my previous experience.

EXERCISE

Take a look at your own watercolor palette. Are there colors there that you never use? Do you know what pigments on your palette are transparent, opaque, or partially transparent? Think about replacing colors you never use with some you would like to try.

As a further exercise, test the transparency of your colors by painting small horizontal washes over a vertical band of black waterproof ink. The transparency of each of your colors will be apparent by the amount of color pigment you can see deposited on the black ink when dry.

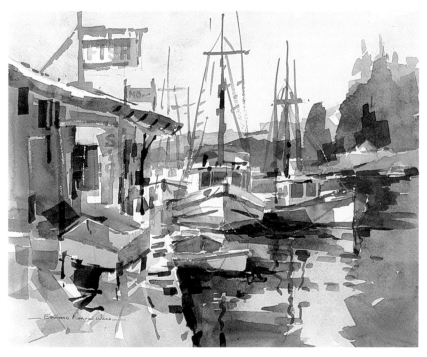

Meredith Fish Company

When signs are present in a scene, I always try to include them in my sketch, although I may change their content. I use a small sign painter's brush to paint them.

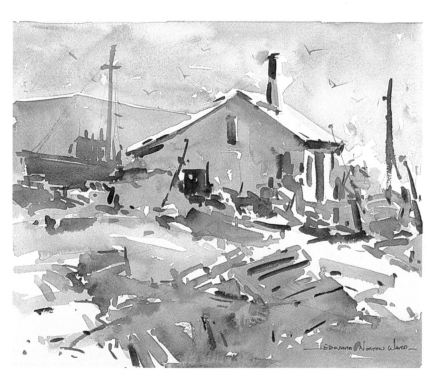

Fisherman's Shack

Technique with a brush is not as important to me as getting a good idea down on paper. The brushwork I use in these watercolor sketches is a natural extension of my work in oils.

I N THE FIELD, I don't want to worry about all the labor and time I spent getting the paper prepared for painting. I used to soak and stretch my paper before painting. Then, thinking about all the work I invested, I would "clutch up" and lose my concentration.

At the same time, I had adopted a habit of making quick watercolor sketches in a spiral-bound book of watercolor paper. Knowing that these sketches could easily be restarted by simply turning the page, I could relax and concentrate on the painting at hand.

I reasoned that if I could eliminate all the work of stretching the watercolor paper, I would also eliminate the worry about spoiling my paintings. Cutting several 22″ × 30″ full sheets of watercolor paper into 11″ × 15″ quarter sheets, I taped down a number of the quarter sheets onto a board that was just slightly larger than the 11″ × 15″ dimension of the paper. This homemade sketchbook worked out just fine, and I have used this method ever since.

Sketchbook as Journal

The sketchbook is an artist's most useful tool. With a sketchbook, it is possible to think graphically, explore the possibilities of a scene, and, if necessary, execute a small watercolor sketch. I make good use of my sketchbook, carrying it with me all the time. After a painting trip, the sketchbook is a journal of my trip, showing where I was, what my impressions were, and even mistakes I made while working.

A 9″ × 12″ spiral-bound book of smooth, fairly heavy paper makes a good-sized sketchbook. It is small enough to fit into your knapsack yet large enough to allow room for freedom of expression.

I use a soft pencil, a pen, and watercolor in preliminary sketching and find that the smooth, heavy paper receives all these mediums quite well. Try several sketchbooks before you decide on a favorite.

Choice of Paper

I like to use 140-pound cold-pressed paper for outdoor sketching. Having tried several different manufacturers' papers, I've found that any good-quality professional-grade paper performs well outside. My outdoor watercolor sketching is direct and doesn't require much scrubbing, washing out, or other drastic modifications.

When I switch brands of paper, I find there can be a noticeable difference in paint application and surface absorption. Since this can cause me some amount of frustration, I try to stay with the familiar paper if possible. I think that knowing what your paper will do for you is much more important than being concerned about the manufacturer's name.

Using one-inch masking tape, I tape down several quarter sheets of paper successively along the 11-inch side of my board. I tape each sheet of paper on top of the previous sheet. The result is a lot like a quarter-sheet watercolor paper sketchbook, but it is made of the paper I want to use.

Since the work involved is minimal, I approach each painting

with the same freedom that I would with a sketchbook. Any buckling of 140-pound paper when wet is minimal, especially with the small quarter-sheet size. Buckling of the untaped corners can be controlled with a small piece of masking tape.

Taping about twenty of these quarter sheets onto a board, I put together two or three of these "sketchbooks" before setting out on a painting trip. Having more than one sketchbook lets me begin another painting without waiting for an earlier sketch to dry.

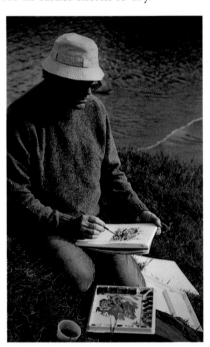

Using Water

Carrying water for outdoor sketching can be a problem. I use an old pint-sized liquid detergent bottle. The top can be unscrewed for filling, and the water can be squeezed out through the valve top. I chose the pint rather than the quart size because it's more portable. This size can hold enough water for at least two sketches, and I can always refill it at any drinking fountain, water faucet, or stream.

The plastic containers dips and cheeses are sold in work nicely as water cups for painting. But don't choose one that's too large. Mine holds less than a cup of water. After

completing one sketch, throw the dirty water out and wipe the cup clean with a few paper towels. Begin with a cup of clean water when you start another watercolor.

Odds and Ends

Tucked away in my knapsack are a few other odds and ends that I find useful:

• a dull knife for squeegeeing lines and texture into a wet passage of watercolor
• an artificial kitchen sponge
• a roll of paper towels for cleaning the palette and wiping excess water from the brush (It is so important to have a clean palette while painting that I clean mine automatically. When I can't find a clean space for mixing colors, I know it is time to clean the palette.)
• an empty box that tubes of watercolor are packaged in for propping up my sketch board (When slanted at an angle of about 15 degrees, the board lets excess water from larger washes run to the bottom and form a bead of water.

The water can then be picked up easily with the corner of a damp brush.)

About Photographs

Many artists like to bring a camera with them when they work outdoors. I carry a 35-mm single-lens reflex with me, but I have mixed feelings about it. I prefer to sketch and paint the subject right there than to take photographs to paint from later in the studio. Photographing the subject just postpones the real task of designing and painting it. With everything right in front of me, I can see how the light modifies colors and creates values. This is the time for sketching.

However, when I know the light will be so fleeting that a photograph is the only way to record it, I don't hesitate to use the camera. One morning while sketching on the docks at Thorn Bay, Alaska, I happened to look back toward the town. The sun was shining through the smoke of the morning's fires. The town's houses

and buildings were in shadow, their smoke rising between me and the sun. In the morning's cool atmosphere, this would appear as only a momentary illusion. Luckily, I had not left my camera on the boat. I took several photographs before the light changed. To date, though, I have yet to use those photographs for a painting. Maybe all I have is a set of good photographs.

And yet, on a fast trip, when I have only a few days to paint, a camera allows me to gather more material than I could sketch in the time available. I will sketch and paint a few subjects, and then, when mentally fatigued, I will use my resting time to look around for other subjects. This is usually when I take a few photographs. Some may turn out to be good material for use later, back in the studio, but most of them will lose their appeal and be discarded. Without the excitement of being right on the spot, I am left wondering just why I took the photograph in the first place.

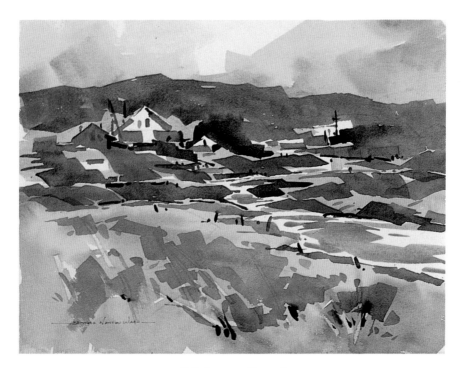

Elkhorn Creek
On a short trip, you can paint several sketches like this with the paint you would normally put into each well of your watercolor palette.

Spotting Your Subject

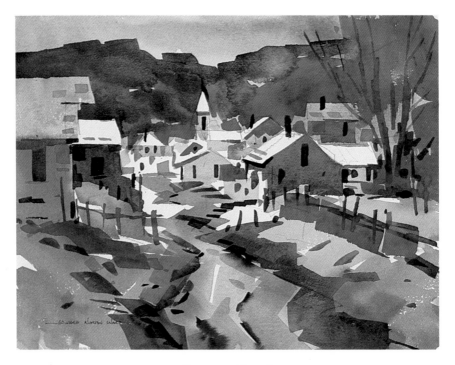

Sutter Creek

Rather than look for houses, roads, and trees, the artist
has trained his mind to find shapes, value contrasts, and colors.
This is what finding things to paint is all about.

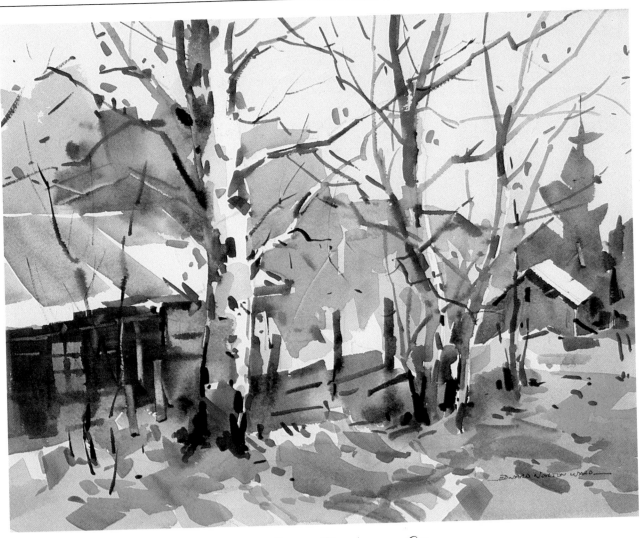

Back Lane, Tuolumne City

You have to go out-of-doors and tramp around to find your painting subjects.
This scene was hidden off to the side of a main road, and it is unlikely
that I would have found it if I had not been walking at the time.

CREATING original work begins with finding your subject in nature. You have to learn how to look at the world the way an artist does—not as identifiable objects such as trees or boats, but, instead, as shapes, values, colors. Instead of seeing an object, learn to recognize the shape. Look for light or dark value. Train yourself to see colors. This is what the artist needs to do—learn to look at the real stuff of painting— the shapes, values, and colors. To do this well, it is almost impossible to remain in the studio. The clumsy beauty of nature just doesn't exist there.

Not only must we go outdoors, but we have to walk around to find our subjects. Getting your feet on the ground, tramping through the weeds and over rocks, you begin to get the feel of the painting location and mentally start to explore its possibilities. If you just drive around in your car, no matter how slowly, you'll never experience this feeling of intimacy with your subject.

Don't be in a hurry to start painting when you have found your location. Walk around a bit. The exercise will calm you down. You want to get yourself in sync with the painting location and the material it presents. Actors have known for a long time that before going on stage, they have to get themselves psyched up for the part they will be playing. Preparing for this transition requires calm concentration. Once on location, you have to put previous thoughts aside and concentrate.

WALKING AROUND, you gradually become aware of what you are seeing. Maybe it *is* a nice color. Never mind what it represents—it *is* a nice color. The subject could be a rusty reddish garbage can, some yellow weeds, a flower bed of tulips, or a sunlit stream. Just note that it *is* a nice color.

Most likely, you will see something that appears to be very light or even a strong white. Is there something dark next to the white or close to it? Is there anything interesting about the shapes of these things we are seeing? Be interested in anything and everything because now you are an *artist*—not a casual observer. You want to observe things around you and note their relationships—as colors, values, and shapes.

By a simple change in your habits of observation, you will stop seeing trees, boats, flowers, or "things," and you will begin seeing interesting combinations of color—light and dark colors coming together into interesting patterns of interlocking shapes. With a little practice, you can learn to locate the colors in a scene. You can also learn to compare and identify the light and dark parts of a scene. And with a little more practice, you will begin to note the way colors, lights, and darks relate to one another.

Here is a simple exercise to use to practice this new way of seeing. It can be practiced any time and any place. No tools or special equipment is required. All you need is a little time and an open mind.

Put your book down and look at the things around you. Look for an obvious color, any color. Now find another color. Then find something light or white, then something dark. Now ask yourself where each item is in relation to the others. The more you practice this exercise in different locations, the better you will become at seeing your surroundings as an artist does.

There are few ready-made painting compositions in nature. It is the various combinations of colors, lights, and darks in nature that make good painting subjects. With the shapes and lines we see, we can arrange and "design" our paintings. With colors and light and dark values, we can create forms and add meaning to our design.

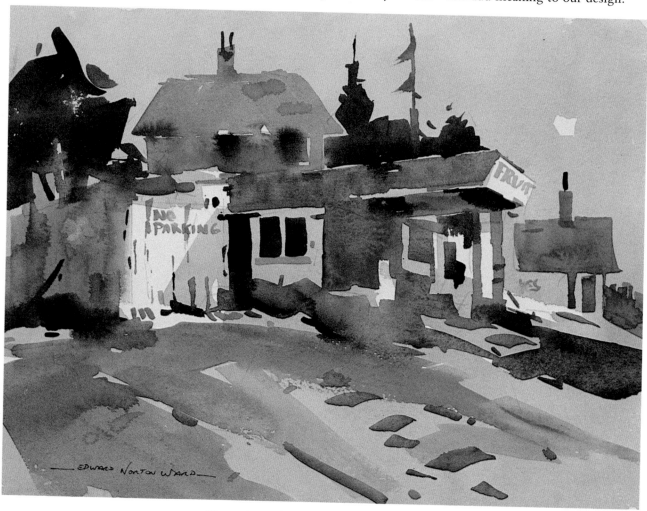

Pacific Grove Produce Stand

In my town there is an old filling station that was converted into a produce stand. I found the contrast of the strong white shape against the dark door too good to pass up.

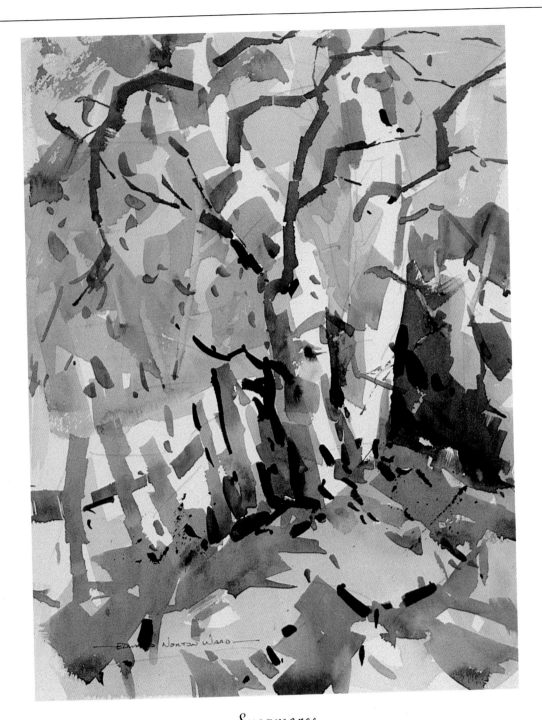

Sycamores
These two trees might easily have been overlooked since they were
at the edge of a hotel's parking lot in downtown Saratoga,
California. The warm background colors made the picture.
Adding the white tree trunks provided the viewer interest.

Visually, the light and dark relationship is one of the strongest contrasts there is. When you explore a painting location, you will notice that the effect of light against dark will command your attention more than anything else. Painters have always recognized the strength of these value contrasts, and they make good use of them. The value of an object is its relative lightness or darkness in a scale between pure white and absolute black.

Take a good look around your own neighborhood and see how many places this light and dark contrast occurs. Every occurrence presents a possible painting subject. Signs put up by local businesses not only attract your attention to the business but make good material to include in a sketch.

In *Sailing Off Moss Landing*, the placement of the light water and sails against the dark background hills creates the main interest. This is a good example of how contrasting values can create a good painting subject. In *Snow and Shed*, I placed the dark shapes of the shed and trees against the lighter background and almost-white foreground of snow. Note how little color is necessary in both sketches.

EXERCISE

Take one of your watercolors that you feel was a failure. Force the white shapes by consciously painting in a few brushstrokes of very dark color next to the whites. Does that give the painting more punch? Give the white shapes better definition by creating a nice sharp edge between the dark paint and the white paper. You can see how strong value contrasts will sharpen your design and your painting.

Take another discarded watercolor. Look for a place where you have painted in some identifiable color. Do the same thing you did with the white paper before. Add some strokes of rich dark paint next to the color and again define a nice sharp edge between the color and the dark. If there is any white paper nearby, leave that alone as an additional contrast to the dark.

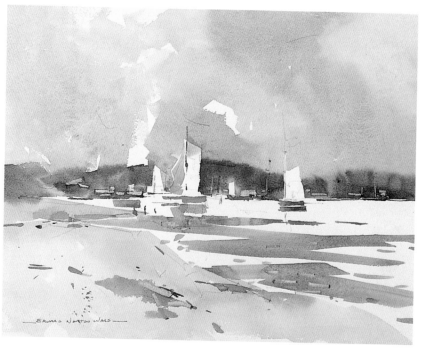

Sailing Off Moss Landing

Although small in proportion to the rest of the scene, the three white sails immediately attract the viewer's eye because they are surrounded by a strong contrasting dark.

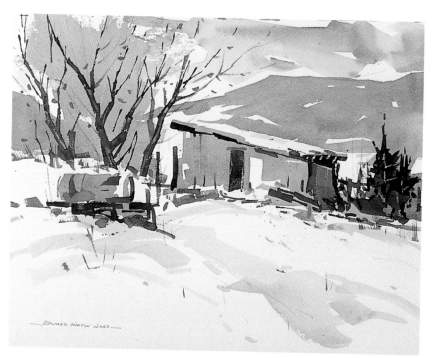

Snow and Shed

When the subject is a forceful value contrast, it is not necessary to use a lot of color. I think the subtle hues here are more in keeping with the mood of the scene.

WHY IS IT that some colors are more pleasing to us than others? Because of contrasts: Trees in fall attract our attention because their orangy yellow hue is played off against the blue sky and blue violet background. In *October in New Mexico*, I have exaggerated the color relationships of the fall colors in the mountains of northern New Mexico. The contrasting warm yellow and orange are the main focus of my sketch, working together with the complementary blue shades. This is the kind of almost too-strong relationship that is part of the charm of painting near Santa Fe and Taos, New Mexico.

Whenever there is a contrast of color, no matter how subtle, there is a subject for a sketch. It is not necessary to seek out dramatic color scenes, such as fall color scenes. Good color is right there around you—right in your own backyard! Take another look at your garden, but this time with an eye toward color relationships. Colored awnings on buildings, people on the street, automobiles, signs, all provide an abundance of color relationships that you as a painter can exploit.

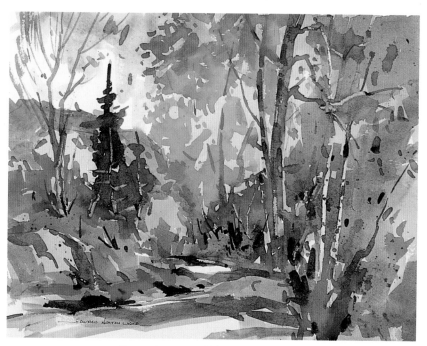

October in New Mexico

Here I left just enough of the white paper to show the lightest value in the scene but not enough to lead the viewer's attention away from the fall color, which is the main focus of this sketch.

Delphiniums

Color contrasts are everywhere, many of them right in the house. Varying blues against the warm dull orange made a painting of color.

EVERYTHING has a shape of its own. A tree is identified by its shape. Pines are triangular. Elm trees are fan-shaped. An old oak sprawls over the hillside in a half-circle shape. Most of what surrounds us in our day-to-day lives—houses, automobiles, boats—we can recognize by shapes.

In nature, these individual shapes are often crowded together into a larger composite mass that has a shape of its own. Buildings overlap trees; boats are tied up together alongside wharves; crowds of people form a moving mass of color and value. In *Docks at Hoonah, Alaska*, I have overlapped three buildings on a dock. Individually, the shape of any of these buildings would have been uninteresting—a static square or rectangle. But, in this case, the overall shape of all three buildings taken together presents an interesting single mass. Inside this larger mass, I was able to create even more interest by using a variety of color and value contrasts that were present at the scene.

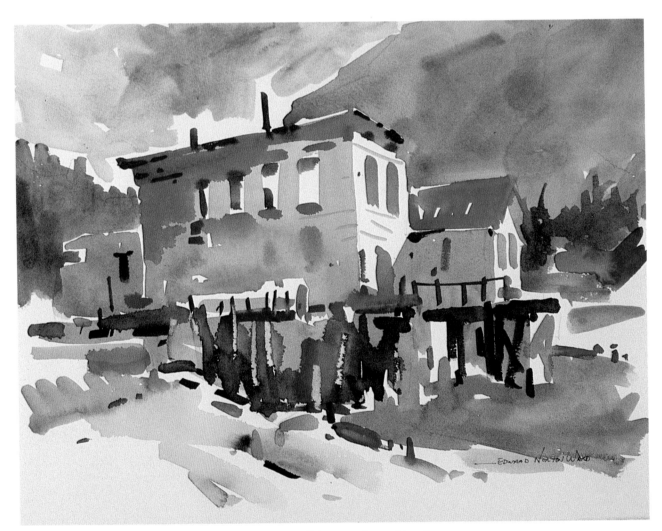

Docks at Hoonah, Alaska
By crowding individual dock buildings together,
I was able to create an interesting composite shape.

NEGATIVE SHAPES can be just as powerful a pictorial element as the positive shapes of things combined into masses. A negative shape can be thought of as any space in nature between two obvious positive elements such as tree trunks. What you see between them off in the distance, if anything, you would simplify, abstract, and lose into a single negative shape.

Noyo Harbor is a quick watercolor sketch I made of the harbor at Noyo on the Mendocino Coast. What I was interested in was the shape of the water's surface between the wharves and the buildings. Often, water and its reflections are used as a negative shape. At times, when I am placing the major shapes of a sketch, I will consciously draw in the negative shape first. With this shape in place, the positive shapes of boats and wharves can be drawn relative to the negative shape of the water's surface. Artists have a saying that if you "take care of the negative shapes, the positive shapes will take care of themselves."

A less obvious example of negative shapes can be found in the quick watercolor sketch *In the Forest*. Although this seems to be a sketch of tree trunks, if you look at the space between the larger tree trunk and the smaller tree to its right, you'll notice something else. Two hard edges of the trees' trunks pull the viewer's eye into the distance beyond. This is where the real payoff of color and white paper is to be found.

EXERCISE

The next time you are painting outdoors, try to locate a strong negative shape between two positive shapes. Draw this shape first, placing it as your center of interest. Next, broadly paint in the positive shapes that surround and define the negative shape. Leave the negative alone as white paper. Can you interlock the white paper of the negative shape with the painted positive shapes? After you have practiced this exercise a few times, your sense of negative shapes will sharpen and you can begin using them in your outdoor paintings.

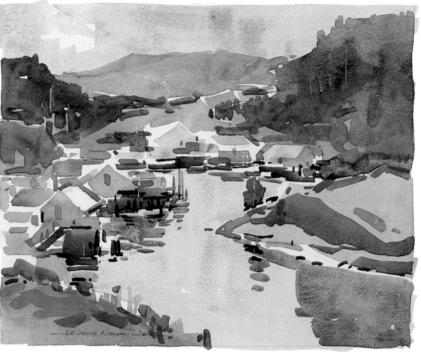

Noyo Harbor

In this sketch, the negative shape of the water's surface attracts the eye. The value contrasts keep It from straying from the water's surface.

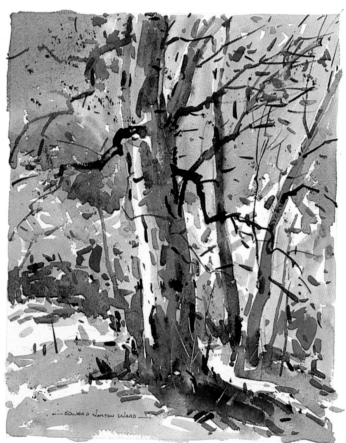

In the Forest

Strong edges create negative shapes. It is within this space that the artist can introduce his payoff, no matter how subtle or undefined.

IF WE CAN SEE things as simple shapes, the way these shapes fit together in our painting will determine to a great extent the design of the painting. A weak relationship among shapes will result in a weak painting. If there is a way of making our shapes interlock like pieces of a puzzle, then there will be a stronger bond among the shapes and a stronger composition.

In *Fallen Leaves, Tuolumne City*, I was interested in the way the darker-valued trees seemed to wrap around the lighter shape of the two overlapping houses. In fact, that edge where the light rooftops met the darker tree foliage became so interesting to me while painting that I felt I was finished before I had completely covered the paper. Whenever there is a strong bond of interlocking shapes in a subject, you have a good subject for a painting.

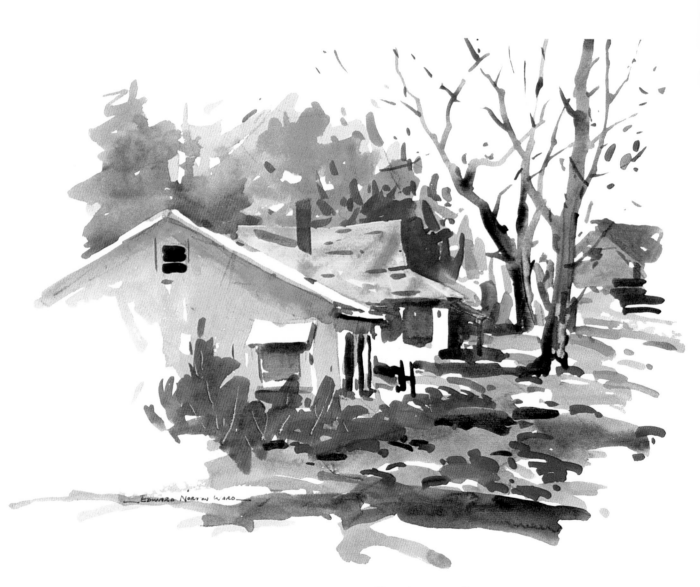

Fallen Leaves, Tuolumne City

The shape of the blue house interlocks with the darker surrounding foliage to lead the viewer's eye well down the lane into the picture. The yellow house and the foreground bushes unite both buildings into a large configuration of two contrasting colors.

ONCE YOU FIND your painting subject, reducing it to its essential parts—shapes, values, colors—creates a simplicity of raw material that allows you to concentrate on what it was that attracted you to the subject in the first place. By this kind of simplifying, you begin to form a plan of execution. The painting will proceed rapidly after that. Simplification is the best means of planning and transforming what you see into a painting.

Taos Pueblo Houses illustrates what I mean. My first interest was the blue building contrasted against the warm fall color. As I painted, I realized the sunlight on the larger building was so strong that I could leave the paper white. I could have developed the sketch either way, but I decided to pursue the color focus rather than go for a strong value contrast. The white paper and small dark shapes added subordinate interest, and the way the buildings overlapped created a pleasing geometric pattern against the rounded treetops. But the main focus is the color contrast between the cool blue and the warm muted oranges in the scene.

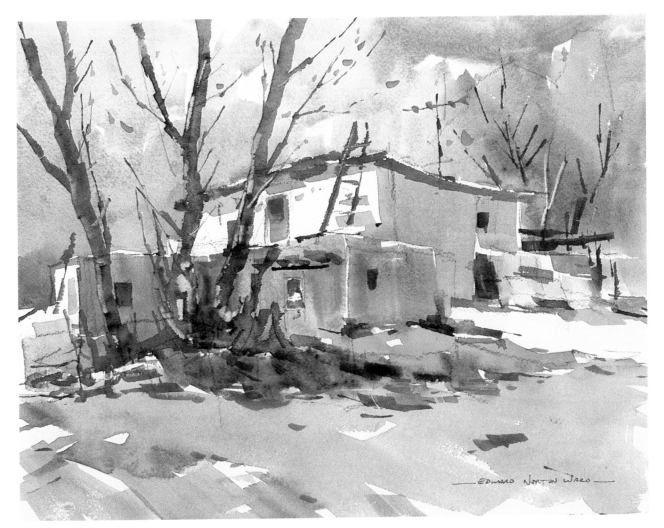

Taos Pueblo Houses

The white sunlit side of the rear building is almost strong enough to dominate the picture and lead the viewer's eye away from the blue and orange buildings. But here I decided to stay with the color focus rather than go for a strong value contrast.

WHETHER DIRECTLY related to color or value contrasts, a human figure in a painting immediately attracts the eye to it—no matter how small or impressionistic it is. I am not in the habit of putting figures in my paintings, but there have been times while sketching when I have seen people whom it seemed right to include. An obvious example is when I am painting a city street scene. *Flower Sellers* presented me with such an occasion. Crowds overflowed the sidewalks. I wanted to paint the San Francisco flower sellers, but to get more truth and feeling into the sketch, I had to include the people.

It is not difficult to sketch the human figure in watercolor for this purpose. It takes but a few strokes of the brush using a couple of colors. With a little practice, you can put such strokes of color into a painting almost as fast as you can write your signature. Your main goal is to capture the gesture of a person doing something. People walk; they carry things; older people stoop a bit; some turn their heads and look around. A good way to develop this practice is to cover a quarter-size sheet with quick figure studies from photographs in a travel magazine or ones you yourself shot on a trip. *San Francisco People* is an example of one of my recent practice sheets.

EXERCISE

With a small sketchbook and a broad pencil, quickly and secretly sketch the people passing by the next time you are on a busy street or mall. Don't worry if they notice you sketching. They'll just think you are making a traffic survey or recording something of no interest to them.

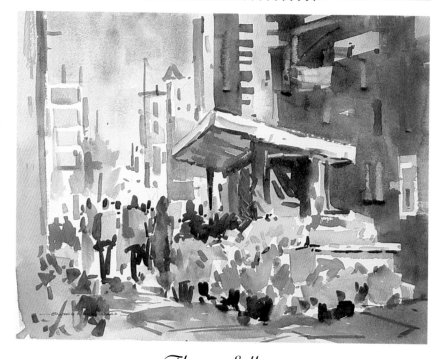

Flower Sellers

Although the brightest color is in the flowers, your eye wants to look at the crowd of people on the sidewalk.

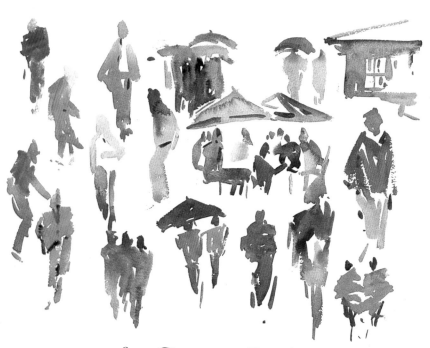

San Francisco People

I had taken a few color photographs on the corner of Stockton and Gerry streets one morning. I used the people in the photograph here, adding umbrellas over a few of them just to experiment with the placement of color.

ONE OF THE dividends of working outdoors is that you are continually presented with new painting ideas. When you have trained yourself to see the obvious value, color, and shape, unexpected ideas present themselves in such a way that you can see at a glance if something will make a good subject. It may be something you never considered before. When this happens and you paint the sketch, the results are often surprising. These are subjects no one has ever seen in quite this way before. These are paintings only the artist on the spot can paint.

Light coming from a different direction can turn an ordinary subject into a dramatic composition of light and shadow. A different time of day can offer a totally new effect.

Alaskan Village is a sketch I made one rainy morning at Hoonah, Alaska. I hadn't intended to paint— the weather was so bad—but my knapsack was with me nevertheless. I had worked my way up above the town for a better view of the bay and the islands offshore. When I realized how subtle the colors of the town below me were, I felt compelled to paint this sketch. The ever-present threat of rain made me work quickly. The effect I achieved would not have been possible in better weather. Because I worked so fast, there are a few blooms and runbacks in the sketch. I had only enough time to put the paint down and keep going. If you look closely, you can even see where a few raindrops hit the paper.

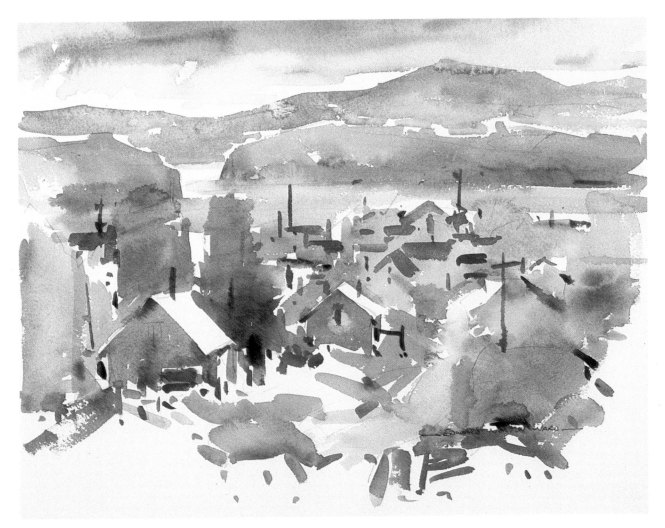

Alaskan Village

By looking back toward the town, I found an unexpected painting idea.
The artist has to continually be aware of his surroundings and
receptive to all the painting ideas as they present themselves.

Checking Light and Shadow

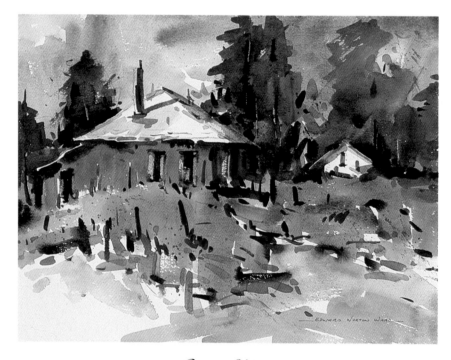

Gray Skies

When you understand the effect of the light's
qualities on the scene, you add an additional dimension
to the processes of creating a painting.

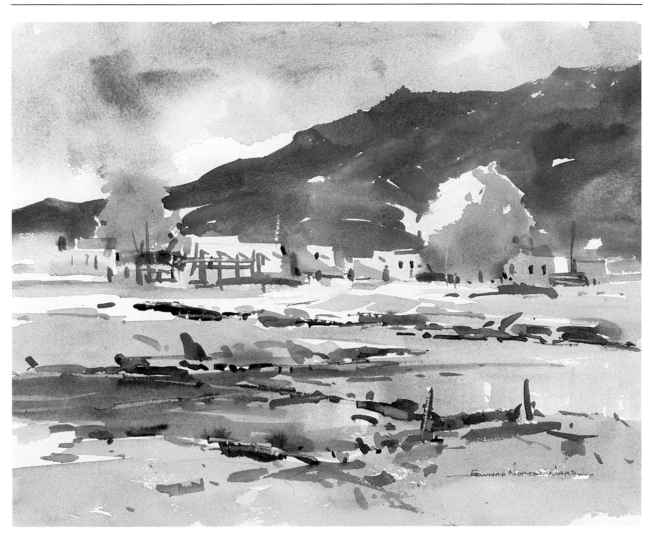

Taos Pueblo Creek

The light falling on the land and the distant pueblo buildings
and trees is the major unifying quality of this sketch.
It is the light that the artist is always trying to paint.

I T IS NOT enough to know that contrasts of value, color, and shape help create painting subjects. We also have to understand something about the qualities of light. When light strikes an object, some of it is partially absorbed by the local color of the object's surface. The remaining light is reflected away, but now it is the color of the surface it just illuminated. The light reflected off the first surface continues on to cast its color onto the next surface, and so on, thus creating a unity of color.

Also, you may remember that light as we see it is made up of all the other colors in the spectrum. Look closely and you will see that light shatters the edges of the things it hits. Artists say that the edge is "refracting" the light. As light rakes across the edge, the sharp edge is softened. At the same time, all the colors of the spectrum might appear as if that edge acted like a prism. This is why so many hues are present when the sun shines around the edge of a tree trunk, branch, or across a rock's edge. A similar refracting effect can occur when the light falls across the texture of a field of dry weeds. All the weed stalks act like countless little edges breaking up the light.

I**T IS THE NATURE** of light to strike a surface and bounce back; it doesn't just hit something and stop. Some of light's color is absorbed by the surface it hits. This alters the color of the reflected light. Strange as it may seem, the color of reflected light is the same as the color of the surface it originally hit. We see a red fire engine because all of the light's color components except the red component were absorbed into the red surface of the fire engine. We are seeing and recording only the red light that reflects off the surface and into our eyes, registering on the optic nerve.

The reflected light, with its new color from the surface of the first object it hit, continues on a new path, striking and illuminating other surfaces. Next time you are near a brightly lit color, look for it also in the shadows nearby. Just as the blue light from the sky shines into the shadows, light reflected from nearby colors will do the same thing. You'll notice this effect when you paint houses on a sunny day. Warm light from the grass near the house reflects up under the eaves, throwing a warm yellow orange color there. When you paint outdoors, look for this reflected light. Including it in your work is a subtle way of adding form and roundness to shapes.

Gold Rush Relics is a sketch I painted in the back streets of one of the old gold rush towns in the foothills of the Sierra Nevada Mountains. This old red building stood in bright sunlight, and red light was bouncing all over the place. With a reflective surface of new tin roofing, you can see a little of the sky color, but the overall effect of the sketch is red, owing to the amount of red light in the scene.

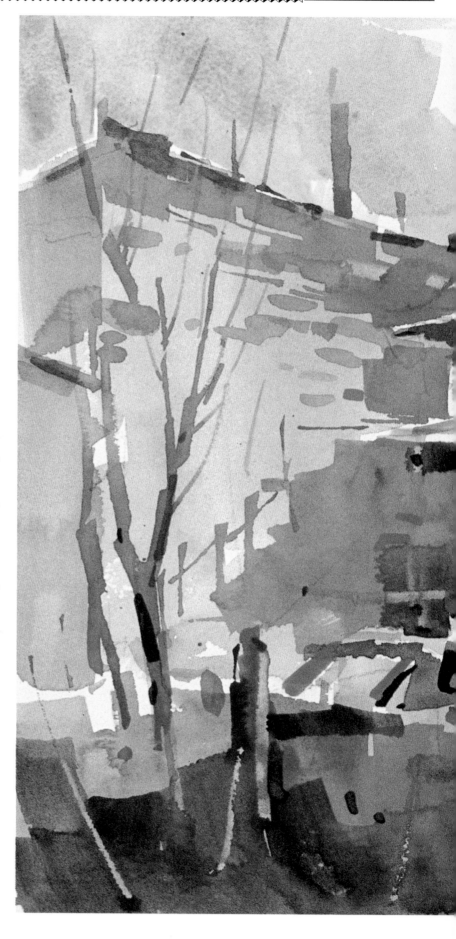

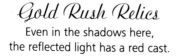

Gold Rush Relics
Even in the shadows here,
the reflected light has a red cast.

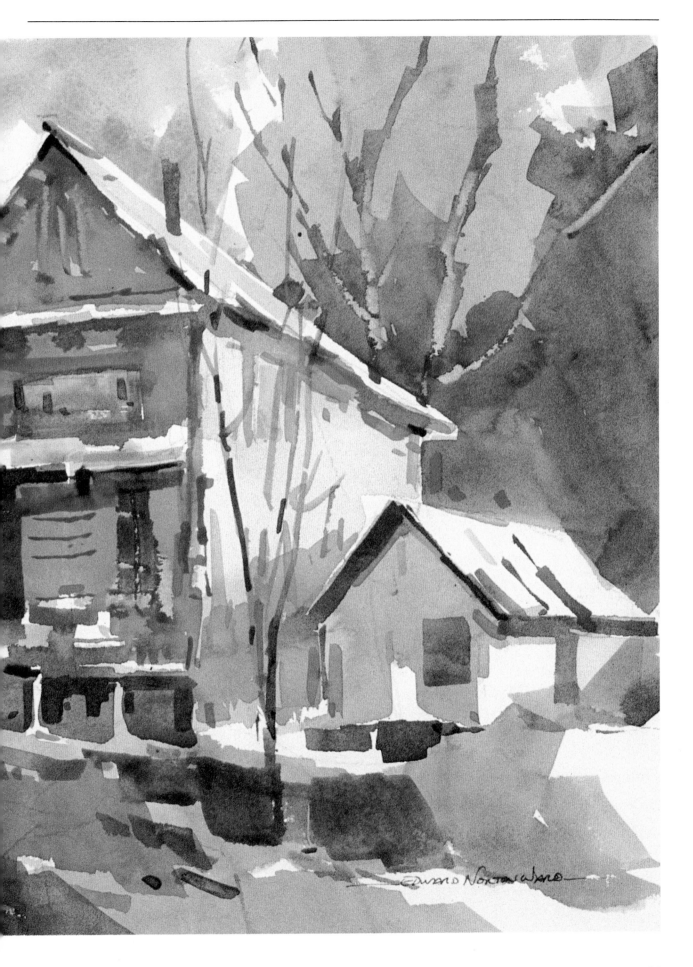

WHEN STRONG sunlight blasts one side of an object, a shadow forms on the other. This transition from the bright sunlit side to the darker shadowed side clearly lets the viewer see two different values. Difference in value is one way of creating a sense of three dimensions.

The watercolor sketch at right was deliberately left incomplete. You will notice that I just painted the shadowed side of the building, some background foliage in shadow, and a foreground wall that is also in the shade. Already, you can see the form of the building, even though you are seeing only shadows. When you learn to use sunlight to create depth of form, your work will begin to glow with an inner light.

Look again at my incomplete sketch. Notice that I have painted in a cast shadow on the sunlit side of the building and that I have left white paper. The direction of this cast shadow, along with the shadow the building itself is casting on the ground, shows where the sun is located. It could be said in a general way that where the sunlight strikes, a light value occurs, and where it doesn't strike, a dark value appears. Generally speaking, you can create better value contrasts by making the shadowed side a bit darker or the sunlit side lighter or by leaving the paper white.

Sometimes, especially with white buildings or boats, it is hard to see just how dark the shadows should be. I have found that if I squint my eyes, those seemingly middle values will appear either lighter or darker than they are when viewed with open eyes.

In *Morning at Thorn Bay* on page 37 the low angle of the sun hit the side of the weathered buildings on the right-hand side almost straight on. It was so bright that morning that it was impossible to see the small cracks and texture. Under the eaves and on the sides where the sunlight could not reach, I painted shadows that are quite dark in value. The result was a nice contrast of values to lead the viewer's eye to an even stronger contrast in the distance.

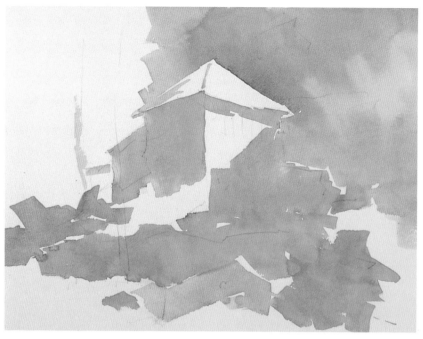

Where the light strikes an object determines the way the artist creates the illusion of form.

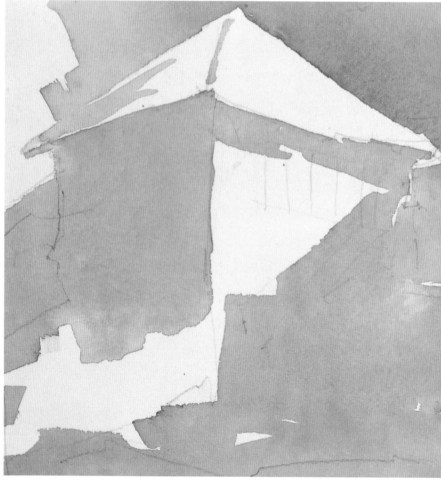

It is the angle of cast shadows that indicates to the viewer where the sun is located.

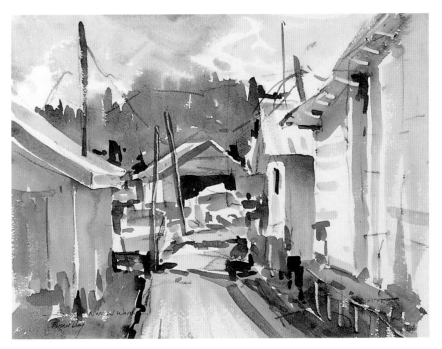

Morning at Thorn Bay

Shadows define the forms and create a pleasing design of darker-valued shapes, where I could add suggestions of texture, detail, and color.

EXERCISE

Take one of your previous watercolors and paint it again. This time, just paint in the shade and cast shadows. Leave the rest of the paper white. Does the resulting sketch give a sense of the light's direction?

Outdoors, try the same approach to simplify a watercolor sketch. Paint only the shadows and leave the sunlit parts as white paper regardless of what colors they really are. Put all the reflected color you wish into the shadows. Does this sketch show where the light is coming from?

Try a second sketch as before, but this time concentrate on painting the shade and cast shadows in shades of cool blue and blue violet. To suggest the light's color, add just the slightest blush of warm yellow, orange, or a yellow permanent rose mixture to some of the sunlit shapes. Don't cover them all or you will lose the sparkle of the white paper.

Strong shadows can be major design elements in leading the eye, as in this close-up of *Morning at Thorn Bay*.

WHEN THE bright yellow light of the sun strikes something, it makes the local color appear warmer than it really is, sometimes quite dramatically. Red barns, for instance, will take on a light, rich orangy color. Greens in nature move toward yellow and in some cases—late in the afternoon—almost to orange. Light tries to create a dominant unifying color scheme of its own by making every color it strikes warmer.

The old shed in *Shed and Corral* was actually covered with weathered barn siding, but the late-afternoon sun cast a glow of warm light over the whole scene so that everything gave off a red-orange glow. Even the trees in the background were affected by the sun's warmth. As the sketch developed, I had to introduce the violet and blue into the fence and the shadow in the foreground just to balance the dominance of the red-orange of the sunlight.

When sunlight cannot reach into cast shadows, there is a strong secondary source of light from a blue sky. Colors in the shade will be altered also, but in this case the blue light from the sky will make them appear cooler. In the shade, the greens will move toward blue and in some cases as far as the blue violet hues. Besides cooling it, the mixture of the blue light with any other color in the shade will also cause it to appear to shift to the complement of the same color in sunlight. The shadow side of a red barn can often appear dull green in places. Fall color can take on a shade of blue in the shadows. Knowing about this effect, the artist can exaggerate the shift in color while making the light in his paintings seem more accurate.

In *Sonora Pass Country*, most of the foreground embankment is in shadow. I have introduced cobalt blue into the red-orange color of the foreground weeds. Then I painted in a small patch of brighter red-orange in front of the house. This gives a feeling that the sunlight is hitting the small patch of pure red-orange, since it is contrasted with the cooler, large foreground of dull red-orange.

EXERCISE

Take one of your old watercolors. Repaint it pretending that you are painting the light as it bounces off the colored objects in your painting.

Sunlight is very warm yellow orange when it leaves the sun. Where it strikes an object, the sunlight is altered to take on some of the color of the surface it is reflected from. This color mixes in with the original yellow orange. In your painting, where might this newly created colored light strike a second time? How will the surface it strikes be altered? What color could it be? Paint the light in your painting that color.

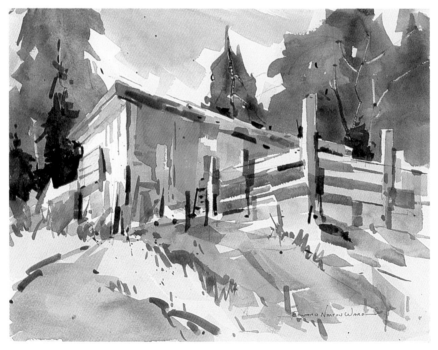

Shed and Corral

By taking into account the unifying color effect of the warm light, I was able to use a dominance of red and red-orange in my painting. To offset the red's strength, I added a small amount of pure blue as a color accent.

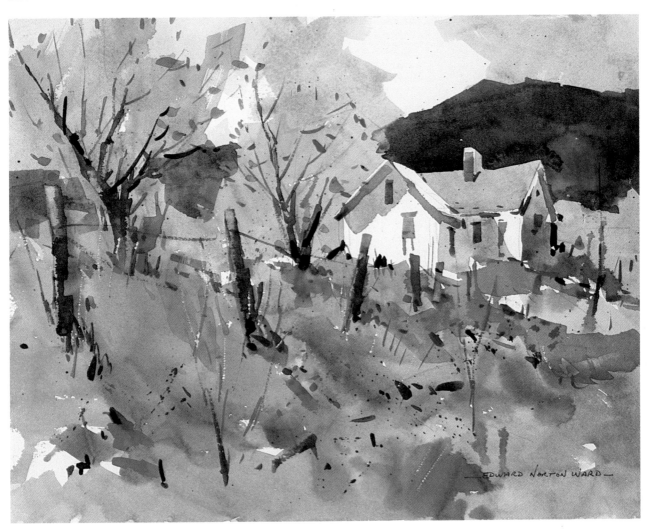

Sonora Pass Country

When you temper colors in the shade with cool blues
and greens, and warm colors in the sunlight with yellows and
oranges, then you are painting the illusion of sunlight.

SO FAR, everything that we have said about light and color is based on light from the sun. What happens to color on an overcast day? Colors without the influence of bright sunlight try to revert back to local color. There is always some effect of sunlight, but it is greatly diffused by the veil of clouds overhead. Since light can be absorbed by any surface it strikes, the small particles of moisture present in the hazy air will first absorb the yellow component of the sunlight. If the cloud layer is thick enough, then orange and red will be absorbed next. This explains why light seems so violet or blue on rainy days.

In order to account for this occurrence in our watercolor sketches, we have to pay attention to the reds and yellows in the subject. If you try to warm them up, you may create a light effect that does not ring true. The viewer may be confused as to whether the scene is overcast or sunny. Unless the effect is actually present, I usually subdue my warm colors by adding a little blue or violet when I am painting an overcast day.

As you can see in *Rainsqualls over the Rio Grande*, I painted a rainstorm over the Rio Grande Valley just north of Santa Fe. The storm clouds over the mesas were my main interest here, and I found

the foliage of the trees and the earth color of the fields and buildings distracting. I glazed a cool wash over them in the lower part of the painting to keep them from drawing the viewer's attention away.

Both green and violet have little or no yellow present in their light. Thus, they appear a bit bluer and colder on a gray day in the absence of the strong yellow-orange sunlight. To my eye, this added blue cast makes the green and violet appear more vivid. It makes it a joy to paint on atmospheric gray days when nature invites me to push those colors to their brighter variations.

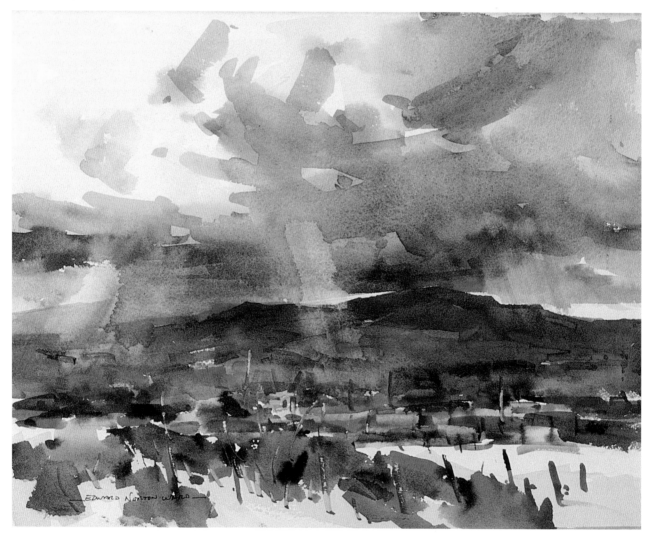

Rainsqualls over the Rio Grande
Gray rain clouds filtered most of the red and yellow from the sunlight. Only a hint of the bright fall colors was visible in the distance. I muted these colors to strengthen the character of the rainstorm.

THE PRESENCE or absence of light can create a high-key or low-key color scheme and hence a mood for our painting. If you study the work of the French Impressionists, you will see that they liked to use a lot of light, bright colors. Their high-key paintings exuded a warmth and sublime feeling. In looking at them, one feels as if he were loafing in a sunlit field.

Or, when most of the colors are dark and muted, the mood becomes low-key—more serious and somber. *Carini's Dock*, the sketch of the waterfront on a bright sunny day, was painted at high noon. To capture the feeling of the time of day and the joy of the moment, I deliberately chose to keep my values keyed from mid-range to white. A pattern of light, bright colors with a lot of white paper creates a lighthearted mood that makes the painting fun to look at.

Catwalks at Inverness is a sketch that created just the opposite mood. It had been raining most of the day. We had to wait until just before sundown for the weather to break so that we could go outside to paint. The low light, the remaining clouds from the day's storm, suggested that a low-key color scheme was needed. The fisherman's shack and the catwalk over the salt grass marsh were just the appropriate subjects for this low-keyed light. What resulted was a somber sketch reflecting the hard life of those who make their living from the sea.

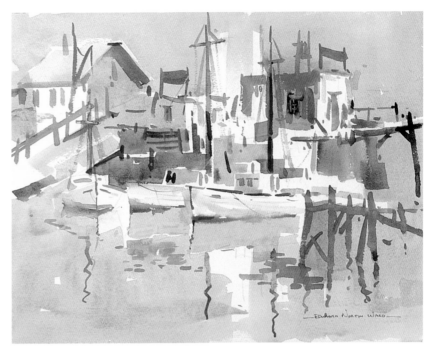

Carini's Dock
I used light high-key colors here and left a lot of white paper showing. This gave a lighthearted feeling to the sketch and reflects the mood of high noon.

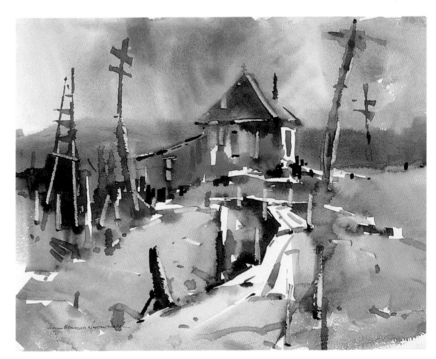

Catwalks at Inverness
Heavy atmospheric color in the upper half of this sketch suggests the somber mood of a rainy day at the sea's edge.

Making Quick Sketches of First Impressions

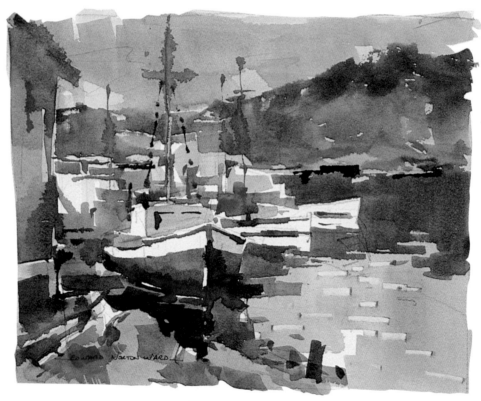

Dockside Boats

There is more to painting than just recording your first impressions.
You have to design an overall plan for your painting.

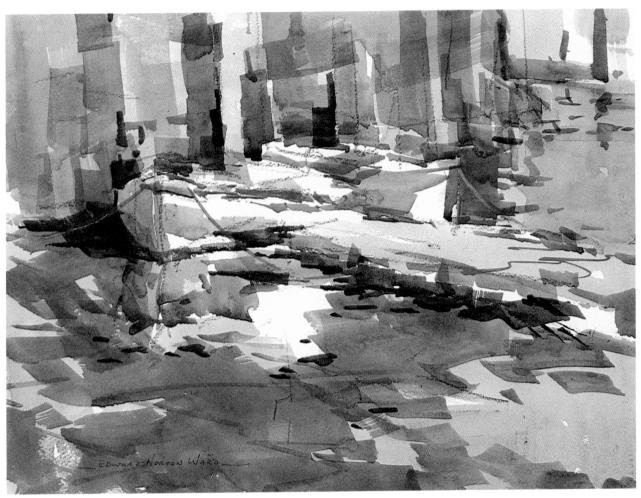

Sunlit Skiffs

As you calmly walk around your painting location, you will find that scenes you first overlooked present themselves as you begin seeing as an artist sees.

I N THE NEXT few chapters I want to show you just how I approach sketching on location. I'll show you how I use quick sketches to get my first impressions down on paper. For this, I work with both pencil and watercolor. Then, since there is more to painting than just recording what you see, I want to say something about creating a design to emphasize the subject and, finally, streamlining it.

Sketching and painting is not a step-by-step process. In actual practice, most of what is explained in the next three chapters occurs almost simultaneously. In most cases, the decisions the artist makes, after years of practice, are almost automatic. But for the purposes of discussion, I will take

the process apart to show you how my system works.

First of all, working a painting location on foot allows you to become receptive to its painting ideas. Snooping around and keeping your eyes open sharpens your creative awareness. When I take my sketch kit outdoors for the first time, my mind reaches an acute creative state. Caught up in the spirit of the place, I see subject after interesting subject for my paintings.

Walking around slows me down and allows me to gaze awhile at a scene. I can roam around, looking and thinking about the subject. As my enthusiasm develops, I begin some preliminary sketching as a way to form a plan for my

painting. I have little trouble getting excited about a subject in nature, but I know I have to consider some design and value possibilities first, in order to make a good watercolor sketch.

Using quick thumbnail watercolor sketches helps me to become better acquainted with my subject. I see how things come together, how colors and values can be played off against one another, and in general what changes I need to make to create a good watercolor sketch. In many cases, this kind of simple thumbnail sketch will give me enough information to start right out painting. Sometimes these sketches can immediately give me the feel for the subject and the way the paint will flow.

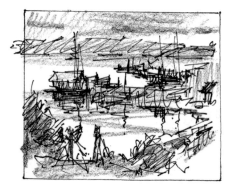

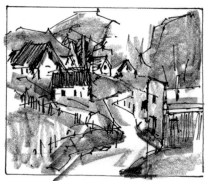

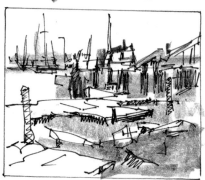

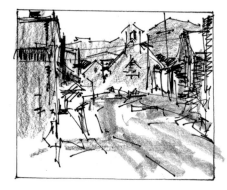

I FIND THAT my best designs result from first working out an idea as a small thumbnail sketch. The thumbnail sketches at left were drawn on location for use in later watercolor sketches. With a soft pencil and a stylus pen, I quickly drew a small rectangular shape about two by three inches and with the same proportions that the finished watercolor might have. The subject determines whether a horizontal or vertical sketch is needed.

I made two sketches of the same subject in a long horizontal format and in a square format, just to get an idea of how the subject would look either way. At first I tried to place a few major shapes in the sketch. I was not trying for fine drawing, just a quick suggestion of how the major shapes might fit together in a pattern. Look at the old boat hull in the two sketches on page 45. I made no attempt to keep the drawing within the border of the sketch. Notice that in each of these two sketches, there is a suggestion of one long contiguous line where the top of the boat's hull and cabin and the background house cross the picture space. This line is the most important: It divides the drawing into two shapes, one larger than the other.

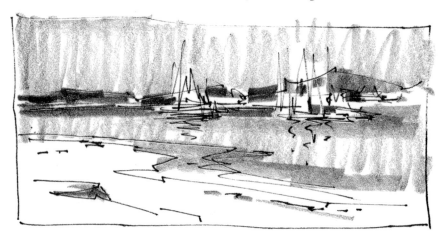

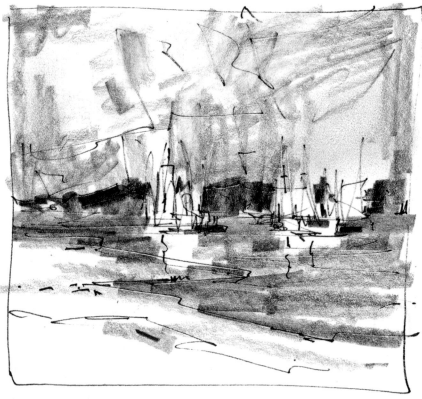

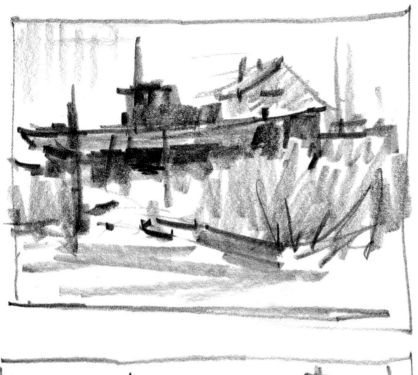

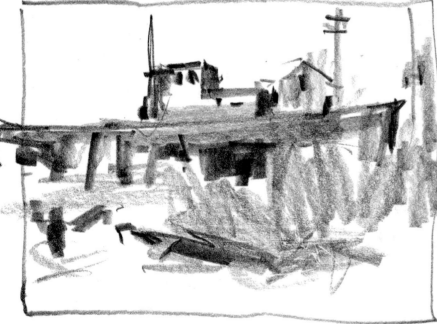

When I started each sketch, I placed that line first in order to divide the sketch into a major and a minor shape. In each case, the major shape is the boat, background house, and the foreground. The minor shape is an interesting negative shape representing the sky. Once I see how the shapes fit together, I try to determine their values.

Now look at the sketches on the left side on page 46. Here again, the subject itself was my guide. Squinting my eyes, I looked and could see where shapes of things were dark or light and where others were middle tones. Identifying these values can determine the success of a sketch and of any paintings from it. Searching for the greatest contrast of light and dark in the scene, I'll introduce an exaggerated value contrast in the sketch. The white paper will serve as my lightest value. The darkest dark can be put down with the soft pencil applied with some pressure or with solid pen strokes. Middle tones are created with a light stroke of the soft pencil or lightly crosshatched pen strokes.

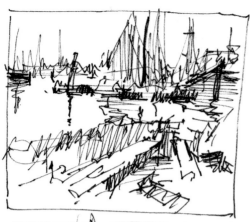

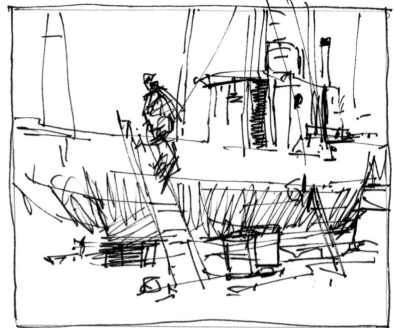

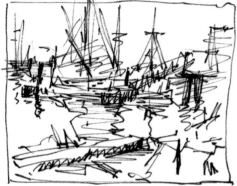

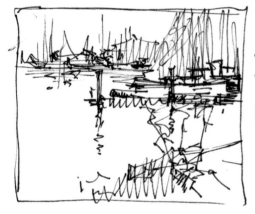

Making successive sketches
helps me to refine my design.

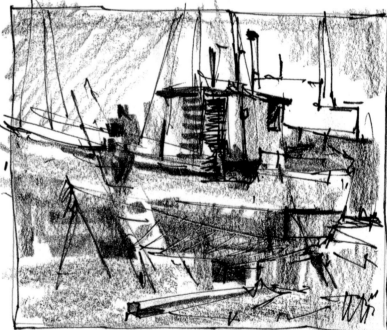

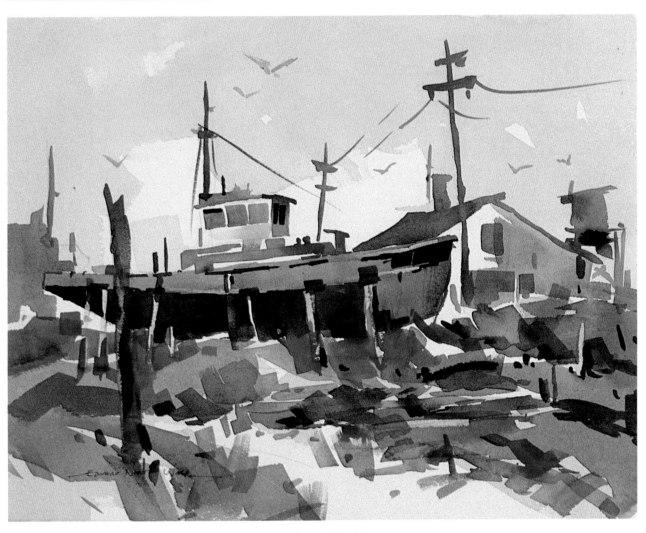

Old Hull
Practicing with thumbnail sketches can lead to
better design choices in later watercolor sketches.

Remember to draw thumbnail sketches rapidly and don't give more than a few minutes to each. I like to draw several of them to explore and refine my design. In the successive sketches on page 46, I was building on ideas and experience gained from earlier efforts. I moved and collected light shapes into larger light shapes and related darks to one another or used them to enhance light-valued shapes. The interweaving of light-, dark-, and middle-tone shapes becomes the start of a plan for the later sketch.

By executing several thumbnail sketches in a few minutes' time, it is possible to find designs that work and discard those that don't. As you look for interesting shapes, your creative senses become sharper. Insight into a completely new approach may be found through designs suggested by earlier sketches, or a better structure of light and dark may become apparent.

EXERCISE

Take one of your old watercolors and redraw its design as a thumbnail sketch. Can you improve the value structure to get a better design? Look carefully at where you placed the darkest dark and the white shapes in your thumbnail sketch. Could you change things around a bit in order to place one or more darks next to a white shape?

47

J UST AS THE thumbnail sketch provides insight into the overall design and value pattern of the subject, a quick watercolor sketch shows its color design and contrasts. Quick watercolor sketches like those here allow me to identify colors in the scene and to decide what color dominates and how color will look with the light and dark shapes I have isolated in my thumbnail sketches. Since white and dark shapes can hardly be identified as colors, the mid-tone shapes are where the colors will be introduced.

When painting a quick watercolor sketch, I'll use almost any paper that is handy. In the sketch here, you can see I have even used pages in the same sketchbook I used for black-and-white thumbnail sketches. I am more interested now in how the subject will look with color masses merged into the light and dark masses.

The quick watercolor sketch brings the idea for a painting to a state where a final painting can be started with confidence. A plan for the sketch is complete. The set of thumbnail sketches along with a few fast watercolor sketches is all that is necessary. There is no need to identify and record every detail, every house, tree, and rock to paint a successful sketch. Getting the shapes, values, and color of things is better. Combining shapes into compound shapes of the same value is the final goal.

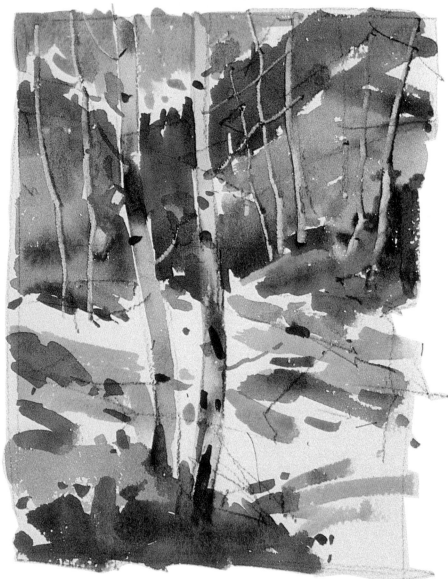

Fast watercolor sketches help you to feel confident about starting your final painting.

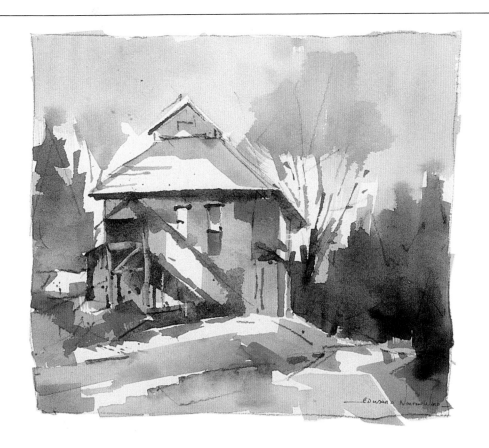

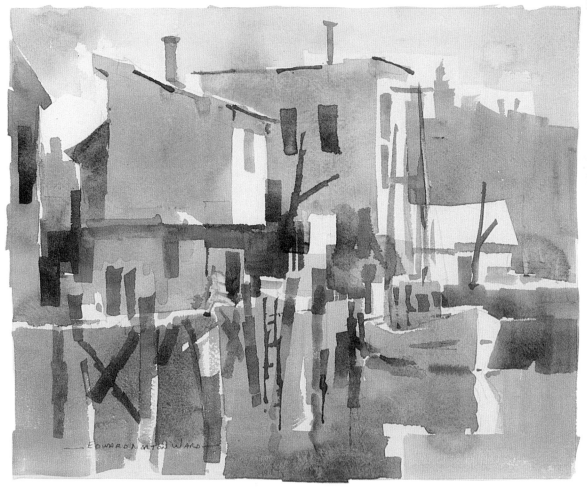

WITH THE QUICK watercolor sketch, I also want to record any color contrasts that are present: the warm colors of sunny days; the cool tones of harbor and coastal scenes. Whatever the emerging colors in the sketch, one always seems to dominate. Within this scheme of things, I like to locate touches of contrasting color and bring them out in the sketch. Whether they be flowers, someone's hat, old working gear, whatever—the representational factor matters less than the color accent and the life the color gives to the sketch.

In the illustration here, I had quickly sketched a mass of white fishing boats. A closer study of my subject revealed that the little spots of color were actually fishermen. An oil slicker became a spot of yellow.

Nets became a rusty heap. Colors blended to suggest masts and trim. Fish boxes and other gear strewn about the deck contributed their own particular hues. This variety is there for your use as an artist. What you choose in creating the

EXERCISE

Take one of your old watercolors. Quickly paint several small watercolor sketches. Look for ways of improving the color. Would a light-colored shape be better as white paper? Can a unity of color be introduced by painting most of the first lay-in wash the same color? Try putting in some accents of contrasting complementary color next to some large shapes of color. Do you feel your color has been enhanced by introducing this minor conflict of color?

conflict of contrasting colors in your sketch lends to it a vivacity crucial to a good outdoor watercolor painting.

I am always on the lookout for these little color accents. I don't look for nets, doors, boxes, or whatever—I look for spots of color. When I see them, I touch the appropriate color into the sketch about where they appear within the larger shape of the design. I might even "borrow" from nearby if I like the color enough.

I once asked a dockworker in Gloucester why the New England fishing boats were all painted blue and green, whereas those on the West Coast were predominantly white. "The rust spots don't show" was his Yankee reply. So every color you see has a reason. Put it down without fear.

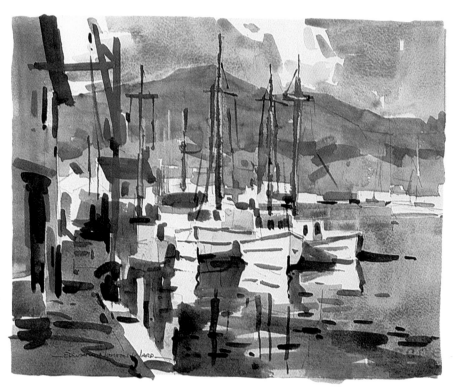

Morning at Noyo
In the quick watercolor sketch, small color accents can represent anything the viewer imagines them to be. Put them down as you like, even "borrowing" from nearby if necessary.

IDENTIFYING color in nature can be confusing. Man-made objects usually have colors that can be easily identified, but when objects become weathered or are located far off in the distance, their colors seem to gray out. The quick color sketch gives the artist a chance to experiment with colors in nature. You can identify them often by a process of elimination. As you study the grayed color, determine if it is warm or cool.

In *Lower Hondo Creek, No. 1*, I painted the scene pretty much as I found it. I identified the grays as either warm or cool. Once I had decided what kind of gray I was looking at, I had identified a color, no matter how subdued. It was either within the warm color range of orange and yellow hues or within the cool color range of green, blue, and violet hues.

You may then want to exaggerate its intensity. Don't worry too much about finding the exact pigment color as you see in nature. How the color looks in the final sketch is more important than making an accurate match with nature. If you choose to exaggerate the color, your identification will show you which way to push it.

In *Lower Hondo Creek, No 2*, I painted the same scene with same colors I had used in *Lower Hondo Creek, No. 1*. However, in the second sketch, the colors were not muted or grayed. If I saw a tone that suggested violet, I painted a stronger, purer violet. I did the same for the other colors in the scene. It was possible to try one color and see how it looked in relation to those already used in the sketch. It's a matter of personal taste which sketch turned out better. Some like the quiet mood of the muted colors; others like the vibrancy of the intenser colors. As I push and pull colors about on my painting, I try to add a variety of color intensities in place of nature's more muted grays. I like to intensify some while leaving others alone. Many times the reasons for altering colors are unconscious, and I trust my unconscious where painting is concerned.

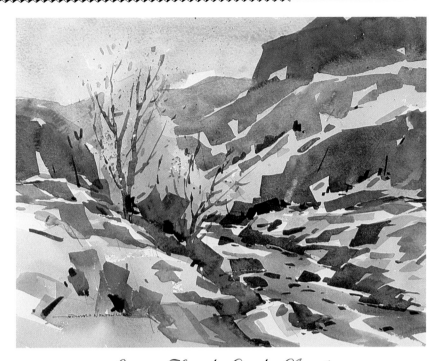

Lower Hondo Creek, No. 1
The grayed colors are the colors in nature as they appear to the artist.

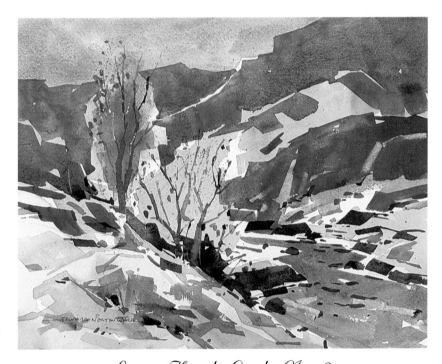

Lower Hondo Creek, No. 2
Quick watercolor sketches are an excellent form for experimenting with color. By exaggerating the intensity of a color, the artist can add an exciting spark to an otherwise dull subject.

Creating a Brisk Design

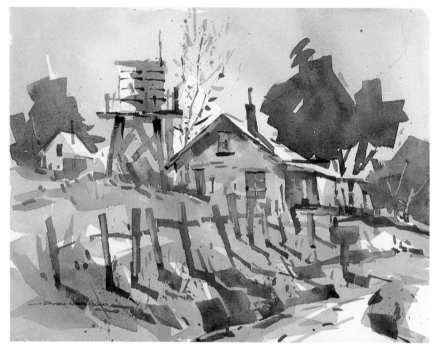

North Coast Ranch

It is rare to find a perfect composition outdoors. Nature
supplies the artist with the raw material in generous amounts.
The painter supplies a knowledge of design to create the painting.

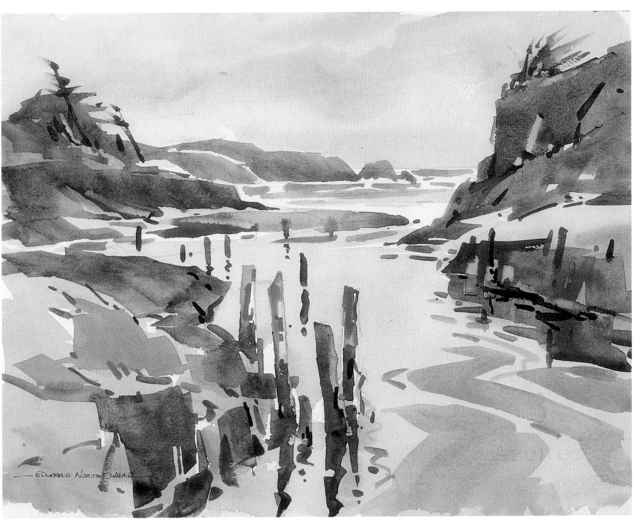

Mill Site at Caspar Creek

To be able to create a good design demands an awareness
of the many possibilities a scene has to offer.

IF AN ARTIST paints a scene as he finds it—no matter how exciting the subject—the result may turn out to be little more than a record. For me, the challenge is in taking the raw material of the scene, applying a knowledge of design and color, and in the end creating a greater painting.

As the painter develops his skills, his knowledge of design continues to grow. Design is not something you learn once and for all. Design skills develop through continual practice. Each venture outdoors, each discovery of a new subject, teaches the artist a little more about design. Sometimes a new understanding allows a

breakthrough where great advances can be made, but most of the time it is in living our lives, day by day, that we continue to see new things and learn more about design. There is no end to the learning and increasing awareness, and that is why painting has such a powerful attraction for so many people.

Later, we will talk about simplifying the subject. This is the ultimate goal of design, but in order to lay a foundation, I want to talk about three basic concepts: massing shapes together, organizing intersecting planes, and creating transitions. Though they overlap, we will discuss each separately for ease in understanding them.

As MENTIONED earlier, one of the approaches to sketching and painting outdoors is to look for shapes of similar value that can be fitted together into an even larger shape. A good design results when different objects seem to flow together because of their common value. Smaller shapes may be of different colors, but if all the hues are held close in terms of value relationships, the common value seems to pull everything together into one large shape.

I was able to define a large simple mass of buildings in *Backyard Patterns* by keeping the contrasting orange and blue of the separate buildings close in value. A liberal amount of interesting white paper shows throughout this large shape. Nevertheless, the viewer reads the

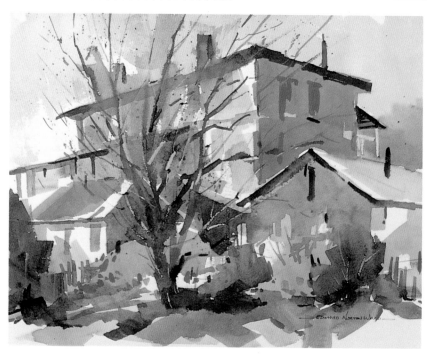

Backyard Patterns

You can combine two or more shapes of similar value into one larger shape and use almost any color in the smaller shapes, as long as the value is similar.

EXERCISE

Take one of your old watercolors that you no longer want to keep. Cut out the main shapes of the watercolor, especially those with good color qualities. If you want some brighter color than you have in the old watercolor, cut out pieces of bright-colored paper from some of the fashion magazines.

Arrange these pieces of color and value on a piece of white mat board in a design similar to your original watercolor. If a piece seems too large, cut it to a smaller shape. Overlap pieces to create larger shapes. Be sure to leave some larger shapes of uncovered mat board showing for your whites.

Can you make a more interesting design than you had in your original watercolor? Can you find places where you can overlap some shapes of similar color or value and combine them into larger shapes? When you have found a design you like, paste the pieces down on the mat board for a permanent record. Now paint another watercolor using the original subject matter but with a new design based on your "collage."

This is the thought process you go through when selecting and painting a subject outdoors. You mentally cut out the pieces that represent the shapes in the scene and then mentally paste (paint) them back on your watercolor paper where you want them to be instead of where they actually are.

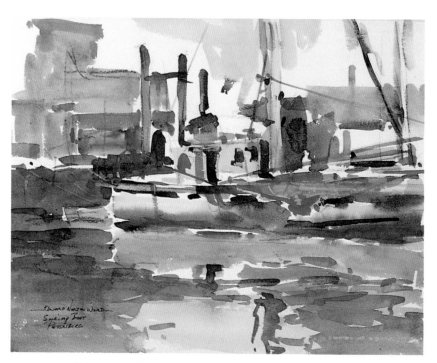

Shrimp Boat—Petersburg, Alaska

Since the dark secondary shape of massed buildings, pilings, and water reflections "stages" the rear of the white shrimp boat with its warm nets and dark rust waterline, the viewer is not conscious of what the shape really represents.

mass of buildings as middle value. The white paper adds textural interest, not a value standard.

Whenever possible, secondary shapes of like value should also be created by massing together smaller shapes. I like to create these secondary shapes in order to "stage" the primary theme.

The main subject in *Shrimp Boat—Petersburg, Alaska*, was the hull and cabin of the white shrimp boat. The nets, the rusty waterline, and the light blue trim on the cabin gave enough color so that it was not necessary to include the full length of the boat's hull. In order to focus the viewer's attention at the shrimp boat's stern, I created a strong value contrast by interlocking a dark shape around

the white of the hull. This dark shape was loosely defined by combining into one larger shape all the smaller shapes of the buildings and the dark pilings and their reflections in the water.

Sometimes the possibility of pulling shapes together is not so obvious. The artist then has to make some arbitrary changes in the way the scene is arranged. By imagining a shift of things he sees, he can usually find a better design.

In *Fisherman's Dock* there was no obvious mass of fish boxes piled up on the dock; they were scattered all over the place. The overall shape and color of the building was what first attracted me to the scene. After my first few thumbnail sketches, I became aware of the warm-colored

boxes and saw how they could be introduced as a mass around the base of the building and out onto the dock. This created a larger, less static shape than one that used the shack or the boxes as separate shapes.

As an artist, I felt free to move the boxes and adjust their values to build a more interesting design of large massed shapes. When I was a beginning painter, I found this freedom hard to understand. I knew I was allowed to change things in my painting from the way they were arranged in the actual scene, but I didn't know why I would want to make such a change or when I should do it. *Fisherman's Dock* illustrates one of those reasons.

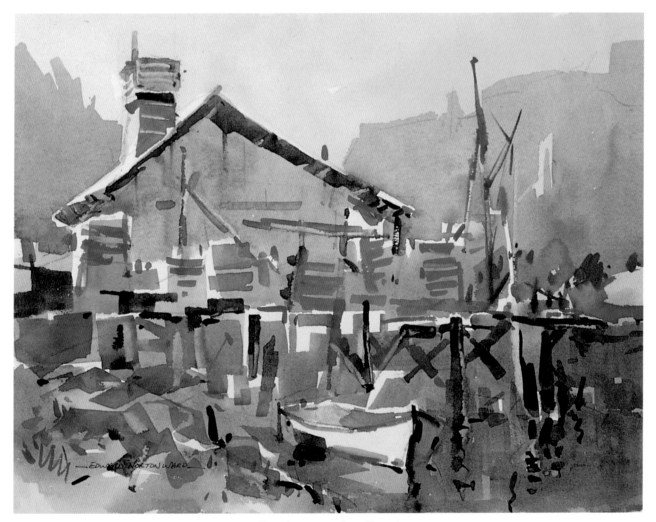

Fisherman's Dock

As I began to mentally move the scattered fish boxes while drawing in my design,
I realized that by exaggerating their number, I could get an even stronger design.

WHEN YOU LOOK at the shapes created in drawing your subject as being made up of planes of flat surfaces, you will begin to see that these shapes are quite active. Most objects are formed by several connecting or intersecting planes. Houses and buildings and their surrounding fences are obvious examples. If you look at *The Yellow House*, you will see that I designed the foreground and the trees as several connecting planes. Light plays an important role in defining the various planes of this painting subject. The side of the building in shadow can easily be distinguished from the side in sunlight. The same effect, however, is also present in the foreground.

I consciously painted three separate planes to represent the irregular grade of the ground in front of the house. I painted the plane on the right in a brighter, warmer color. I painted the plane on the left, which extends out from the dark shed in a cooler, grayer color. A third plane, immediately in front of the other two, can be differentiated from the others by another, slightly different color. When I started the painting, I lightly drew in these three planes so that they would look as if they were at somewhat different angles from one another. For this purpose, I carefully placed diagonal lines, which defined the edges of each plane. The slight difference in color of each plane heightens the feeling of irregular ground.

The placement of these planes in nature gives the illusion of dimension to our paintings. By identifying planes and noting the angles they make with one another, the artist has a subtle means of leading the viewer's eye through the design. There are even planes in clouds and the foliage of trees. In *Clouds over the Mesa*, I used the planes of the foreground and the underside of the large clouds to direct the viewer's eye deep into the painting.

The foreground planes we examined in *The Yellow House* were some of our most interesting design tools. These planes provided a path into the design for the viewer's eye.

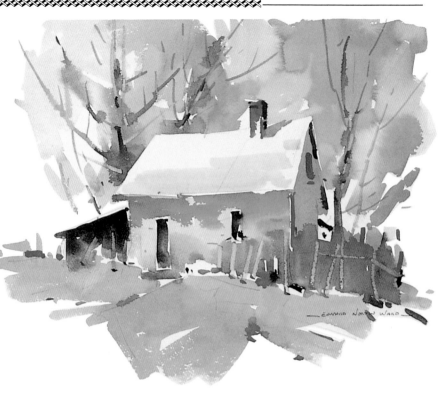

The Yellow House

Besides the obvious planes that make up the building, the sides, and the roof, look at the smaller complementary and contrasting planes: the fence extending past the front of the house, the two planes of the chimney, the windows, the door. Less obvious are the planes of the foreground.

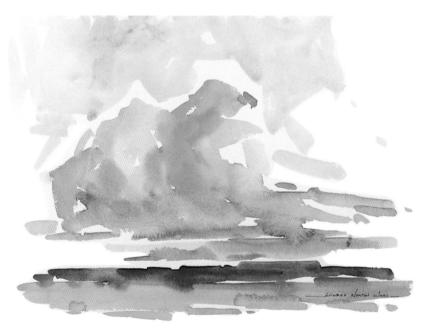

Clouds over the Mesa

By painting the side of the cloud in sunlight as a warm upright plane, I was able to create not only an interesting color contrast but also a way of identifying two major planes in the clouds.

Although the planes here are subtle and hard to see at first because of their shallow angular differences from one another, once the artist recognizes their origin, he will have no trouble locating and identifying them.

In *Winter Fields*, the obvious planes of the road and the adjacent fields pull the viewer's gaze back into the painting only to be stopped and redirected by the overlapping upright planes of the distant trees. Nature sometimes creates unexpected planes for us. When the ice melts and water runs off the land, it seeks the lowest point, creating small, barely noticeable streams that meander over the almost flat ground. This persistent erosion changes the grade. At the same time, while presenting us with a set of intersecting planes, it promotes a fuller growth of weeds along the lower gullies, which almost outline the planes for us.

If you look at *Autumn Morning*, you'll see that there was a low angle of light when I painted this sketch. Each plane in the foreground reflected the morning light from a slightly different angle. The ground plane nearest the right front of the barn was hit almost directly by the sunlight. On the other hand, the planes in the immediate foreground were barely grazed by the light as it passed overhead. I chose to exaggerate this difference in light intensity by using more contrast in values between the different planes. This difference in values gave an even greater definition to the foreground planes.

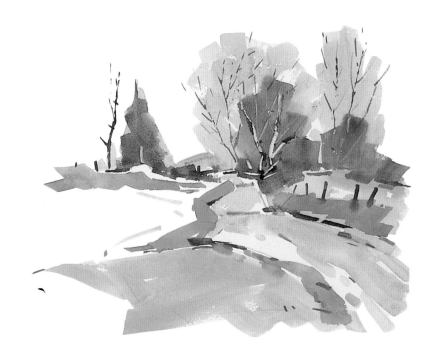

Winter Fields

In this sketch, I was attracted to the way the trees with bare foliage seemed to be a transparent upright plane that overlapped the darker tree planes farther back.

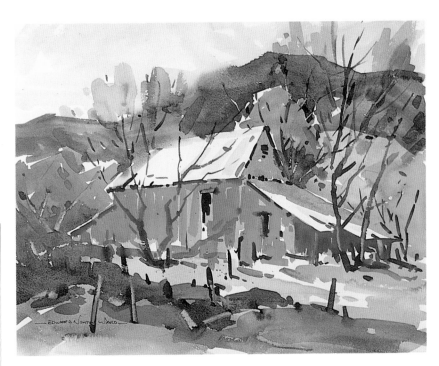

Autumn Morning

The Sierra Nevada foothill country is an area blessed with a generous amount of rainfall that marks the land with slight gullies and watercourses, creating planes that affect the light's intensity.

EXERCISE

Outdoors, look over an otherwise meaningless weed-grown field or hillside. Try to locate where the water has drained off the field. Look for obvious little gullies and patches where weed growth is a little lusher. Draw the water courses you have found on a page of your sketchbook. Most likely they will appear as S-shaped lines.

Now, with light-valued watercolor, paint one side of each line slightly darker than the other. Can you see the planes forming?

WHILE PLANES of different values create dimension in our designs and help lead the viewer's eye, we need passages of light or color between the planes to link them together. In the quick study *Sunlit Shed*, I connected the side of the shed and the ground in front by leaving both planes as white paper. This is a simple example of a "passage" connecting two separate planes. It creates a strong design relationship and unifies the shed with the ground.

When we massed smaller shapes together to form one larger shape of the same value, we were consciously trying to create simpler forms to gain a stronger design. Using passages of white paper is another less obvious method of relating shapes of similar or different values. Light knows no boundaries. Even though a shape or plane may have its own color and value, it may be so brightly illuminated by the sun that it appears almost white. This bright light could easily extend into an adjacent shape or plane, as I have shown in *Sunlit Shed*. The light forms a white shape of its own that seems to flow across the boundaries.

Not all passages of light are so obvious. In *Morning Mist, Noyo Harbor*, white clouds in the sky knit together into a passage of white mist that meanders through the background above the roofs on the dock. Using a white passage such as this in a sketch leads the viewer's eye through the picture space where the painter wants it to go. Even though several values—both dark and middle values—interrupt the white passage, the eye automatically goes on to the next white area in its viewing path. When we find and paint passages that connect our shapes, the design of our painting will be stronger and more charming. Finding these unexpected passages is one of the rewards of sketching outdoors.

Sunlit Shed

A strong design relationship results when a "passage" of
white paper can be left connecting two different planes.

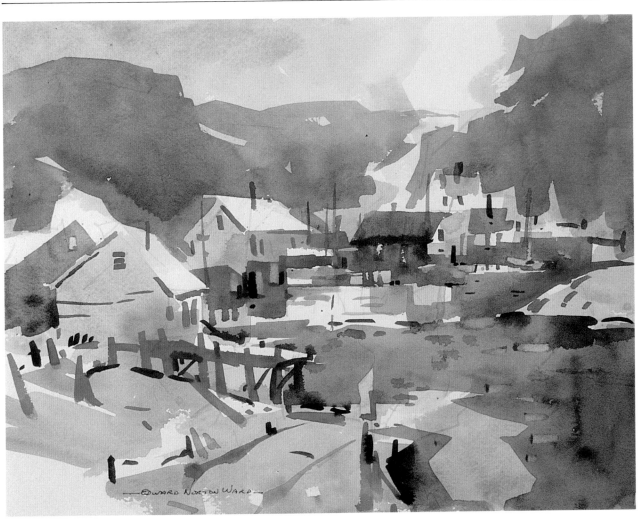

Morning Mist, Noyo Harbor
Passages of white roofs and mist knit the different shapes within the
harbor into a unified mass of different colors and values.

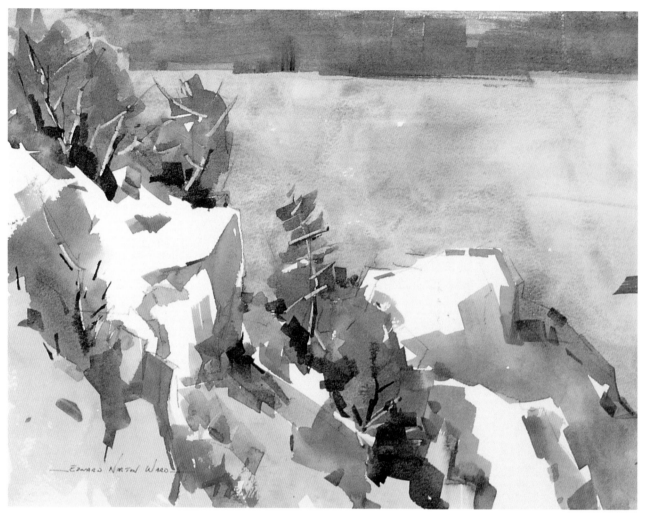

Canyon's Edge, Grand Canyon

I wanted to contrast the strong light on the foreground rocks
with the blue void of the Grand Canyon's depth. I chose the variations
of orange as a contrasting color for the colored passages of shadows.

A passage of color can have an equally unifying effect on a design. In *Canyon's Edge, Grand Canyon*, I painted the shadowed sides of the foreground rocks in several variations of orange of almost the same value. This color passage knits the edge of the canyon together as it connects several foreground cap rocks.

There could be several reasons to use this orange hue. Besides being the color of light reflecting onto the shadowed side of the rocks, orange could be the color of some foliage along the canyon's edge or of the rocks in the sunlight, or of an imperfection or a vein. These unexpected accents of color give the artist a great deal of freedom to paint in arbitrary color passages. Once the color passage is started, it seems natural for it to continue through shape after shape. Like beads strung together, this expected continuity can be reinforced by the painter's own touches of color. In a sense, once started, the painting shows the painter where the color strokes should be placed.

EXERCISE

Take one of your old watercolors. Look for places where passages of white paper or color could be introduced in place of the color and values there. Repaint the watercolor while concentrating on painting those passages you have decided to use. Don't worry about how the painting is turning out. See if the resulting sketch is different from your usual work. While concentrating on getting the passages just right, your unconscious was painting the rest of the painting and your inner creativity was free to come through.

Try this exercise outdoors. Look for passages and draw them in as shapes that flow from one object to another.

By NOW the reader must have discovered that much of good design is simply a matter of controlling where the viewer looks. It is the artist's job to prevent the viewer from looking where he isn't supposed to and wandering out of the picture space. By means of large simple shapes, a succession of intersecting planes, and the linking passages, the artist attracts the viewer's eye and then directs it from place to place within the picture space in a circulating motion. The viewer's eye is never allowed to creep too close to an edge or corner without being directed back into the main areas of the painting. The shapes and colors are what attract the viewer's eye, and the planes and passages guide it from place to place throughout the painting.

In *Sierra Village* planes and passages exist all over the place. The group of buildings is the main focus, but the plane of the road leads the eye into the picture. Passages of light pull the eye through the groups of buildings up onto the background mountain. Other passages on the mountain pull the eye back to the church steeple. If the viewer's eye wanders too close to the edge, the strong repetition of fence posts pulls it back into the picture, again to where it can wander off following another passage or plane.

The three buildings on the left of the road illustrate a second means of directing the eye. All three buildings have the same general shape and form a sequence of repeated shapes, which cause the eye to move from one to the other deeper into the picture space. They have the same effect as the strong pull of fence posts in a row without being so obvious. Each building is a different color, and a strong dark shape separates the blue building from the orange. Yet there is a compelling need to follow the sequence back to the white building.

As you realize by now, besides knowing what to look for in a painting subject, you have to have some idea of how to use the scene's raw material. If you know that you will mass smaller shapes into larger simpler shapes, you can confidently move things around to create those larger shapes. By recognizing how light falling on planes defines form, you can search out the subtle planes of the scene, move them about, tilt them, or whatever the painting needs to give it an even more dramatic sense of light.

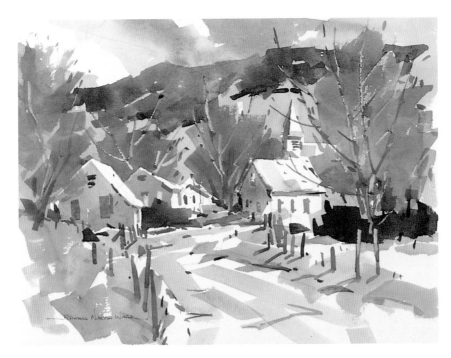

Sierra Village

Note the way the grays of the road shadows continue right on back into the mountains and come back around the upright planes of the trees. Although the sky is an interesting pattern of grays, blues, and white, the dark ridge of the mountains seems to compel the eye to follow it downhill to the trees and houses on the left and back into the center of the painting.

Streamlining Your Design

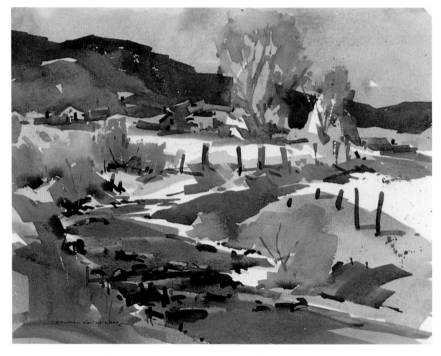

Frozen Stream at Trampas

When a scene presents good design possibilities, simplifying
that design completes your plan of executing the painting.
A good plan leads to the efficient completion of the sketch.
Often, there are other rewards. Whenever I look at this painting,
I can still feel the raw cold of the day I was there.

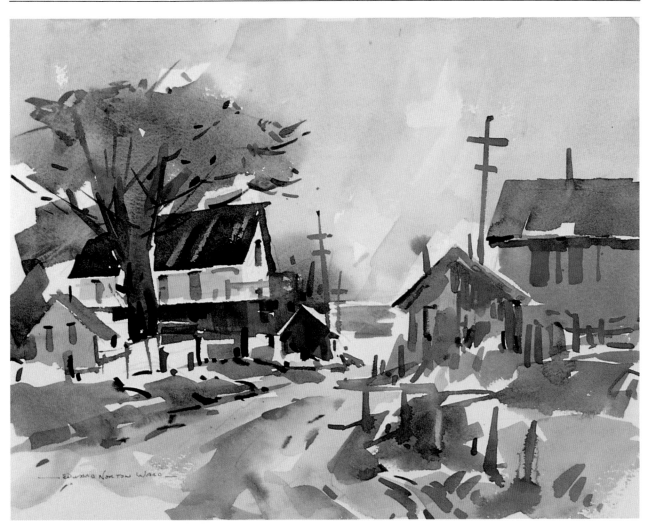

Road to the Sea

In this sketch, I liked the way the road led down to the ocean through the
buildings. Everything used in this picture either strengthened the design
of the road and the negative shape between the buildings or it was discarded.

NATURE SEEMS to offer too much material to the painter. He has to sort out what it is that really interests him. Choosing one dominant concept from a scene can help the artist make a powerful design. Once this main theme has been selected, further consideration has to be given to simplifying shapes, values, and colors. Complicated shapes result in busy paintings, whereas simple shapes lend themselves to powerful paintings. We can reduce our value scale to just three or four distinct separations of middle value. Color, which appears in numerous variations in nature, has to be ruthlessly categorized to those few we can mix from the colors that appear on our palette. When we have finally mastered this art of selection, we will be seeing and working with artistic skill.

THE KEY to simplicity in a painting is to have just one dominant concept. What *is* a dominant concept? The best answer I have found to this question came from the artist Charles Movalli. Basically, his answer was "What part of the scene is the most interesting to you as an artist?" I interpreted this as meaning that one part of the scene attracted the artist more than any other. This part might be a single tree, a feeling of light, a sense of space or size. But whatever it was in the scene that attracted the artist at that instant became a strong candidate for being the dominant concept of the painting.

patch at the expense of the background hillside and trees. Finally, in the fourth sketch, I mentally moved in close and emphasized the fallen log as my dominant theme. I could have used any of these quick color sketches as a painting, but that afternoon I was most interested in the large foreground snow patch, which I chose as my dominant concept; *Tesuque Creek* was the result.

• By selecting and exaggerating a dominant concept from the scene, the artist projects his own personality into the painting. Since each painter sees a scene through his own interests, each creates an original interpretation.

Movalli showed us an exercise for using thumbnail sketches to exaggerate a single element of our scene at the expense of the others. In one thumbnail sketch, exaggerate the sky, using a low horizon. In another thumbnail sketch, exaggerate the foreground by means of a high horizon. Repeat this exercise, selecting other parts of the scene. To show you how this exercise works, look at the series of four sketches here. These color studies were painted quickly one late fall afternoon in the mountains above Santa Fe, New Mexico.

I painted the first sketch of a patch of snow and background trees with the scene pretty much as it was. In the second sketch, I decided to exaggerate the hillside in the background, leaving very little foreground. The third sketch emphasized the foreground snow

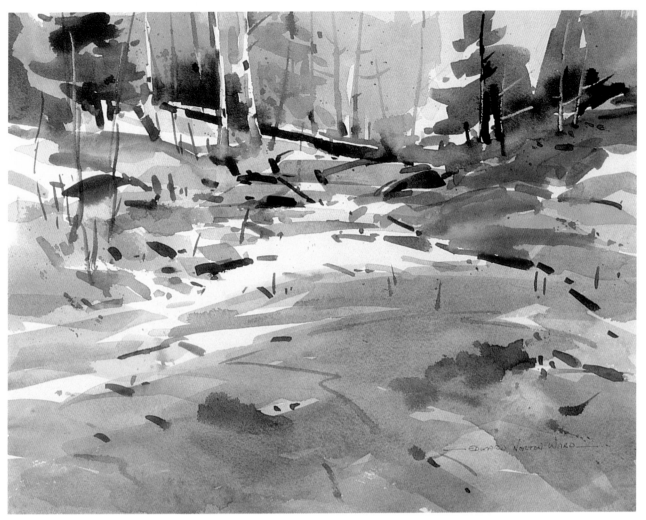

Tesuque Creek

From several possible ideas, I selected as my dominant interest the large
snow patch over the creek bed. I liked the way the warm colors of the trees
and brush contrasted with the cool blue-violet shadows cast over the snow.

I F ONE PART of the scene is to be emphasized, then other parts will be deemphasized or maybe completely discarded. Notice that in the second, third, and fourth sketches on page 64, once the theme was selected, that part of the painting filled most of the picture space. Had I allowed equal emphasis to be placed on any other part of the scene, it would have confused the viewer. He wouldn't have known what he was to look at.

The artist can ensure that emphasis is placed on the right element in a scene by exaggerating the size of that element and having it fill up most of the picture space. In *Sierra Vista Apple Orchard*, I sketched a few trees and a fence in an apple orchard. In *Apple Trees*, I was attracted to one particular apple tree. I painted it large at the expense of all the other trees and the foreground. There is no mistake here about what I am interested in.

Sierra Vista Apple Orchard

Here I was interested in the way the light created cool color in the background against the warm color of the trees and background.

Apple Trees

By painting the main tree large against a background of white paper,
I wanted to eliminate all doubt about what my main interest was—
a sketch of a tree. I used a low horizon to make the tree loom even larger.

Similarly, in *In the Sierra Foothills*, I found a road, a white fence, and some background trees along the edge of the same apple orchard. Although I was satisfied with the result of this effort, I felt I could create an even stronger statement if I featured just the white fence and a few apple trees. In *After the Harvest*, I enlarged the drawing of the fence and played down everything else, leaving the road out altogether. I feel that this resulted in a stronger statement of the scene—it's my favorite. The red shape at the base of the tree was a lucky stroke. It was an empty box, which had been left behind from the harvest. When I painted its shape, it came off a little too red. Looking at it again, I decided that the brighter red color was just the payoff needed there, where the white fence ended. I now had a value contrast and a bright color together just about where I felt they belonged.

EXERCISE

Take one of your watercolors that you feel was successful. Look it over and decide what part of the scene you liked the best. Be ruthless. You can't like everything equally well.

Now draw a few thumbnail sketches emphasizing what you liked best. Exaggerate its size in the sketch. Fill up most of the picture space with it.

To complete the exercise, paint a new watercolor with your newly designed emphasis and exaggerated subject placement.

In the Sierra Foothills
I liked this sketch when I finished it, but then I had second thoughts about it. There seemed to be too much to look at. I resolved my design dilemma by painting another sketch featuring just the fence.

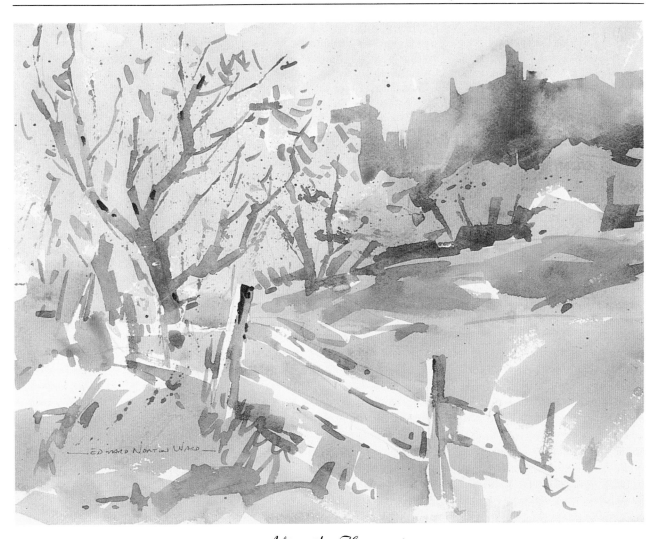

After the Harvest

This is a painting of just a fence. I treated everything else
in the scene, except the tree, as a simple shape or I eliminated it.

S YOU CAN SEE, I am not interested in reproducing a scene as I find it. I feel free to rearrange the scene as I choose, eliminating what I don't want. Nothing should be included in a painting if it does not contribute to the dominant concept. Just because "it was there" is not a sufficient reason for including it. But how do you decide what is needed in a painting?

To help answer this question, I have included the two watercolors here. These sketches are barely started, but they reveal the way I think when deciding what is important and what is not. In the first sketch, notice that as I put in my first washes, I carefully cut around the white roof of the large house, leaving a generous amount of accidental white in the near vicinity of the house. I knew that the house would be my main theme, and I had enlarged it considerably in relation to the other houses on the street. By leaving a strong edge of white against a middle value on the roof, the house would immediately gain the viewer's attention. Since everything else in the scene was unimportant, I gave only the slightest suggestion of the forms of the other houses, even playing them down by covering their shapes with the middle value.

In the second sketch, I chose the concept of the street with houses on both sides as my subject. In this case, I wanted to get the viewer's eye down the street deep into the picture. I chose two houses of different sizes to emphasize as one compound shape of white. I wanted to suggest the closeness of the houses along the street's edge. Again, my first wash defined the main white shapes and the white passage leading up into the foreground. In both cases, once I had made the decision about what to exaggerate, the rest of the scene lost most of its importance for me. My approach was simply to throw everything away and then carefully select those elements from the discard pile that I thought would best contribute to the final design. I placed the main subject where I wanted it in the picture space, and I sketched it to the size I wanted.

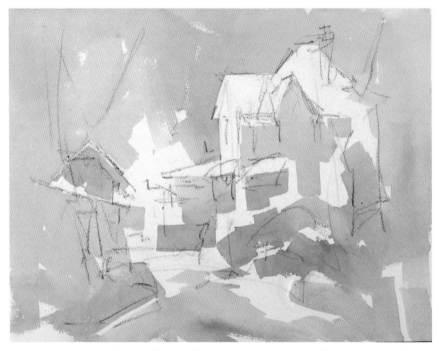

Looking at this sketch, you can see the way I think when deciding what is important to me and what is not.

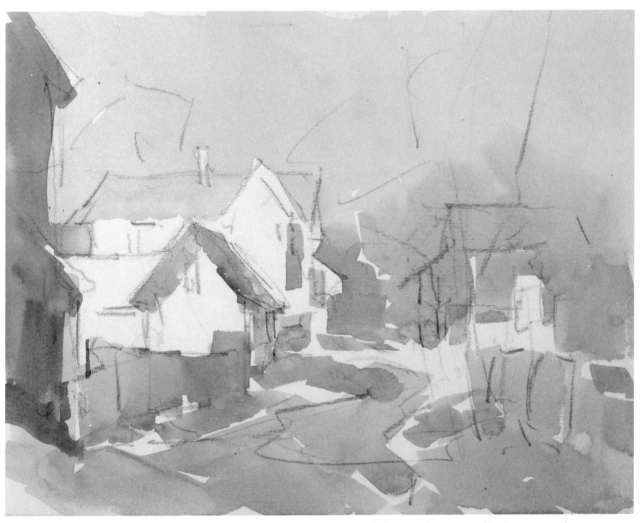

Once I had made the decision about what to exaggerate, the rest of the scene lost most of its importance for me.

EXERCISE

Take one of your watercolors and find the thing that interests you most. Draw this onto fresh watercolor paper. Exaggerate its size to fill the space.

Now review your original watercolor and decide what else is needed to emphasize the shape you have just drawn on your new sketch. Don't look for interesting things. *Search for a value or color that, when included, will* enhance your first design. If an object doesn't contribute to the overall design, ignore it.

Draw in these few secondary objects and paint a new watercolor using the limited shapes and color. Start this watercolor with a large lay-in wash to isolate the larger white shapes. Later, this wash will fill in the unexplained areas of your finished sketch.

ALTHOUGH THINGS in nature appear as complicated shapes with random edges, the painter can learn to look for ways to reduce these shapes to more graceful, simple geometric shapes. The mass of a tree need not be drawn with hundreds of lines. Squint your eyes as you look at it; you will see that most of these unorganized lines merge into a few major lines defining no more than a five- or six-sided irregular shape. The cottonwood trees in *Early Snowfall near Trampas* had hundreds of branches and leaves. When I put down the watercolor wash, I simplified their irregular edges to a minimum of lines. In the thumbnail sketch I have drawn these trees as a few overlapping five-sided shapes and then suggested the trunks with two or three lines at most.

Morning at Noyo Harbor shows how this principle also applies to man-made objects. Here, the subject is boats. Notice that the bow of the nearest boat is drawn with only seven lines. There is a line for the top edge of the hull and the waterline on each side. There is the vertical line of the bow and two small angled lines that suggest the rear. The other boats were drawn in the same way. Since the docks and buildings were of less importance to me than the boats in this painting, their shapes are barely suggested—just simple rectangles. The sketch of boat hulls shows how with just a few strokes of the large flat brush, one can quickly and simply suggest fishing boats.

When you paint outdoors, it is your ability to quickly select from a complication of shapes just those few lines that define the essence of the subject and lead to a strong, simplified painting. An artist has to squint, see his shape, paint it in quickly with a few strokes, and then ruthlessly leave it alone. Two few brushstrokes are better than too many. Nothing will give a painting that overworked look faster than going back and trying to make a shape look better with more and more timid brushwork.

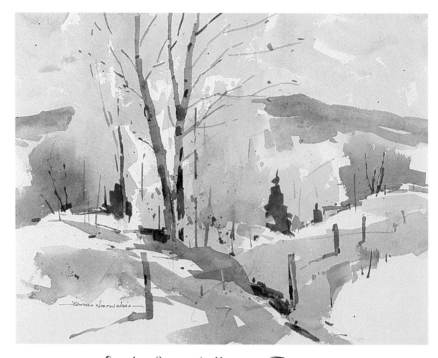

Early Snowfall near Trampas

Most complicated or busy shapes can be reduced to simpler forms. When the edges of shapes are too busy, they are distracting and the resulting sketch begins to look overpainted.

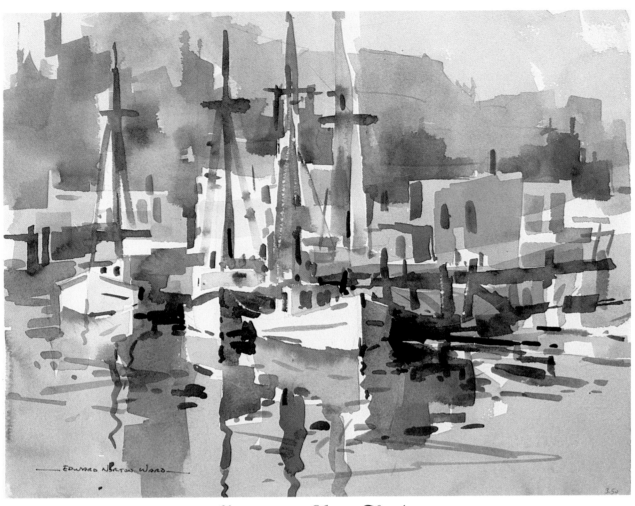

Morning at Noyo Harbor

The shapes and values of the hulls were important to me rather than the individual planks. Too few brushstrokes are better than too many.

Boat Hulls

I N MY OWN WORK, I have found that I seldom use more than five value steps in a painting, including the white paper. If you look back at the sketches on pages 70 and 71, you will see that I lay in my middle values first, leaving white paper where my main theme will be. This is the first step in keeping dominant shape values simple. I use darker values for selected shapes in subsequent washes placed over first washes and sometimes in the white paper passages. The sketch can be finished by adding a few final touches of darker middle value to introduce texture or emphasize edges.

Look at the values of dark and light in *Country Lane*. There is the white paper at one end of the value scale and the dark accents indicating shadows beside the sapling trees. In between, I've used a light middle value for the sky, a middle value over most land forms and the shadow sides of the buildings, and finally a darker middle value for background hills and land forms not in the light.

Autumn in the Foothills is an example of this procedure carried to completion. The fall colors of the trees and ground make up most of the middle values; secondary washes add darker values and complete the forms. Late in the development of this sketch, I put down the dark accents to indicate fence posts and windows on houses in the distance. At the same time, I introduced a few darker strokes to suggest leaves both on the ground and on the trees. Don't overdo this, however, or your painting will look weak and spotty.

What has been said about simplifying values can also be applied to our use of color in a painting. You can gain the greatest emphasis and simplicity by using only one color when first painting a major shape. Decide what color the shape or passage should be and then exaggerate its intensity. Resist the temptation to go back into those first color passages with modifying strokes of different colors. Modifications should be saved for the finish when all the major shapes and whites have been painted as simple values and colors.

Country Lane
There are only five value separations in this sketch, but it reads as if there were many more. If the painter represents the full value range from white to darkest dark, then the middle can be painted in relation to these extremes rather than to each other.

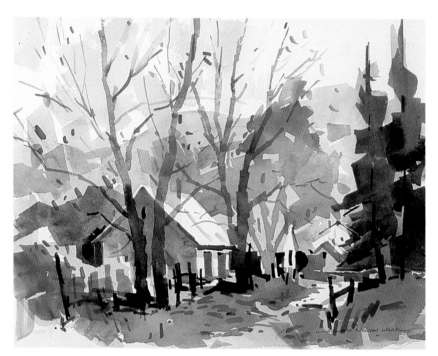

Autumn in the Foothills
The rich fall color was the result of second washes of yellow, orange, and red over the initial lighter-valued washes. When these were dry, only a few dark or colored accents were needed.

Trees, shadowed sides of buildings, and foreground on the right-hand side of the road in *Back Street at Chimayo* were first painted as simple one-color shapes. As the painting developed, I saw where I could introduce complementary cerulean blue accents into the building and small trees. I added complementary olive green strokes over the red-orange foreground. Rich rusty red accents were used to suggest leaves on background trees and texture on the shadowed side of the main building. These few accent strokes of color allowed me to leave most of the other color passages untouched. This created an even greater contrast in my painting—busy small strokes in the areas of main interest vis-à-vis the simple broad shapes of color in the subordinate parts of the painting.

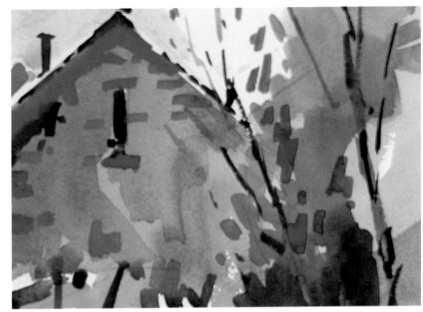

In this close-up you can see where smaller strokes of blue and olive green create the complementary color accents over the dominant orange and red of the scene.

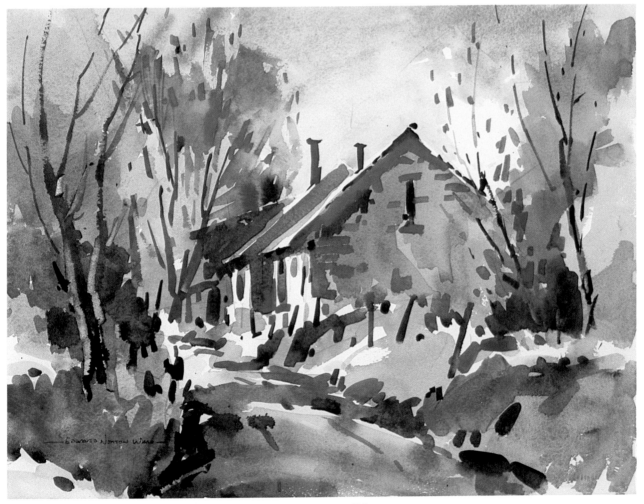

Back Street at Chimayo

By keeping the color of the shapes simple at first, I was able to introduce small accents of darker color or contrasting color to add both texture and light.

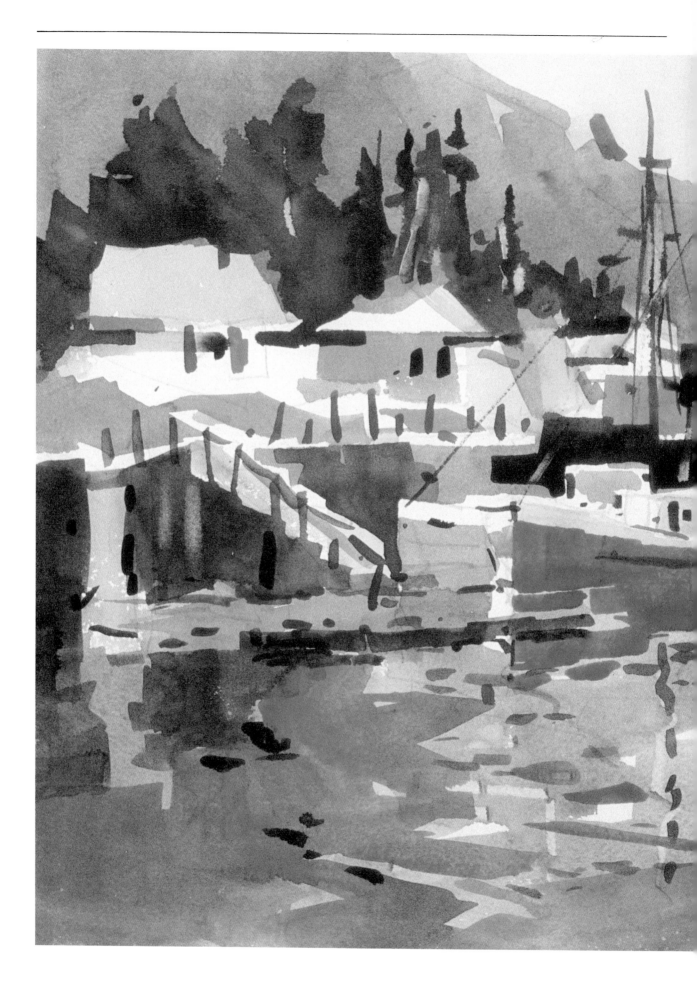

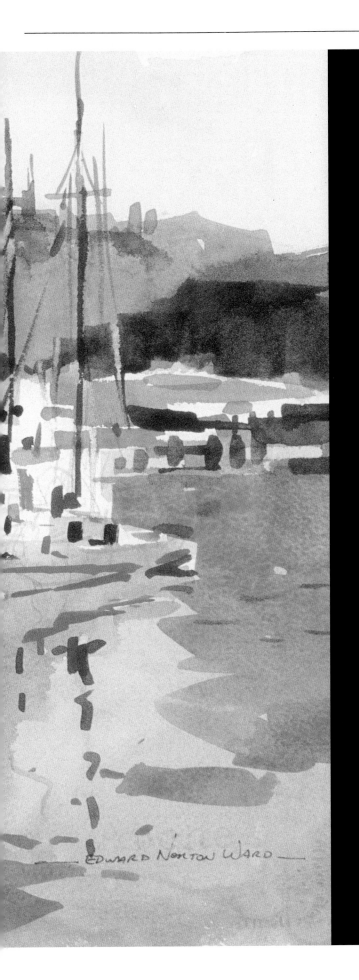

EDWARD NORTON WARD

PART 2

KEEPING YOUR SUBJECTS FRESH

The Garden: A Private Place

Garden Drifts

Flowers clump together and grow in their own form of
abstract design and color masses. They are the ideal subject
for exploring your theories of color and design.

Courtyard Blue and Violet

There is no better place for exploring the possibilities
of the colors on your palette than in the quiet and privacy of a garden.
Flowers, foliage, and the contrasting old walls, fences, and buildings
give you all you need for a good painting.

PAINTING FLOWERS is about as close to abstract painting as you can get and still produce a realistic painting. Flowers are a perfect subject to use for exploring theories of color and design. It is pure design to arrange colors, values, and shapes and still retain the idea of flowers. The bright colors, strong whites, and rich darks of flowers give the artist all the ingredients for a good painting.

My garden is my own intimate, private world, where I can be by myself for a while. I lose myself there in the painting process and feel completely free from the demands of time, people, and the other distractions of the outside world. It is no wonder so many painters have chosen their gardens as their source of material.

You can find flowers everywhere outdoors. Many painters have their own private gardens. Even shopping malls try to make their surroundings pleasant by featuring planters full of blooming flowers year-round. Every public building, church, and city park has a garden, some quite breathtaking. In Carmel, California, we have a small shopping complex, The Barnyard, where every bit of space not used for buildings or walkways is continually planted with a riot of colored flowers. It is always easy to find something to paint there, no matter what time of year.

Y OU DON'T have to know much about botany to appreciate the color and values present in a garden full of flowers. I know common flowers by sight, but I prefer to see them as objects to paint, edges of vibrant color, intricate white shapes against light or dark backgrounds. I like to see how I can make the viewer's eye skip along several white shapes as he explores the painting.

This is what I mean. We have a church in Carmel whose garden blooms throughout the year. I always stop to consider if there is a new way for me to paint this garden, and I am never disappointed. In *The Parson's Garden*, I caught the shadow of the bare tree cast across the path and tried to get a sketch of the tree against the background light, with just a mere suggestion of garden flowers. I don't even know what kind of flowers they were. They were just red mounds that I placed against the white shapes and accidentals I left for the background light.

I designed this sketch with one strong line crossing the paper and defining the top edges of the flowers. It starts with the white shape on the left, moves across to the top of the red shape behind the tree, and continues over a second less obvious red shape at the right. At first, all the paper above the edge was left white and I

concentrated on placing simple washes of red and warm green in the foreground and beneath the tree. I also left white paper where I planned to have the path.

Once I had my picture space divided into two main shapes, I decided that the tree had to have a feathery feeling where the light was catching the many small bare branches. This was painted in with a quick scumble of light warm gray. Immediately, I could see that the overall shape of the tree had to be defined and painted a blue negative shape in the upper-left corner. I carried a gray wash over the upper-right corner to focus the light in the upper center of the sketch.

When the first washes had dried, I painted the remainder of the sketch. I painted the main tree trunks with the sharp edge of my one-inch flat brush. By just touching the chisel edge next to the main trunks, I was able to suggest a few of the smaller branches. At the base of the main tree, I used a mixture of cerulean blue and cobalt blue to create a strong shadow. Shadows of the tree trunks seem to twist across the white of the path.

I added final touches of darks next to some of the white shapes, darker red to the red shapes, and blue greens over the earlier warm green washes—and I had what I wanted to say. This completed my sketch of light playing across the Church of the Wayfarer's garden.

The Parson's Garden
The colored shapes of red against white and warm green,
together with the bare tree standing out against the light
in the background, was the main idea of this painting.

Path Through the Garden came easily to me. The path and flowers were one of those rare finds—a perfect composition in nature. I liked the way the flowers formed an edge of white and yellow across the design, which stood out against the cool dark background. Farther down, yellow mounds of flowers against whites formed another interesting line that could be used to divide the major flower shape into smaller secondary shapes.

When such a profusion of flowers is available, I like to paint them in their natural setting. Growing together, they are a natural order of shapes, values, and colors. They crowd one another, trying to reach for the sky above their neighbors, creating a colorful tangle of competition. A garden in full bloom is nature's finest selection of color and massing of irregular shapes. There is no artificial staging of individual blossoms that we see in careful arrangements. Scattered naturally throughout the garden, these flowers can be painted just as they are.

Outdoors you can find small intimate flower studies in planters and window boxes. An unexpected splash of blue and white lobelia growing in the window box of an old rock building became my painting in *The Old and the New*. Most of the side of the building was cast in shadow, but where the flowers and window box extended from the wall, they caught the sunlight. A painter willing to look again at many ordinary subjects will be pleasantly surprised to discover flowers unexpectedly.

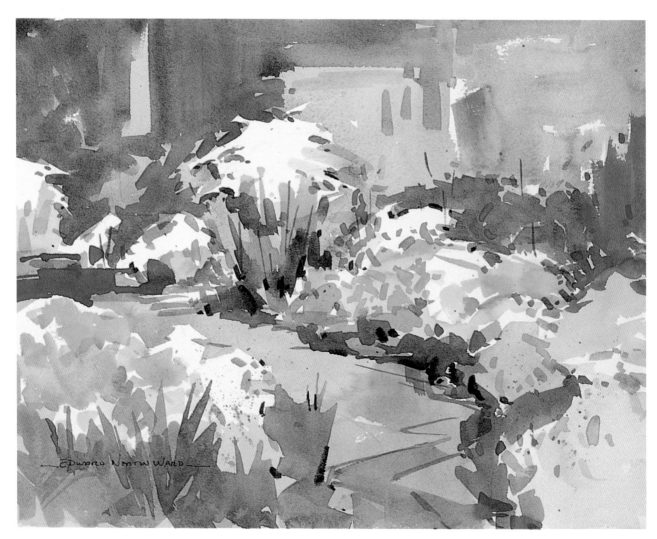

Path Through the Garden

The color-against-white relationship in this sketch appeared quite by accident as the sketch progressed, but I was quick to recognize its possibilities and did not change it. Good painting is often no more than recognizing these "lucky strokes" when they happen and having the courage to leave them alone.

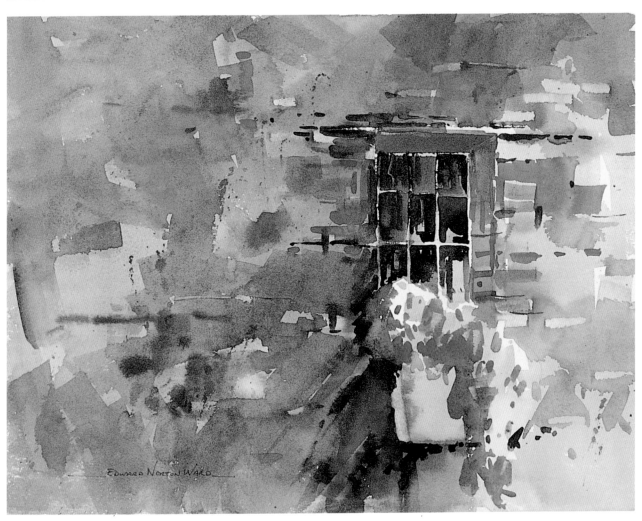

The Old and the New

The contrast of the old wall and the fresh blue and white hanging
lobelia gave me both a color contrast and a textural contrast.
The old wall was divided into two large shapes of light and dark.
I placed the flowers where these two shapes came together.

N O MATTER what the light of the day—sunny, overcast, rainy—flower gardens are beautiful. The varying outdoor light allows me to return to the same scene again and again to discover there yet another, different painting. Knowing how colors respond to light and how different atmospheric conditions create different effects, I can expect to find strong bright highlights on blossoms one day and return on a gray day to find flowers displaying a full-intensity of color against a cool background light.

The poppies in *Iceland Poppies* were mostly in shade when I first saw them. When the sun moved out from behind a cloud, suddenly several blossoms stood out in sunlight. In the background, there were still flowers in the shade, but I was interested in the contrast between those in the light and those in the shade.

My preference was for the sunlit blossoms. I decided to show only a few shaded flowers in the distance along the diagonal edge at the tops of the flowers. I chose the green foliage as my dark shapes and used it to frame the main group of poppies. Notice that I painted the poppies primarily against a white background, which sets them off dramatically. To further emphasize the feeling of light, I painted a few leaves and buds in a warm yellow green as a contrast to the cool blue and gray green of the darker foliage.

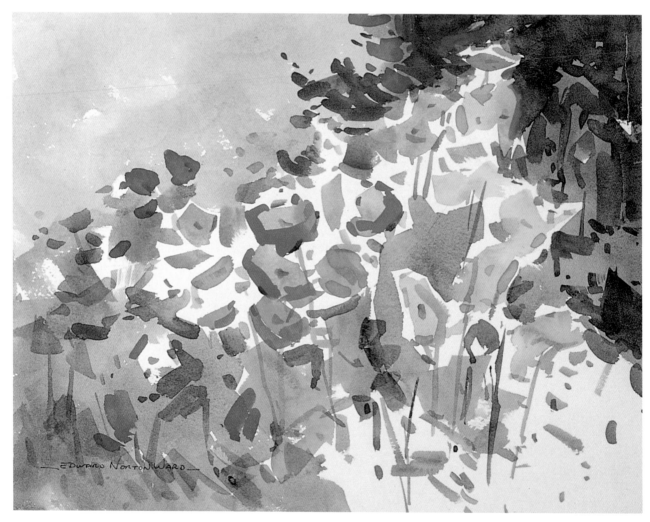

Iceland Poppies

I painted the individual blossoms in two or three strokes, emphasizing the red poppies over the yellow. When these first small washes were dry, I added darker red strokes to the poppies I favored in the sketch, further defining their character for the viewer.

WHEN I PAINT a flower garden, the colors first attract my eye. Once I've featured a dominant color, I can use several variations to perk up the earlier flat washes. *Ivy Geraniums* was a quick sketch of a plant my wife had growing in a pot on our deck. It was in full bloom, almost a solid mass of cool pinks and reds, with hardly any of the yellow green leaves showing. I decided to feature one large shape of cool pinkish red as an underpainting. Before the initial wash of light permanent rose could dry, I put in some strokes of the richer scarlet lake to add both interest and dimension. I made no attempt to paint the individual blossoms botanically correct because I wanted to show them massed together. The touches of scarlet lake introduced a second variation of red and gave texture to the large wash of pink.

In this sketch, I left several accidental spots of white paper when I put down the initial wash. These "accidents" create sparkle and highlights, adding yet another dimension and texture to the initial wash. Actually, these whites only appear to be accidents. You would probably be surprised to learn how hard the artist tries to protect these little patches of white.

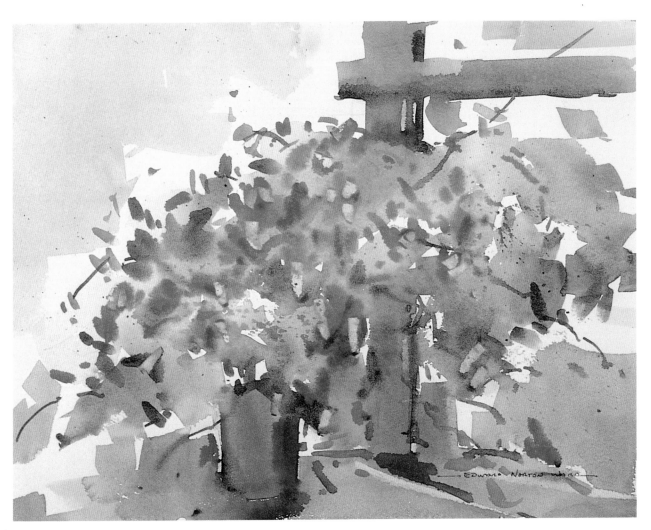

Ivy Geraniums

If I had come on this plant and found that there was an equal amount of red blooms and green foliage, I would have forced the color red to dominate by eliminating the green foliage from my sketch. You will get a better color scheme when you paint flower masses if you force the flower color at the expense of the green foliage.

When I painted the flowers in *Red and White*, although there were several varieties in the garden, the mounds of red and white stood out from the others. I chose to feature them in my painting at the expense of the other flowers. I recall that yellow snapdragons were present in profusion. Instead of painting several patches of different colors of the same size, I painted one large shape of white and then introduced strokes of bright red into this shape. Over the remaining picture space I painted secondary colors of muted greens, blues, and oranges. The small color accents I dropped in were a few strokes of pale yellow (for the snapdragons), where I thought yellow would bring in a bit of a color contrast. Ultimately, painting flowers is the same as painting any other subject. You pick one color as dominant and then use others as subordinates.

In *Red and White* I have used another painting contrast to give more interest to the color scheme. Notice that although the red and white shape is the dominant shape in the painting, it does not cover much of the picture space. This is because all the other colors in the painting have been grayed or muted so that they do not compete with the red and white. I have contrasted bright color with muted color, which is a more subtle contrast than dark against light. It is quite effective here.

Nature has a way of helping you select a dominant color. Flowers have a natural tendency to group together by species and color. The process of natural selection allows the stronger, blooming flowers to crowd out the weaker varieties. When I painted the sketch *Picket Fence Flowers*, I had found clumps of delphiniums growing in a natural wild state. The picket fence was a subject in itself, but when you find one adorned with summer flowers, you really have something to say.

I was taken by the scene of an old house and a neglected fence in a world where someone still cared to plant some flowers. The strong bright blue color of the flowers dominated the painting.

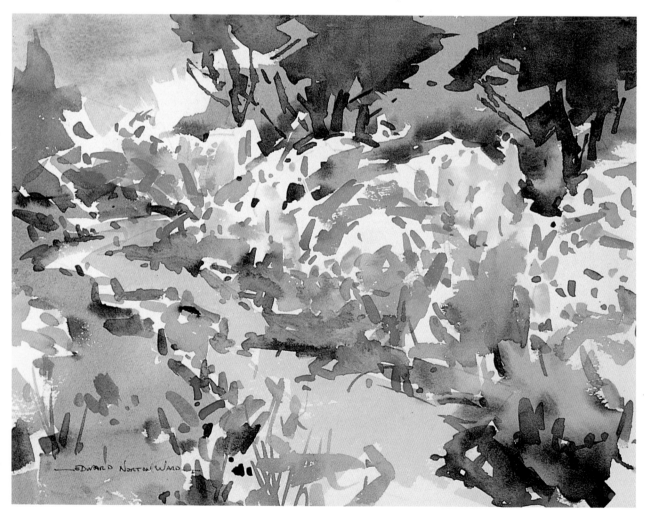

Red and White

The garden along this path was dominated by mounds of white daisies
and red poppies. There was also a strong presence of yellow snapdragons.
To keep the color balance, I decided to save the snapdragons for another painting
and use just a few accents of pale yellow.

Against the interesting white shape of the fence the color is especially stark. These flowers were in a plot of delphiniums next to a ranch house I visited last year in Montana. I wanted to see if I could paint a bit of civilization amidst wild country, big mountains, and spirited horses—and so this garden.

Since this is not a true flower painting, I'll digress a bit and talk about the painting process. For the picket fence, I drew a ragged line right across the painting to indicate the top of the pickets. I drew in a side of the house to provide a diagonal line countering the upward diagonal thrust of the fence. Everything else was sketched with watercolor.

I painted a large wash down the paper to the top of the pickets, leaving the roof of the house in white paper also. I continued this wash down between the individual pickets about one third of the way. As I placed the final strokes of this initial wash, I kept my attention on the way the individual picket tops related to one another. I wanted them of unequal height.

While the wash covering the top half of the sketch was still wet, I scumbled in a few strokes of darker paint to suggest the trees and then started placing a mixture of manganese blue and cerulean blue where I wanted the stalks of delphiniums to appear. While the blue was still damp, I touched in a

few strokes of darker blue— ultramarine and cerulean—and a hint of permanent rose to suggest the flowers' violet hue.

When the initial washes were dry, I painted the house a dark, warm rusty red to set off the white pickets. By scraping out lines with my squeegee knife, I suggested clapboards. As the painting developed, I kept placing darks here and there between pickets with the edge of the one-inch flat brush. In the same way I suggested the trunks of trees.

Finally, I quickly put in a wash in the near foreground with strokes of warm and cool green and a few touches of orange and pink to suggest low-growing flowers.

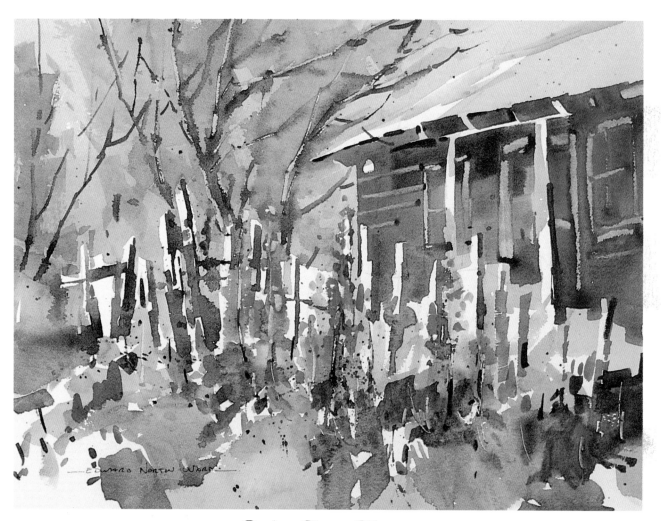

Picket Fence Flowers

Since this is primarily a painting of a white picket fence, I increased the color interest by adding the blue stalks of delphiniums. The shape of the flower stalks is quite similar to that of the individual pickets, and I felt they complemented each other in the design.

ONE OF THE MOST striking contrasts in the garden is white flowers against a dark background. When you feature white as a dominant color in your painting, you have to be aware that white has much the same visual properties as real colors. Nearby colors can reflect into the white in shadow. Knowing this gives the painter opportunities to find different shades of white within the overall white shape.

Shasta Daisies and Coreopsis is a sketch of some flowers that grew in my wife's garden last year. I wanted to suggest the ragged edges of the daisies by cutting brushwork of dark background color into their white shape. A few yellow spots at the centers of the blossoms and the shape looked like a cluster of daisies. I let a little of the yellow creep into the lower edge of the white daisies to show that the light was reflecting off the coreopsis.

When I painted *Apple Blossoms in the Sierra Foothills*, I had been scouting the Sierra Nevada foothills for other reasons and was pleasantly surprised to find the orchard in full bloom. It had been raining on and off all day, and I wanted to try to capture the feeling of that time of day when the sun goes below heavy rain clouds and casts a strong low-angled light across the landscape.

Usually, I visit the apple farm just after the harvest, when there is fresh apple cider, pies, and the tang of fall in the air. The color is warm then and rich against dark violet blue hills. The atmospheric feeling I was seeing at this time was lost in the first sketch, which came off too strong. Reaching for another sketch board, I decided to let up on the strong contrast of light and dark and work the gentle color contrasts in the white blossoms instead. The dark ultramarine blue in the background hills would be replaced by cobalt blue. Where I had left the flowering trees almost all white before, I decided to wash a gentle blue violet over most of them. Light, cool shadows replaced the darker one. I reserved the rich color for the warm russet reds I painted as symbols of the bare wet earth.

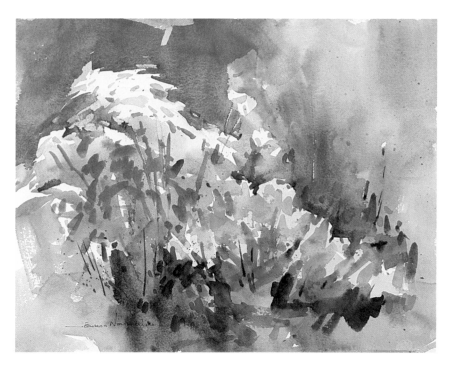

Shasta Daisies and Coreopsis

Here, the strong diagonal line of the shasta daisies continues over the top edge of the yellow coreopsis. I wanted the edge of the shasta daisies to identify the flowers. I used a few accidental white spots in the dark background wash to suggest distant daisies and to complete the design.

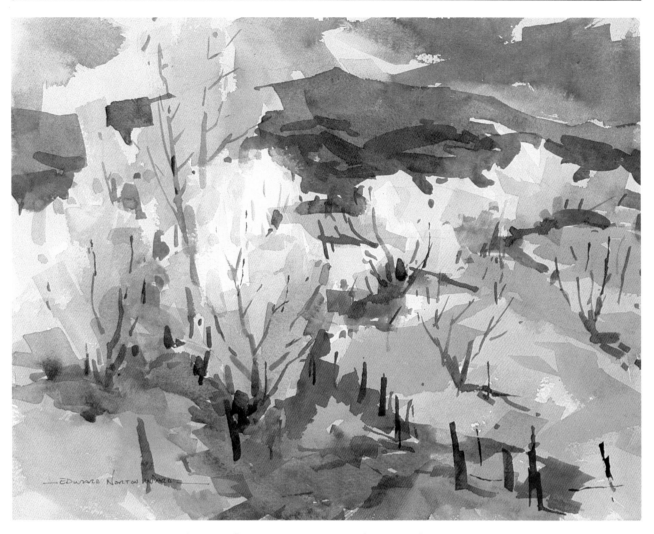

Apple Blossoms in the Sierra Foothills

While the main color of the flowering trees is white, I could see several
pastel shades of the surrounding colors reflected up into the cool shadow
sides of the trees. Only enough white was left at the tops of the trees
to show that the sun was shining behind the dark rain clouds.

U P TO THIS POINT, we've considered flowers as the main concept of the painting. When I am painting outside in the spring or early summer, I find I can include flowers in landscape or paintings of buildings without taking too much interest away from another major theme of the painting. Spring and summer greens, which are often overpowering, can be tempered by exaggerating the size and color of flower beds that may be near the scene.

I painted *Working in the Garden* one April afternoon. When I saw the figure working in the yard, I wanted to include him in my sketch. I was interested in the way the strong line of the walk pulled the eye toward him near the house. Since the red of the blooming crab apple trees made too strong a contrast with the bright green grass in the foreground, I enlarged the flower beds on the hill near the walk and moved them closer to the foreground. This left just a little foreground for painting in some muted green. I was able to keep the walk, the foreground, and the house as major shapes. If I had painted the whole foreground in variations of green, it would have contrasted so much with the red trees that they would have separated visually from the foreground.

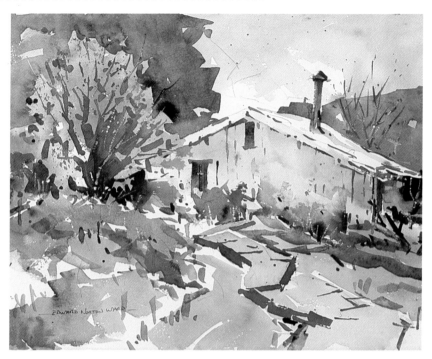

Working in the Garden

A figure working in a garden adds human interest to a painting. In this sketch, I let the wooden walk lead up to him. Since the flowering trees were dull pink and red, I carried the color over into the figure's red shirt and painted some red accents in the foreground.

EXERCISE

Strong lines are defined by the tops of flower masses. Locate some flowers for this exercise. If you don't have a garden, look around your local park, shopping mall, or church grounds. Make a few thumbnail sketches to plan a watercolor sketch.

Use the strong line of the tops of the flowers to divide your sketch into two main shapes of unequal size. Have the line continue clear across the paper from side to side. Because you can see an edge, one of these shapes will be lighter than the other. Exaggerate the dark of one shape and leave the other as white paper. This will be the main value structure of your sketch.

Try a watercolor sketch with this main line dividing the paper. Try to get the character of the blossom's edges into the line. If the edge is jagged or smooth, draw it that way. Part of the line may be jagged and the other smooth if there are two different flowers growing in the same bed. Break up the line to show this characteristic of the flower bed.

As you start to paint, break up the

flower mass shape into a few smaller shapes showing how the flowers are grouped together. The background shape can also be divided into a few minor shapes. While painting, be careful not to lose the overall value of the main shapes. You can vary the light and dark within the large shapes.

Where color is placed in the light shape, keep its value key high. A few accidental color spots for color enrichment may be added, but don't lose the overall light of the main shape. Where color is used in the dark shape, use a rich full-strength color.

Concentrate on painting the color of the flowers. Exaggerate their number. Hold back on painting the green leaves. You'll want only a hint of leaves. Where leaves are painted as accenting darks, use varying shades of green.

Finish your watercolor with accents of contrasting color, darks, lines for stems, etc. Paint some of these final accents in the damp parts of your sketch as well as on the dry surface. Let the water help add character to your painting.

Besides the beauty of the gardens of the Carmel churches, I find their distinctive roof lines equally interesting. I returned again to the Church of the Wayfarer to paint *Garden of the Wayfarer*. The contrasting white roofs and dark trees and eaves provided me with my dominant theme. The flower gardens contributed the feeling of early summer. White passages working their way through the garden lead the viewer's eye right up to the door of the church. There, the eye can circulate back across the roof and down into the garden from the building on the left. In this case, the flowers and white passages created a path that was easy to follow, without being too obviously staged.

The garden is a good place to try out many of the ideas I have presented so far. It is safe, convenient, and full of colorful subject matter. Practice in the garden will pay off immeasurably when you venture farther afield. Give some of your new ideas a try here first.

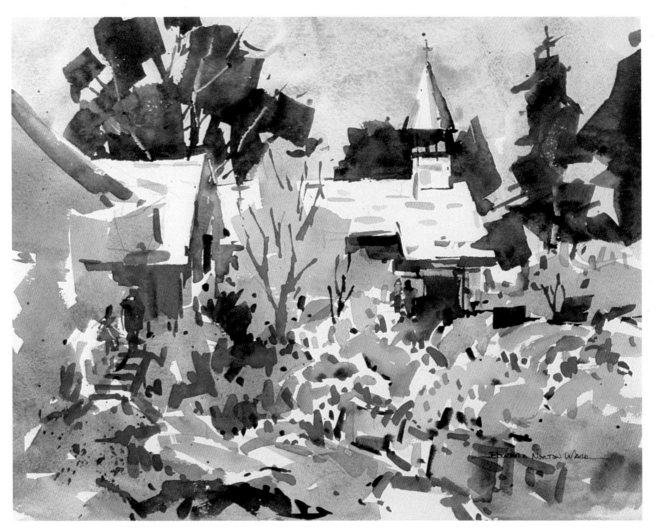

Garden of the Wayfarer

Passages of white paper knit the garden and the white roofs together in this sketch. I left several accidental whites around the color of the flowers. These irregular-shaped white passages contrasted with the strong geometric shape of the church roof and the bell tower.

The Landscape: Capturing a Broader View

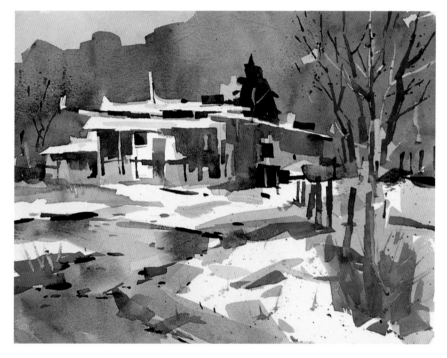

Adobe and Snow

When you are painting outdoors, your eyes will show what
the subject is, but your brain will complete your first reaction to it.
Your overall feeling for the subject—based on what you also feel,
smell, and sense—should guide you to what should be said in paint.

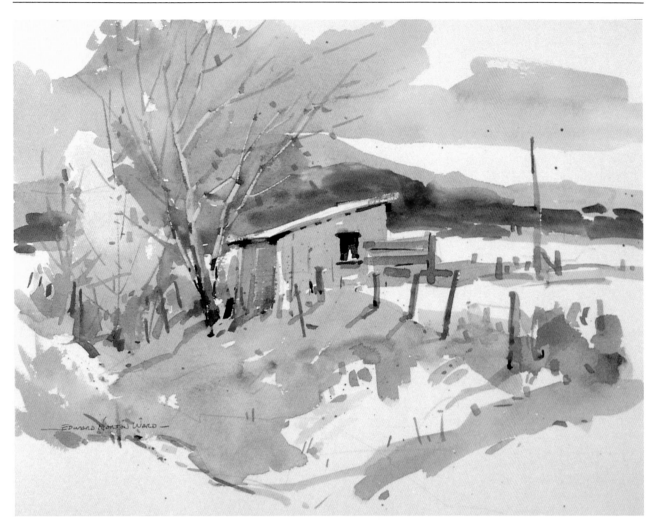

Taos Valley in Winter

Each landscape subject has its own particular atmosphere. It can be one of cold, a place of wonder, or a scene of nature in a dry season. Whatever feeling you are aware of, show it in your sketch.

I N A WAY, it could be said that all outdoor paintings are landscapes, but in this chapter I want you to consider landscapes differently. In the last chapter, flowers were the subject. The flower beds in the garden are as much a landscape subject as any other outdoor subject. The garden, however, is a rather intimate and private place, seldom more than half a city lot in size. When I paint garden subjects, I feel this intimacy as much as I see the flowers and colors. This feeling for your subject is what I want to consider now.

In his fine book on painting, Emile Gruppé said: "The problem is knowing what you want to say in a picture. . . ." I have thought about that many times. I think you have to spend a lot of time outdoors looking and painting before you can understand the full significance of Gruppé's statement.

When you are outside, your mind is always working, looking for things to paint and being aware of where you are. Most landscape subjects will evoke a certain feeling in you about the place, just as the

garden does. My garden and its privacy give me a feeling of both beauty and security. I would like the person looking at my paintings to feel the same feeling I did when I painted it.

My eyes tell me what the subject is, but my brain lets me know other things as well—the type of day it is (sunny or overcast, hot or cold); the fragrances I smell; the sound of insects circling in the heated air; the hush of nothing moving about at all. Everything I sense combines to give me a certain feeling about what I am seeing.

WHEN YOU KNOW how you feel about your subject, you will know what you want to say about it in paint. Let me digress for the moment. In the summer of 1987, I was invited to ride with the Charlie Russell Riders as a guest artist. The ride is an annual affair sponsored by the C. M. Russell Museum in Great Falls, Montana. The riders, who come from every corner of the country, are generous sponsors of the museum.

As we rode along the Sun River, approaching the Bob Marshall Wilderness country, all I could think of was how vast Montana country was. No wonder they call Montana the Big Sky Country. Somehow I had to find a way to express this feeling in a sketch. I wanted to say, "This is a run of the Sun River. Look how big the country is and how far you can see." With a few thumbnail sketches, I explored a design of the river stretching away to the distant mountains. First, I asked myself if I should place the horizon low and let a large cloud-filled sky dominate the painting? Is that the Big Sky Country feeling? Or do I raise the horizon and show the feeling of "bigness" by letting colors and values grow dimmer by successive stages as the land recedes into the distance? I knew what I wanted to say; my thumbnail sketches began to show me how to say it.

The two thumbnail sketches here came close to the design I wanted. I decided to use the low horizon approach for a watercolor sketch because it carried the concept of bigness better than the higher horizon where too much land competed for the attention. I painted the watercolor sketch *Big Sky over the Sun River*, which emphasized the sky and the big billowing clouds overhead.

Since the sky was to receive major emphasis in my sketch, I started with a clean wash of manganese blue, adding just a hint of cobalt blue. I was careful to leave a generous amount of white paper for the large clouds building up over the mountains. I warmed up the sky mixture with a little permanent rose.

I carried the wash all the way down over the distant mountains. A second application of the clean manganese blue wash indicated the surface of the river. Adding a little new gamboge to the blue mixture already on the palette, I stroked in a suggestion of light foliage across the river and a stand of willows in the lower right-hand corner. With a wash of light pink and orange to suggest the river's sandy bank, I was ready to let the first application of paint dry.

Finishing was just a matter of introducing an interesting line to show three distinct mountains receding into the distance. I was careful to leave some of the underpainting showing through, to suggest texture and exposed places on the mountainsides and along the distant bank of the river. Finally, I added to the foreground strokes of rust, a darker blue, and lines suggesting branches. The overall effect was one of open country and light, spacious skies.

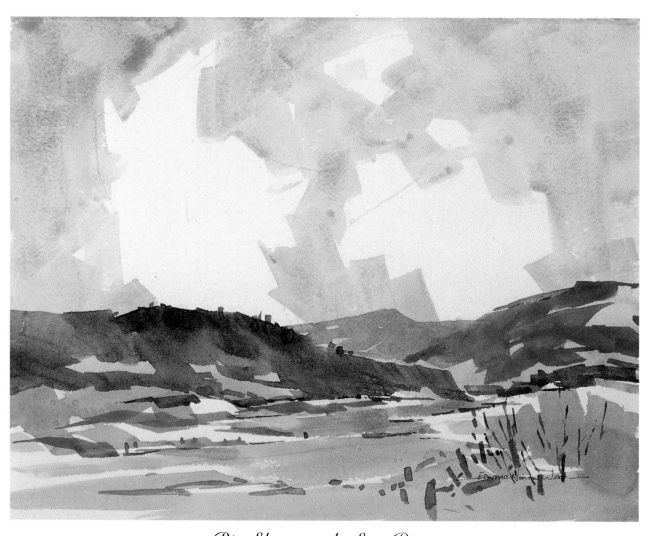

Big Sky over the Sun River

When the country impresses you as being "big," then try to paint it as you want the viewer to feel it. Say what you want to say in the most forceful way you can.

A S WE RODE into the upper canyons of the river, the mountains closed in and the country's character changed markedly. A feeling of real wilderness came through, and one felt that there had to be wild game nearby and the river had to be full of trout. It was still big country, but its bigness was of a different type. These were very wild no-nonsense-type mountains. If you didn't watch your step, you could be in trouble.

Carl Rungius, the noted wildlife painter, did a series of small oil sketches. These sketches were all quickly painted 8″ × 10″ panels, some hardly more than a brief statement. It is obvious that they were studies of settings for later wildlife paintings Rungius planned to do at his studio in the East. But each of these small studies had a feeling that was similar to what I was experiencing on the upper reaches of the Sun River. One sketch of an old burn had a distinct "moosey" feeling about it. This was just the type of country in which you could unexpectedly come face to face with an old bull. Another—a study of a grassy streambank and fallen aspen logs—made you feel that an old "she-grizzly bear" and her cubs would come along any minute. Rungius could put that "gamey" feeling into his landscapes because that was what he wanted to say.

I tried to catch that feeling in my sketch of the North Fork of the Sun. Here, *In the Bob Marshall Wilderness*, I was interested in the river as it made its way down through the massive mountains. I tried to suggest the scale of the country by keeping the size of the trees small in relation to the river and the mountains. You get the feeling that the river is big and could be difficult to cross—it was! There is hardly any sky showing because it didn't contribute much to the feeling I was trying to capture. The major line of the design is the white passage that suggests the near bank of the river and leads the eye back to the dark trees, ending near the dark shape on the distant round mountain.

Because I wanted to emphasize the river and its banks, I made sure that its blue shape was painted first. I left white paper for the flat meadow area on both sides. Then I quickly laid in a light, warm sky with cool underpainted washes for both of the distant mountains. I didn't carry the blue of the river all the way to the bottom of the paper but changed to a warm orange and blue mixture to suggest the bottom of the river.

When the first applications of paint were dry, I painted second darker shapes over the first washes to indicate the dark on the distant mountain, the warm rust color of the slope on the left, and the main groves of dark trees. I added touches of light green and rust over the white paper next to the river to indicate where the meadow grasses grew down to and mixed with the rocks along the edge of the water. The rocks were very light in value and gave me the chance to save the white paper along the riverbank.

Since this was grizzly bear country we were riding through, I never felt relaxed enough to just paint. Because of this, I worked rapidly. After painting, I had a chance to cast a fly over this water. I was somewhat nervous fishing here and very careful as I moved through that growth of Lodge Pole Pines downstream. I wanted just a hint of that feeling of lurking danger because it never left me—so far was I from civilization.

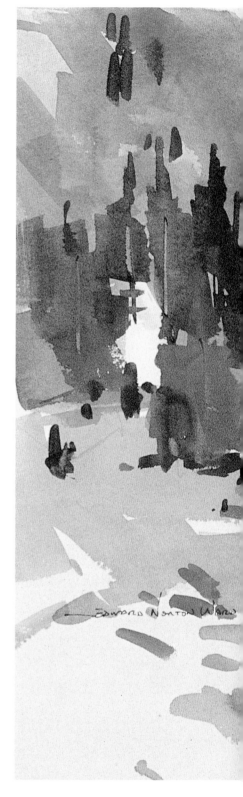

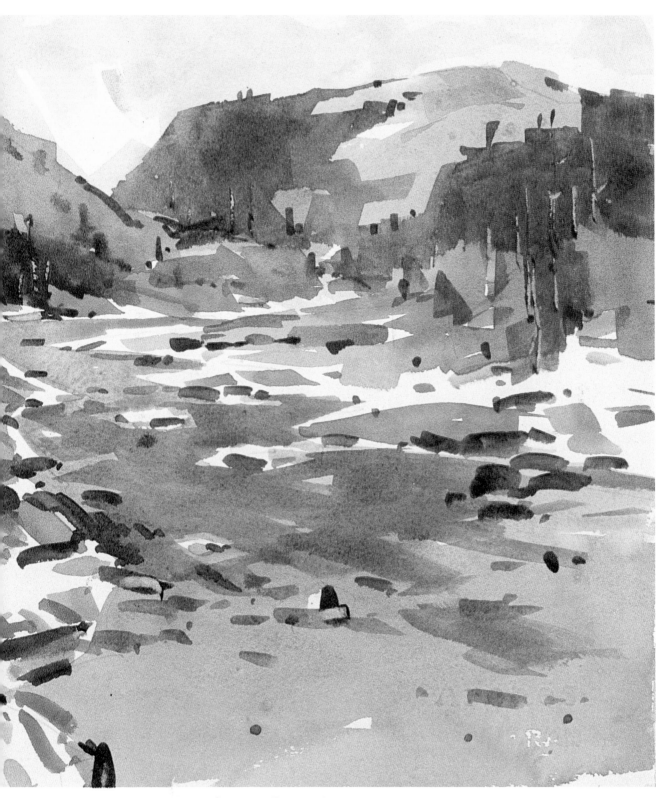

In the Bob Marshall Wilderness

This is dangerous country. Grizzly bears are about; crossing
the river can be treacherous. You can't be careless here.
I tried to say as much in this sketch.

Now let's move on to a different part of the West. I like to paint the mountain valleys of northern New Mexico around Taos and Sante Fe. Here, there is quite a different feeling in the landscape. These valleys are quiet and peaceful agricultural settings surrounded by the Sangre de Cristo Mountains. Descendants of the early Spanish settlers have lived and worked here for centuries. It is a hard life, but these are proud, hard-working people. The sketch I painted near Nambe,

New Mexico, *Farm near Nambe*, tells what this country is all about. The same sky and mountains are there as were in Montana, but here I tried to show a different feeling for my subject by emphasizing the rural character of the land.

When I see fields, "coyote" fences, sheds, and houses, I know people are working the land. I tried to emphasize the fields and fences and hint at distant houses. There is little sky, and the mountains help locate the scene. A warm light suggests the Southwest.

This sketch is designed around the diagonal line of the fence moving back from the lower left-hand corner into the distance. A large white shape between the two fence lines holds the viewer's eye until it sees the buildings. The blue roof of the building is the obvious place for the eye to rest, but then the subtle sheds hidden under the large tree pull the eye back and let it wander off to the left, up into the distant mountains, where several diagonal strokes return the eye to the blue-roofed house.

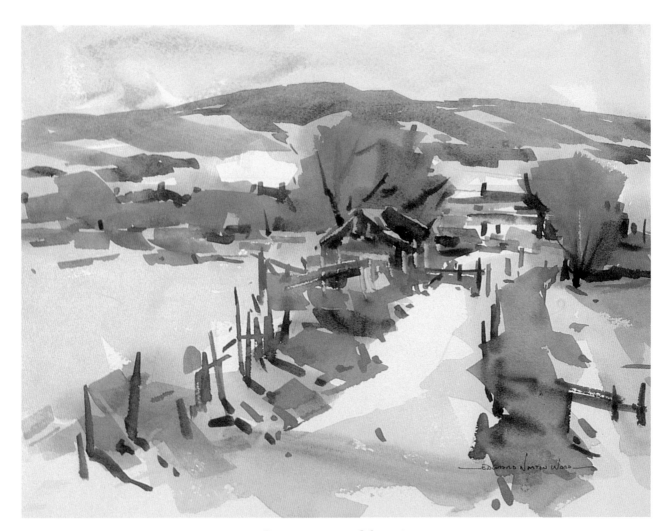

Farm near Nambe

The mountain valleys of northern New Mexico, still part of big country, always have a peaceful effect on me. I like being there and exploring the back roads. I like to paint the warmth of the country and its people.

IN *The Blue Depths*, a sketch of the Grand Canyon presented quite another idea. I tried to capture the awe-inspiring feeling one experiences standing there at the edge of the canyon as the sun comes up, seeing the immense "blue depths" of the canyon. This is what I wanted to say when I painted this subject. I had to try this sketch four times before I resolved the problem of light and got what I wanted. So dramatic was the light on the canyon that I kept featuring the colors in the distance and losing the feeling of depth. Again, it is big country, but it is big in a different way.

My idea for a design was to play off the foreground cliff against the distant sky and canyon rim to the north. However, the monuments in the canyon kept competing for attention, and I finally decided to leave the whole area under the background rim as a big white shape. Then, since blue shadow and depth was the concept I was trying to convey, I selectively cut in light washes of cool and warm gray while concentrating on leaving as much white paper showing as possible. I gave the foreground cliff a broad wash of warm yellow orange with a small touch of cobalt blue in it.

When my first washes had dried, a lot of white paper was still showing. I resumed cutting in deeper blues to suggest the depth of the canyon and cast shadows out to the north. In the secondary washes, I gave a final suggestion of warm color on the distant monuments and a slight hint of warm green on the lower mesa. I completed the sketch with the suggestion of a few dark trees in the lower foreground as essential dark accents. This gave scale to compare the size of the canyon.

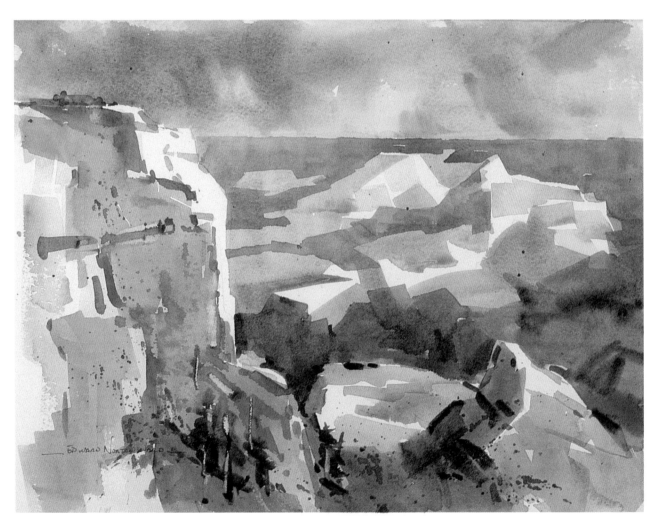

The Blue Depths

The Grand Canyon is deep and blue in the early morning light.
In this sketch, I wanted to show its awesome depths.

IN CONTRAST TO those sketches that were landscapes of open country where you could see for miles, what can we say about our subject when the landscape is closed in? Consider the inside of a forest. What do artists feel in such a space? With so many surrounding trees, a sensitive artist feels shut off from the world, maybe even on the verge of being lost. Light has a hard time reaching the forest floor. One can't easily tell directions.

Shadows in the Forest is a sketch I made while a friend and I were painting along the upper reaches of the Pecos River after an early snowfall. The trees were quite thick where we had stopped to look around, and I was attracted to an opening between the trees that led into the near distance. It attracted me as a source of light, but it had an even greater attraction. I don't like to be too closed in. Sunshine was showing beyond the opening, and there was a possible escape route from the stillness and gloom within the stand of trees. In my painting, I tried to say that I was very interested in that opening and I wanted to go through it.

First I indicated in pencil where that opening would be on the paper. This was to be a negative shape, which would have the strongest contrast of light and dark, since here was where the sun shone through on the snow. To either side of me, a screen of trees cast shadows and gave an overall blue green coloration to the place. To warm it up a bit, I moved the small patches of dry glass visible on the surface of the snow to the foreground against the blue shadows. Grayed blue and green washes suggested the screen of trees. I added darker blue to the trunks of the trees later to give a strong definition to the negative shape of the opening to the distance.

A scene that is mainly white and grayish blue-green needs a few touches of warm paint. When finishing the sketch, besides dry grass, I added more grass, almost pure yellow, over the small white patches in the foreground, where spots of sun came through the trees to the forest floor. The pure yellow, contrasted with the duller grass, suggests a feeling of sunlight from above. Also, there were still traces of red fall color from the scrub oaks found in New Mexico. These traces of color gave me an excuse to touch in accents of varying intensities of rust and red.

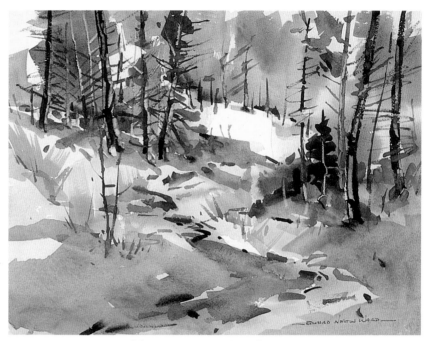

Shadows in the Forest

I was constantly aware of the opening in the middle distance as I painted this sketch. In the deeper shadows of the pine forest, with snow on the ground, I felt pulled toward the clearing and the sunshine.

EXERCISE

Find something outdoors to paint. As you look at your subject, become aware of what your other senses are telling you. What kind of day is it? Is it a warm sunny day or a cool brisk sunny day?

What feeling of space, depth, or height do you get? Do you have to look up or down at your subject? What is your state of mind? Are you content? Wary? Afraid? Is there a lot of noise, or is it quiet?

As you begin to design your watercolor, decide where your horizon should be to emphasize the space feeling of the scene. If you must look up, maybe a low horizon is needed. A high horizon may help emphasize a feeling of depth.

Decide on a color dominance that will say something about the weather. A dominance of warm color will give the feeling of heat; cool colors the opposite.

As you paint, keep what you are trying to say about the subject in mind. Don't worry about your technique or level of skill. Trust those tasks to your unconscious.

Nearing completion, ask yourself where small accents of color or dark can add to what you are saying about the scene in paint. Will a contrasting spot of cool color heighten the sense of sunlight and heat? Will a carefully placed dark give the feeling of glare to the light? When you can no longer find something to say about the scene, you are probably finished.

WHEN I PAINTED *A Threat of Snow*, it was late November and one could sense snow in the air. There had been flurries up at Taos that morning. I was hurrying back to Santa Fe when I saw these red willows along the Rio Grande River. The color contrast was too much to resist, and I knew that the color would be gone after one more snowfall. Keeping pace with the weather, I hurried along with my painting. I wanted to relate the lateness of the season with the impending snow.

Using two passages of white coming in from either side of the foreground, I was able to create a strong directional pull back into the middle distance. I put in the red willows quickly as one large shape of rusty red. The snow-threatening sky was painted simply and carried down to the distant hills, where I warmed it a bit with cadmium orange and permanent rose. Without waiting too long for the first washes to dry, I began adding texture to the willows and defining the foreground planes. Two darker washes in the background created an interesting line of two distinct hills. I added the small trunks of the foreground willows with the front edge of my one-inch flat brush. I decided not to press my luck with the weather. By the time I returned to Santa Fe, almost three inches of snow was on the ground.

To make my point, most of the examples I used in this chapter were of dramatic subjects with strong messages to convey. But all painting subjects have something to say. You can usually sense a mood or feeling embracing your subject. When you paint outdoors, you have to learn to listen to these feelings and incorporate them into the painting record of what you see. This is how you express more precisely what you have to say about a particular subject.

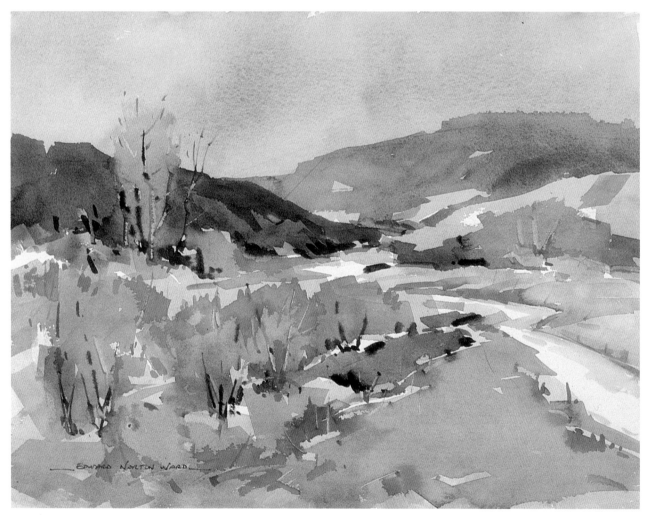

A Threat of Snow

Hurrying back from an outing north of Taos to the safety and warmth of Santa Fe, I had to stop for one more sketch when I saw these red willows along the Rio Grande. Working against time, I completed this sketch quickly and simply.

Buildings and Their Surroundings

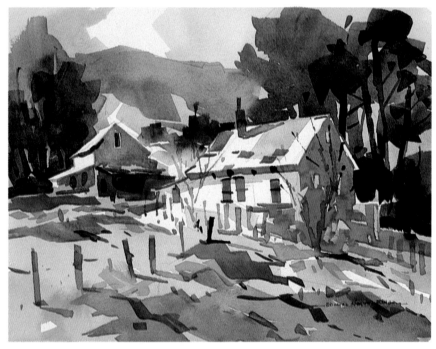

Viera Canyon Farm
Familiar buildings such as barns and houses
should be massed together with their surroundings
to form a more pleasing design. By themselves, their
rendition is little more than a record or "portrait."

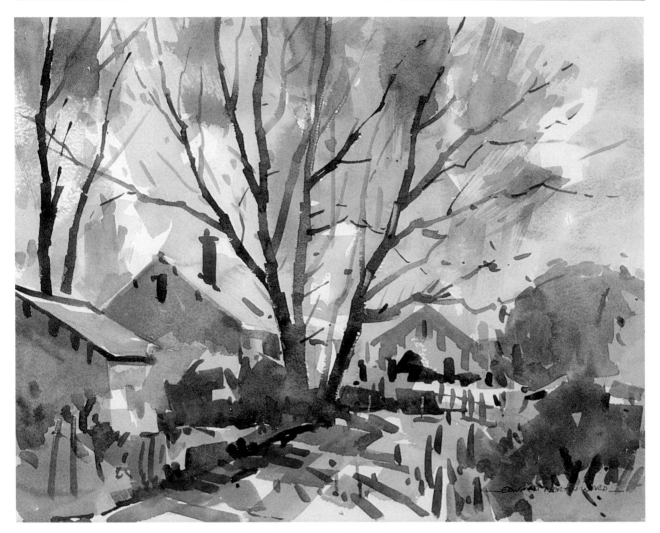

Morning at San Juan

In this sketch I worked with the natural shape of the lacy tree trunks
and the geometric shape of the houses to create a contrast between large
dark shapes and light shapes. This contrast allowed me to use the
white paper and to introduce a warm wash into the background that
suggested the peaceful early morning light I discovered on this occasion.

I WOULD RATHER use buildings as elements in an overall design than paint them as "portraits." Buildings, being geometric shapes, contrast well with the irregular shapes in nature. When the familiar shapes of houses, barns, and sheds are found massed together with trees and other natural forms, the shapes of their combined mass can often be the basis for a strong design.

One spring morning I was wandering through the back streets of San Juan Bautista when I noticed the outline of a tree and houses. By concentrating on the ends of the houses, I was able to trace an interesting line most of the way across the painting's space. If you look at *Morning at San Juan*, you will see how I broke the repeated shapes of the houses slightly by introducing the round tree shape at

the right and by leaving white paper as an impressionistic suggestion of light behind the large tree trunk. Because I wanted to paint the illusion of morning light behind the large tree, I used this strong line to define a contrast not only of large dark and light shapes but also of geometric and natural shapes. This contrast is one of the reasons I like to include buildings in many of my paintings.

103

BECAUSE WE SEE so many buildings in our everyday life, they seem commonplace and we tend to neglect them as painting subjects. To be sure, as artists we are attracted to the peaceful setting of rural villages and barns. But have you considered the possibilities right in your own neighborhood? If you live in a large city, take another look at the streets downtown. All that hustle and bustle of people going about their daily business . . . the colorful signs and awnings . . . what a marvelous mosaic! Even automobiles on the street can be used for shape, value, and color.

Your own neighborhood with the houses standing side by side can make a delightful subject. If streets are tree-lined, you have all the charm of the rural village right in your own front yard. Although rural villages and farm buildings are special subjects to all of us, they are not necessary as fine painting subjects. Before we look at these favorite building subjects, let's look at some possibilities closer to home.

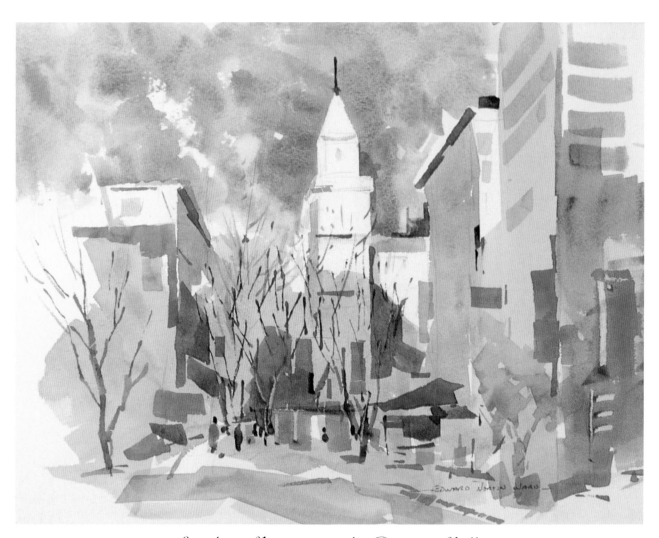

Sunday Morning at the Denver Mall

The morning light was bouncing all over the place—from one building to another and in and out of the shadows. This gave me lots of latitude to mingle warm and cool washes in multicolored reflections. A few lines of calligraphy for trees and smaller strokes for people completed the illusion of a quiet Sunday morning at the mall.

ALMOST EVERY large city in the United States has some form of urban renewal in the inner city. Recently I had to spend an extra day in Denver, Colorado, while I was on a trip elsewhere. I decided to explore the downtown area. Urban renewal had saved many of the distinctive buildings from the turn of the century. I was pleasantly surprised to see a new mall built up around them. I could see that the mass of light buildings against the deep blue sky had good picture possibilities. I painted the sketch *Sunday Morning at the Denver Mall*. Detail wasn't needed because the skyline of the white buildings against the blue sky was my picture. Where the buildings were in shadow, I reinforced the skyline with a few darker strokes at the top.

When I painted this sketch, I was aware of the quality of light found at Denver's altitude. Colors seemed to reflect more than usual in the cast shadows. I tried to exaggerate this effect a bit. I let the windows reflect the unexpected colors from nearby buildings. When you paint a city street as a subject, take a good look at the way the light moves about over an otherwise familiar scene. Then, if you exaggerate the unexpected colors, you will have put real excitement into your work.

That morning, as I moved down the same mall, I saw that I could paint a similar scene with reversed values, looking back into the sun. It was later in the morning, and there were more people around. *Denver Shoppers* depicts more of what was going on at street level.

For this sketch, I selected a vertical format. Although this is a study of massed city buildings, I softened the skyline so that the viewer's eye could wander down to street level—the people, awnings, and signs. To this end, I positioned some lacy trees so that their tops would cover part of the skyline and their branches provide a path for the eye to follow to street level.

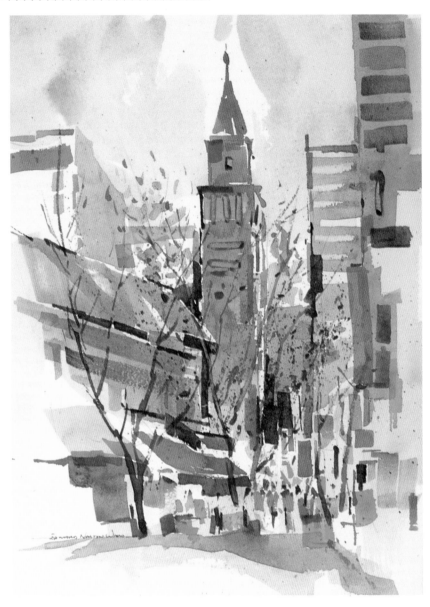

Denver Shoppers

In this sketch, I tried to make a study of the color variations within one large mass composed of buildings, awnings, people, signs, and the street. As contrast, I left white passages at street level. This contrast between white and color pulls the eye down from the strong skyline to observe color variations before moving back up to the skyline. Though mere suggestions of forms, the people are the strongest attraction here.

NO MATTER where we are painting, several buildings massed together will create a more interesting design than a portrait of a single building. The church in *Sierra Village* was interesting in itself from a historical point of view, but as a subject for painting, I felt it should be enclosed in a larger, light shape that would extend out to each side and in front of the church. By combining near and adjacent buildings into one large mass and letting lacy white paper passages interconnect background buildings, I was able to suggest the intimacy of a small village in the foothills of the Sierra Nevada Mountains. Inside this primary mass of white, I introduced a pattern of different colors to indicate several smaller buildings.

Starting with the strongest shape—the steeple— I continued the main line of the design both to the right and to the left, defining the tops of surrounding buildings. Deepening the value of the background hills, I kept this line dominant, especially near the church. When massing buildings together, pay particular attention to the line of rooftops. This is where the character of each building influences the overall massed shape.

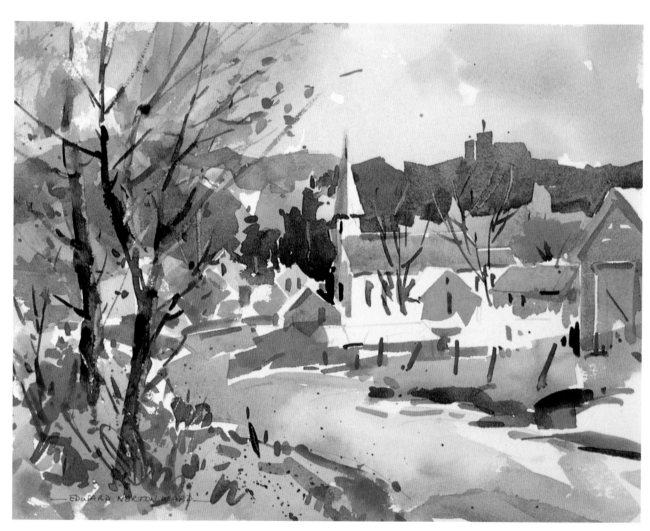

Sierra Village

Massing these buildings together seemed to transform them into an intimate group of buildings in a small mountain village. The contrast of white, color, and dark shapes suggested the presence of several smaller buildings surrounding the church, which remains the main building here.

INTEGRATING BUILDINGS WITH THEIR OWN SETTINGS

J UST AS WE achieve a better design by massing several buildings together, we can improve our design further by the way we connect their strong geometric shapes with surrounding natural shapes. Buildings tend to merge with the ground and surrounding trees and bushes. I like to hide the lower edges of buildings at the point where they come into contact with the ground. A painting that shows a hard nearly horizontal line at the base of a building has an unappealing static quality. A passage of light or color can knit the two planes together. We can use some other object to overlap and conceal the bottoms of buildings. In *Carmel Inn*, a series of terra-cotta planters concealed the baseline of the building. By means of impressionistic brushwork, I carried this illusion further.

The same principle holds in *High Noon*. There I concealed both the side and the base of the building. Combining buildings with their natural surroundings has the same effect as softening the lines of a newly built house with selective landscaping.

If you look at the line of rooftops, you can still trace out the line of light against dark as it makes its way across the picture. Where this line is disrupted by a bush or a tree, the eye is attracted to the continuing edge and moves on.

EXERCISE

Look around your own neighborhood for houses that are near or next to trees. Draw the tree form first. Next place the geometric shapes of the houses so that they overlap the tree form. For charm and character, you may want to alter the drawing of the houses to make them appear old and slightly rundown.

In painting this sketch, concentrate on making the overlapping tree and house shape as one main subject. While painting the wash suggesting the tree, leave some edges and white paper where the partially hidden houses will be painted later. Leave the hard edges where you want to attract the viewer's eye.

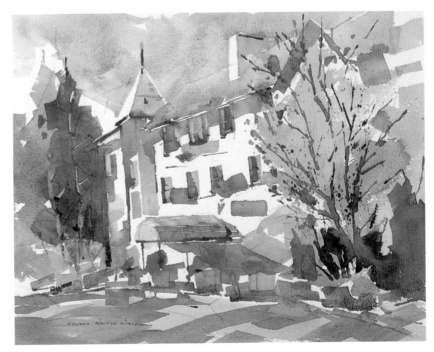

Carmel Inn

To avoid a static feeling, I use any device in the scene to hide a building's strong baseline. Here, broad strokes of red suggested the terra-cotta planters in front of the hotel's entrance. Shadows cast by the red awning contributed a more interesting foundation line to the large white shape of the building.

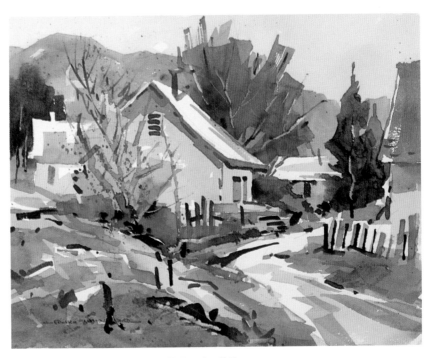

High Noon

I painted this sketch during a lunch break near Sutter Creek. I was attracted to the way all the roofs reflected the bright sunlight. I forced the buildings into a mass by pulling them closer together in the painting. Trees, bushes, and fences were also moved for the purpose of the design.

I HAVE LOOKED at scenes in which there were so many buildings vying for my attention that they seemed to form one supermass. Seeing a small village from a distance or from the height of the hillside often gives this effect. I was able to use this effect to advantage in *Rainy Afternoon, Angoon*, which is a favorite sketch from my Alaskan voyage. I wanted to capture the mood of the rainy weather and play down the shapes of the buildings. To do this, I showed the two large interlocking shapes of contrasting color first, with details of the buildings less obvious. I painted the foreground mass mainly of the warm colors rust and red and used just a few accents of cool color, contrasting it with the cool-colored shape of sky and water. I left a few shapes of white paper in the foreground to create the effect of many houses.

As I have already stated, for me as an artist, what is said about the subject is more important than the subject itself. I could have shown every house in the village, but I was more interested in the soft light reflecting off the water and the rooftops and how the shoreline interlocked with the water in a contrast of dark and light. The finished sketch is quite simple.

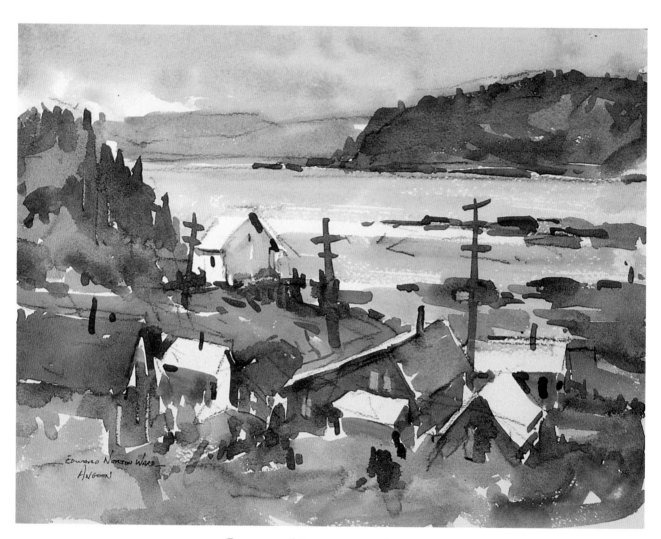

Rainy Afternoon, Angoon

If you squint your eyes, you can see that I emphasized two interlocking shapes of dark and light. The dark, lower shape is predominantly of warm colors, and the light, upper shape is cool.

BUILDINGS HAVE to have a reason for their existence. On a farm or a ranch, every building serves a purpose. Your painting will be more believable if you can show in your painting why the building exists. The shed in *Abandoned Shed* has a story behind it. The fallen fence and the old gate suggest that it may have been built as a shelter for livestock of some kind. Seeing it now, abandoned and slightly overgrown with weeds, one wonders what animals once were sheltered there.

April Showers depicts that peaceful unity that makes farm country so popular with artists. The natural feeling of harmony in such a scene makes it a favorite subject. The buildings here are still actively used. The orchard provides enough crops to need storage in the barn. The work of the farm demands farm machinery and sheds to shelter it in. Here, this complex of farmhouse and outbuildings is connected by way of accidental white passages through the center of the picture.

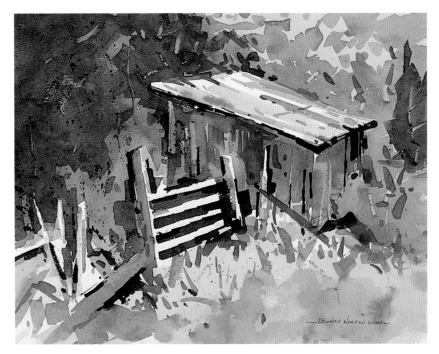

Abandoned Shed

Even though I used only one building, I avoided a portrait look
by featuring the light fence posts and gate. I softened
the shed by letting the sides melt into the background dark and
light shapes. Only the roof has been allowed full definition.

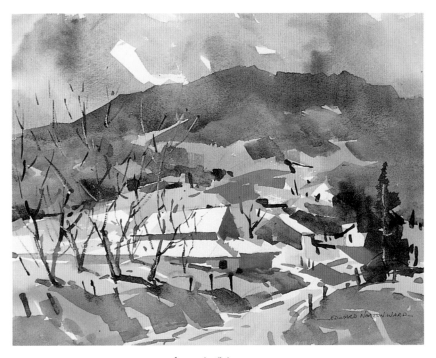

April Showers

I connected these buildings by means of passages of white paper. In that way,
I could spread the scene out while keeping the unified feeling of one large shape.

SOMEHOW I SEEM to paint a lot when the weather is uncertain. Living on the coast, traveling into the mountains on painting trips, I work with a constant threat of rain or snow. But long ago I decided not to let weather ruin my painting trips. Now I find I actually like the way its fluctuations can punch up an otherwise ordinary scene. I can always find some shelter where I can set up for a quick sketch. Changing weather has allowed me to paint yet another dimension of outdoor light on the landscape.

In northern New Mexico in October, one lives with the ever-present chance of snowfall. In fact, in recent years I feel somewhat cheated if there aren't a few days with snow on the ground. Rarely do these early storms last more than a day, and then if luck is with me, sunny days follow and with them the breathtaking beauty of fall.

I was north of Taos the day after a snowfall when I found my subject for *First Snowfall near Taos* right off the main highway. The sun reflecting from the snow was so bright that all I could do was squint my eyes to see the pattern of fences and buildings moving off into the distance. Since I wanted to paint the elongated zigzag line from foreground to background, I painted the buildings so they would not interrupt this line. Quick strokes of color suggested the changing geometric shapes of buildings.

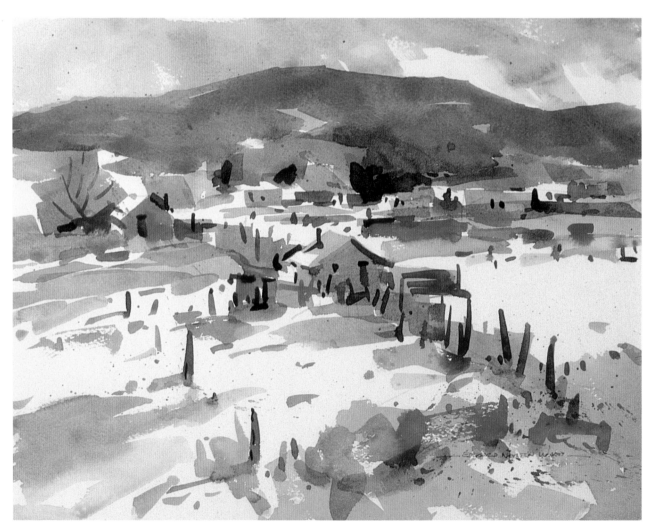

First Snowfall near Taos
To soften the strong diagonal line of the fence and building,
I exaggerated the long shadows on the snow, which gave the impression
of sun setting low in the sky. Against the cool colors of sky, mountain, and
snow, I placed contrasting touches of warm rusts, red, and orange.

When I am painting in the foothills of the Sierra Nevada Mountains, I often encounter gray days or outright rainy days with their varying moods. Since I try to avoid summer tourists, springtime and late fall are the seasons that find me poking around the gold rush villages. At that time, there is always a chance of rain. I painted the sketch *Sutter Creek* one such showery afternoon. Gray clouds hung low over the hills. Now and then a stray ray of sunlight would

lighten the buildings. Everything appeared different from just a few weeks earlier. The place seemed lonely.

I had tried to paint this group of buildings and the stream many times before and failed. On this occasion, although the light was soft, there was just enough sun to cast shadows on the buildings. In my previous attempts, I had concentrated on the unique combination of the buildings and the bridge. This time I liked the

way the stream reflected the light, and I decided to emphasize that and reduce the buildings to a minor role. Consequently, I used the buildings as a white shape that the stream's white would lead to, and at the same time I introduced cast shadows to show where the weak sunlight was coming from. The top edge of the buildings allowed me to show some of their character and their relationship to the bridge. I don't think I would have seen this light effect on a bright summer day.

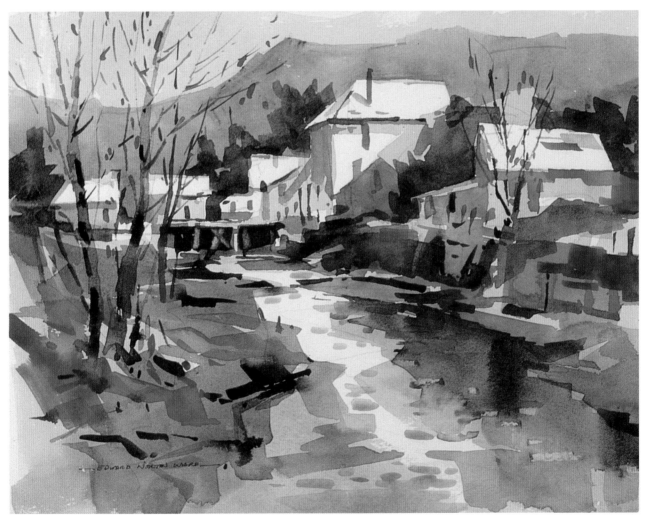

Sutter Creek

If you trace the edge of white against dark in this sketch, you will see that quite a large abstract shape is formed where the buildings and stream merge into one light mass. Low light coming through breaks in dark rain clouds often creates such happy effects.

I F NEGATIVE shapes can be the subject for a painting, the edge of buildings can be used to define the negative space. When an opening between buildings leads the viewer deep into the pictorial space, what is found in that opening can become the main theme of a painting. I like to try for this effect when I tire of painting buildings themselves. *Point Reyes Station* is a quick painting demonstration from one of my workshops. The buildings on both sides of the street made compelling subjects for my group, but I wanted

to show how to split them apart and lead the eye farther down the street to a more interesting set of buildings.

Defining the negative shape between the houses on either side of the road and letting it extend up the hill, I made the barest statement of shape and value in the distant buildings. While just a rough sketch, *Point Reyes Station* shows that it is not always necessary to use the buildings themselves. Their strong edges alone can direct the eye into the space selected by the painter.

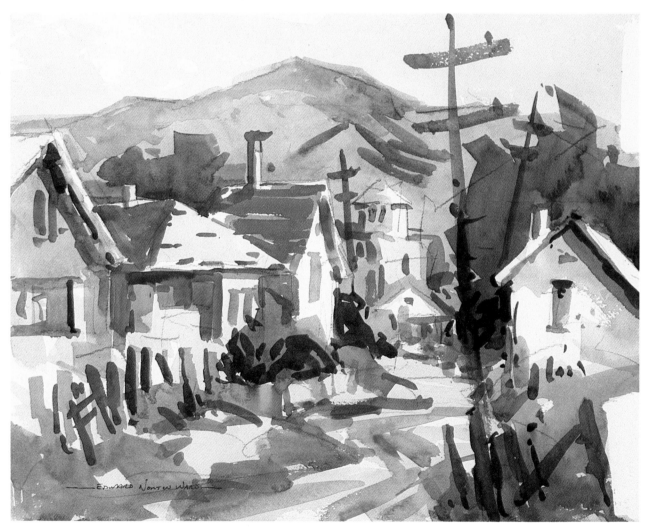

Point Reyes Station

Always be aware of the negative spaces between groups of buildings.
Often the better picture exists just there. I wanted to attract
attention to this negative shape and at the same time keep
the value as a reverse contrast of soft against hard.

WHEN YOU ARE painting buildings, remember that just a suggestion of the geometric shape can read strongly as a building. The barn in *Foothill Country* is placed just a little too prominently for my taste. Although the design works well, I like the placement of the building in *Gold Country Inn* better, where the sketch is about trees. Trees are dominant in the design. The building is only suggested by placing a strong dark shape next to the line of rooftops. Two other lines complete the line at the eaves and far end of the roof. The ridge line has been allowed to merge into the background of white clouds.

By placing darks where one would expect to see windows, I allowed the building to come into focus without detracting from the tree trunks in front. I think that when you can get a sketch to work with this sort of interplay between buildings and trees, you are really achieving a good design.

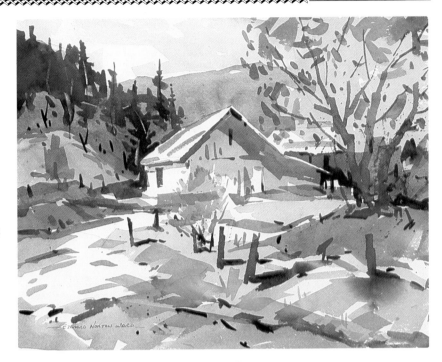

Foothill Country

You don't have to use much imagination to see the red barn.
As it turned out, this sketch is a little too obvious for my taste.
If I paint this scene again, I will move the buildings behind
the trees on the right to make a more pleasing design of the contrast
between the building shape and the natural shape of the tree.

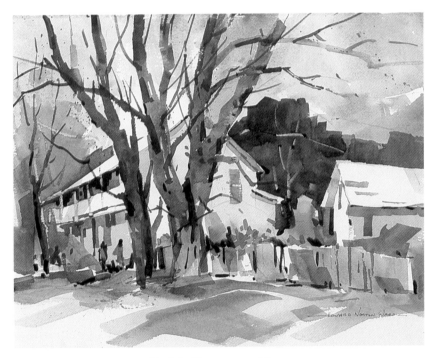

Gold Country Inn

Although the inn is hidden behind a stand of trees, you can still
see its strong outline. The contrast of dark hills defines the end, the roof,
and the front of the building to the right. I painted the dark
negative shapes while paying close attention to the light buildings.

Seascapes: Planning Coastal Scenes

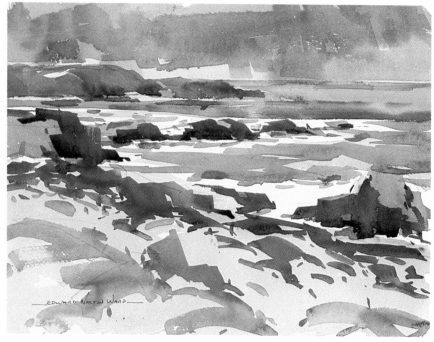

Rainsqualls to Seaward

When I look at this sketch, I can still feel the sea breeze and
sense the impending rain from the swollen clouds overhead. When I started
to paint, this was the feeling I wanted to capture in my painting.

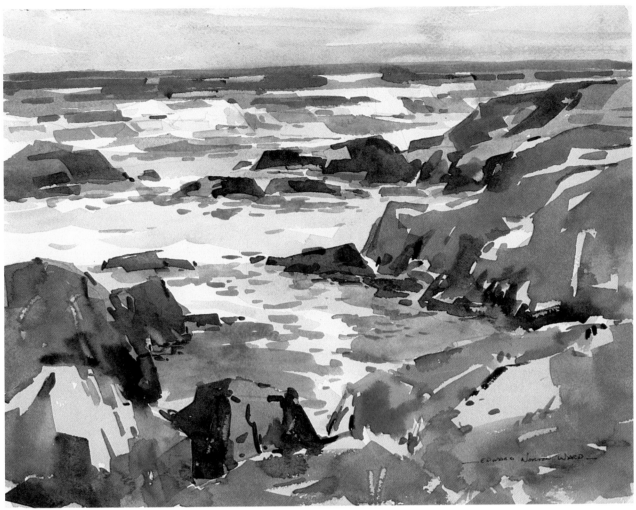

The Big Sur Coast

The marine painter's challenge is to make an original and powerful design of
a few natural elements. Try to become aware of the opposing forces of nature
as the waves move against the rocks and put those feelings into your painting.

THE GREAT MARINE paintings of Frederick Waugh and William Ritchell changed my life and got me started painting. I decided when I first discovered their work that I too would become a great marine painter. After almost forty years, however, I have still not achieved that lofty goal. With a better appreciation and a greater humility, I still consider the ocean one of my favorite subjects. Whenever I see a fine painting of the sea, I still become excited.

I have always lived in sight of the coast. My present studio is near the tip of the Monterey peninsula within a thousand yards of the ocean. Nearby is Point Lobos, which Robert Louis Stevenson considered "the greatest meeting of land and sea in the world." Farther south is the Big Sur coast, with cliffs falling a thousand feet into the sea. With this wealth of marine vistas, I take every opportunity to walk the cliffs and climb the rocks, looking for new ways to paint the sea. As the light and weather change, I discover a never-ending variation of coastal scenes to paint.

Painting the sea is all design. You have only a few elements to work with—water, sky, rocks, and cliffs. How you put these elements together, what you say about the sea, is your statement as a painter. As with landscape subjects, you have to know what you want to say before you start your sketch. To this end, you must go out, walk along the shoreline, and look at the sea. Experiment with sketches; it is there that the original ideas begin to show themselves.

KNOWING WHAT we want to
say, we can begin to search
out the shapes, planes, and
passages for our design. White
water will not only define broad,
simple, light shapes but can be
found as slender passages knitting
other shapes of white water
together. Where you find the white
water, you will also find dark rocks
and deep water. Place these value
contrasts together just as you
would in any other design.

Interlocking edged shapes occur
where the white water meets the
darker rocky shore. The broad
swells of the deep offshore water
can be seen as intersecting planes.
Using a contrast of white water and
irregular-shaped dark rocks, cliffs,
and deep water, you can design a
good marine painting as an abstract
pattern of several different shapes
and planes. If you can select one
part of the scene to dominate all
others, then you can use it as the
foundation for the design.

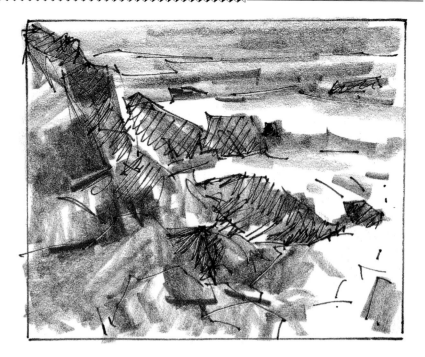

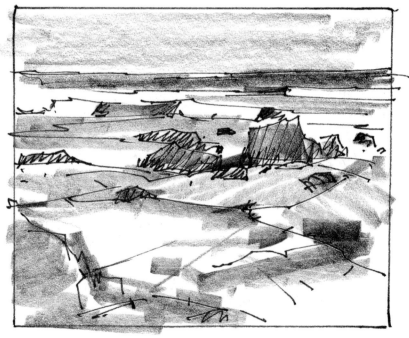

The thumbnail sketches on these two pages reveal some of my thoughts as I walk along the coast. I look at the way white water and surf shapes interlock with the dark rock shapes. Out beyond the breakers, the deep blue-green water merges with the nearer white water. One can find infinite shades of color there. On a clear day, the sun directs a play of light and shadow over the turbulent white water. An endless variety of color is present in the rocks. Finally, there is the play of light and shadow over the steep cliffs that fall into the sea.

Besides reacting to the light and color of water and rocks, other feelings will excite you. Imagine the tremendous forces between incoming breakers and the solid rocks they crash against. Imagine how it would be to stand on the rocks and watch the waves come in. If the weather is threatening, try to get the feeling of an impending storm into your painting. When the fog rolls in, its mood takes over and the sea seems quiet and full. Muted colors take over; some colors completely disappear. Seaweed glistens noticeably.

The sea has other moods. A different point of view can let you focus on them. At the water's edge, with surf breaking all around and forces fighting with one another, there is a feeling of danger. You may feel threatened by the nearness of the white water. On the other hand, if you are high on a cliff looking down, the sea seems more serene. Each point of view can bring about a different composition and an opportunity to show something new about the sea. As one continues to study the ocean, he soon discovers that there is no end to the different ways of painting the sea.

MOST MARINE paintings feature the conflict of surf and rocks as their main theme. Since this is the true edge of the sea, where the greatest conflict of physical forces are found, it should be the strongest part of the design. However, you have to decide whether to emphasize the rocks or the white water as the main idea. Both rocks and surf cannot be painted in equal amounts; one or the other has to dominate the main space. Otherwise, the viewer won't know where to look.

When you are focusing on the white water surf, the rocks are relegated to a minor role. Where the surf is crashing around the rocks, there is a pattern of white water against the dark rocks and deep water. In *The Breaker, Big Sur Coast*, the surf action is so strong that the rocks are almost totally submerged as the water rushes over them again and again. Because of the force and direction of the water's flow, you know the rocks are there, even though they are visible for only brief moments within the cycle of the waves. In this sketch, I wanted that feeling of the force of an incoming wave about to inundate the low foreground rocks with white water. Basically, this is a portrait of a breaking wave, yet I felt I showed a slightly different facet of the sea, without getting too "corny." I wanted to present the sea's force—not just another pretty wave.

When I paint a large mass of white water, I like to play up the water's variations in value and color. When I painted *Light on the Surf*, I saw several places where the surging white water would cast shadows on itself. The shadows gave a sense of direction to the motion of the water. Also, there were always glimpses of light green water breaking up the white foam so I was able to use a full range of middle-key value and color washes within the main shape of the white water. Since the shadows were primarily cool, I could contrast light washes of violet gray against warm oranges in the white sunlit foam.

You can see these colors more readily if you glance at a scene and then turn away. In the bright sunlight, the eye fatigues quickly.

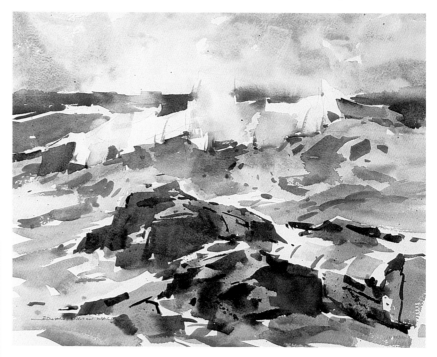

The Breaker, Big Sur Coast

Since I wanted to emphasize the shape of the white water breaking over the crest of the incoming wave, I let the water dominate the design and limited the number of rocks to just enough to indicate the shoreline. The wave itself covers most of the picture area. The water beyond that acts as a dark foil for the white surf.

Subtle colors disappear. A quick glance will leave a trace of color in your memory. If you exaggerate this fleeting color in paint, as you recall it in your mind's eye, you can give the ordinary white of reflected light an exciting hint of color.

The edge of the sea can be rough, with rocky interlocking shapes of white water and dark rocks. If the design calls for an emphasis on rocks, paint them large enough so that the viewer knows they will withstand the force of the strongest storm-driven surf. *Heavy Seas, Big Sur Coast* shows what I mean. When I looked at this scene, I wanted to show how the rocks captured the force of the surf crashing on the shore. To keep the air of danger in the painting, I added the light behind the offshore rocks.

Although the surf is the center of interest, I emphasized the size of the rocks but kept the viewer's interest on the white water by placing the interesting edge of the foreground rock against the lightest part of the water. The eye could then follow a natural path through the rocks into the mysterious atmosphere surrounding the distant cliffs.

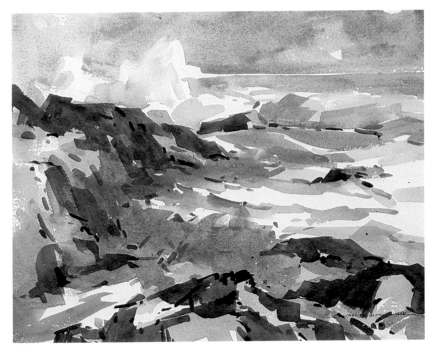

Light on the Surf

Concentrating on the color variations of the white water, I didn't pay too much attention to the rocks or the background water until, suddenly, that slim streak of white paper on the horizon came to my attention. At that point, I realized that the background water was finished and that only a few minor accents of dark color were needed to define the rocks and finish the sketch.

EXERCISE

Study the same source of turbulent white water you painted in the exercise on page 118. You can see that the water is channeled between rocks, logs, or the streambank. These obstacles determine the path the water will take.

Draw a continuous line tracing out the direction of the water's flow through and around these obstacles. Now look and determine how the water's direction is changed by some of the major obstructions. Where the water hits a surface head-on, its force is directed straight back against the current. Where the water just strikes at an angle, its force just glances off the surface and proceeds downstream in a different direction. Roughly paint these surfaces in positions that will show why the water changes its direction of flow. It is this opposition of forces that creates strength and a dynamic feeling in a painting of the surf or white water.

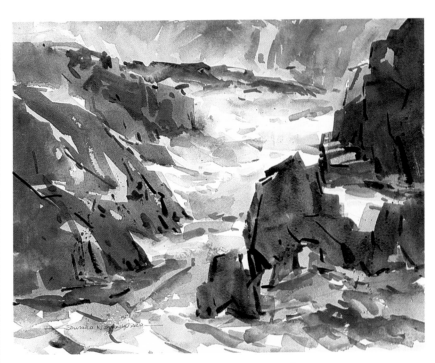

Heavy Seas, Big Sur Coast

Although the white surf—trapped in a cove between the cliffs and the offshore rocks—is my center of interest here, I wanted to overpower it with the larger rock shapes.

IN *Surf Off North Point*, I liked the way the sunlight modeled the cliffs of Point Lobos's North Point. There was a big sea running that day with an atmosphere of soft light from the mist of the breaking waves. North Point is one of the most popular motifs for the painters of Point Lobos, who usually depict the shape of the point against Carmel Bay. Instead of this view, I wanted to emphasize the light on the cliffs and the rocks and contrast it with the cool shadows.

To accomplish this goal, I placed most of the easily identifiable contour of the point above the top edge of the picture space. Because this point is breathtakingly beautiful, had I kept all of it in the painting, the viewer would have seen little else.

At first, I was unsure of how to use the white breakers. I liked the misty atmosphere and muted sunlight they caused and the way the surf was breaking against the background cliffs. The white of the breaking wave against the warm cliffs gave me a chance to contrast light against dark, and cool against warm at the same time. I finally saw that each wave led the eye right to the cliffs and held it where the wave exploded against the rocks before moving to shore. This gave me a chance to place a nice white alongside one of the darkest shadows, a focal point in my design.

The painting was a strong statement of sunlight bathing the scene. This play of light was what interested me. The cool, dark shadows gave form to the steep warm cliffs. A soft, cool shadow, where the breaking surf hits the cliffs, contrasts with the hard shadows of the rocks and adds a cool color near the warm cliff colors.

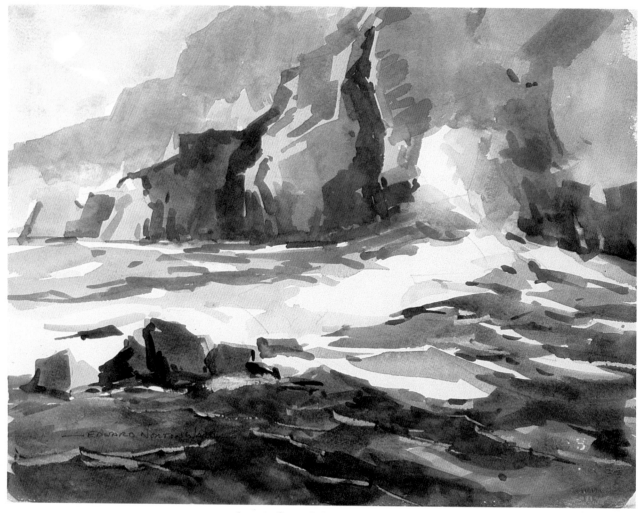

Surf Off North Point

Heavy surf working its way past the steep cliffs at Point Lobos provided the contrast of white and dark values and warm and cool colors in this sketch.

Treasure Cove, Point Lobos

The sunlight reflecting off the top of the breaking wave next to the cave's mouth draws the viewer's attention to that part of the sketch. By letting the wave cast a shadow over itself, I created a transition of light, middle, and dark values in the area of greatest interest.

As another approach, I emphasized the cliffs in *Treasure Cove, Point Lobos.* I painted this sketch at Point Lobos, where there are several sea caves. I wanted to show the relationship between the white surf and the dark sea cave. Another story line I pursued was the hearsay that Robert Louis Stevenson, who had lived in Monterey briefly, used the coast of Point Lobos as the setting for his book *Treasure Island.* The lore of Monterey is full of stories of fortunes in gold found in remote sea caves on stormy nights only to be lost again when the discoverer went back to retrieve his find.

I wanted to capture the way a sea cave fills with spray when a large wave breaks across its opening. The mist from the breaking wave against the dark interior of the cave created a striking blue-black color combination that I wanted to get down in paint. With this strong light and dark relationship, I also wanted to emphasize the height of the cliffs by making the cave area appear small in relation to the overall cliff. I was looking down from the top of the cliffs as I painted, and this viewpoint allowed me to show the green surface of the water with its drifting patterns of foam. I left several passages of white paper to suggest sunlight reflecting off the surface.

Since I wanted some of the mystery of this lore in my sketch, I made the cliffs large enough to conceal such a cave, except when the light focused on it. Although white surf is interesting, its main role was to bring the viewer's attention to the cave at the water's edge, which would otherwise be lost.

WHEN THE OPEN SEA is the subject, we have to bring into play all we know about the planes that constitute the long unbroken waves at sea and how passages of floating foam from whitecaps can be used to knit these planes together. Wave after wave stretches off toward the horizon, and we have to find a way to design them so that we emphasize just one or two that are nearby.

Although it is difficult to compose a painting of the open sea, opportunities occasionally do present themselves. *Open Sea* is a record of such an experience. On board the *Seacomber*, we had just cleared the entrance of the Lisianski Straits and headed out into the North Pacific off the Alaskan coast.

Here are some of the roughest seas in the Pacific Ocean. That day was no exception. During our transit, the surface of the rough seas kept attracting my attention. Since I couldn't paint at the time, I tried to memorize everything I could, hoping to paint when we hit quieter waters. From the wheelhouse, I tried to record in my mind the feel and motion of the sea, imagining how early Russian explorers must have felt in their small sailing craft without the benefit of twin 600-horsepower diesel engines.

An hour later, when we were safely back in the shelter of Porcupine Bay, I painted this sketch from memory at the sink in *Seacomber*'s galley. If I had waited any longer, another experience or adventure might have clouded my memory and I might have lost the feeling of the heavy open seas.

I took full advantage of the white combers at the crest of the swells. In my first attempt at this sketch, I was left with one white shape dead center in the picture. In *Open Sea*, my second attempt, I placed three white shapes in a triangle to keep the eye moving over the surface of the water. I eliminated the horizon and suggested breakers in the distance to indicate a dangerous reef. By placing a pattern of grays and greens where previous combers had passed, I introduced color into the sea. Looking at this sketch again, I can still feel the weight of those big waves.

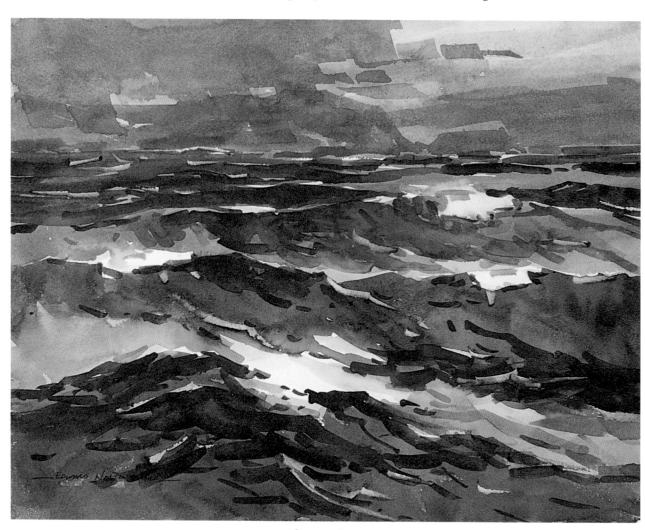

Open Sea

I placed three white shapes of cresting waves in a triangle to keep the eye
moving over the surface of the water and introduced some color into the sea by
placing a pattern of grays and greens where previous combers had broken and gone by.

WHEN WE EMPHASIZE the beach with its minimum of rocks, we have to subordinate the surf and ocean. Along the north coast of California, you can find small streams winding across the sand to the ocean. These make ideal compositional devices to be used to add interest to a spacious foreground beach. With the cool color of the stream and the warm sand color, you can introduce a strong directional to lead the eye toward the surf farther back in the picture space.

In *Spanish Bay*, I wanted to emphasize the sand and stream. This view is typical of the Pacific Grove shoreline in contrast to the rocky cliffs farther south along the Big Sur coast. Since I was painting a beach, I placed the horizon high and left a small area for the sea. A passage of light blue, suggesting a stream, extends from the water in front of the surf right up to the viewer's feet. This stream, flowing across the sand to where it meets the surf, rocks, and water, was my main interest.

The sand dunes and beach represent a series of planes that intersect one another and reflect light from different angles. I drew these as a series of diagonal lines defining the stream and leading the eye out to the dark rocks set off against the light breaking waves. I kept the background surf as small bands of white set against the darker green and blue of the deep water. I used the warm-colored driftwood and other natural debris scattered over the sand to strengthen the edges of the stream, thus giving it more emphasis.

Farther north, the Alaskan beaches extend quite far up into the inlets, where there is little suggestion of ocean or surf to use in a design. While exploring the Chichagof mine in Klag Bay one rainy morning, I found the scene for my painting *Chichagof Landing*. All I had to work with was the beach, the quiet water, and the rain-soaked hills in the background. To direct the eye across the water, I used a series of small dark shapes and accents and let the small white boat become a stepping-stone to the small white shape across the bay.

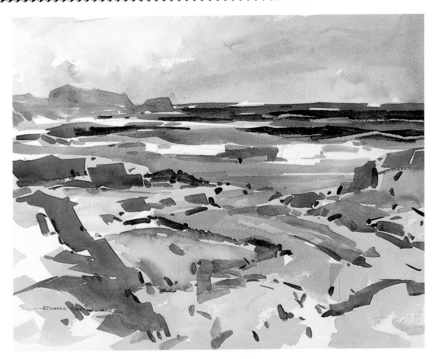

Spanish Bay

Sand, driftwood, and seaweed were a warm contrast of color against the blue stream leading out to the open ocean's deep blues and greens. The contrasting warm and cool colors create an interesting relationship here.

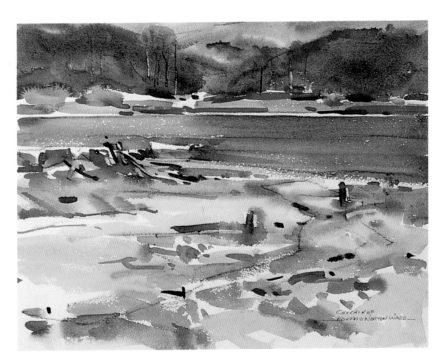

Chichagof Landing

I wanted you to be able to smell the dampness of the day and the tidal beach when you viewed this painting. I used a wet into wet technique mostly, not by design but because of the weather: My washes would not dry. You can see where some of my strokes bloomed.

EACH VIEW OF the sea presents a different subject to paint and a completely new set of problems to solve. At the edge of the sea, the action of the surf almost hides the horizon and background water. From this point of view, there is a lot of drama. Above the water, from the top of a cliff, you can see patterns of white surf and foam against the deep water. Thus, you can show a high horizon, and both height and distance become dominant.

In *Shadows on the Water*, I was interested in the effect of the clouds on the inshore white water. That morning, as I walked along this part of the Big Sur coast, there was very heavy surf. The pattern of white water could be seen for miles. The inshore water was completely white with the foam of breaking waves. Looking seaward, I observed the way the clouds cast shadows on the white water and created a sense of distance.

To emphasize the distance, I drew the large foreground rocks near me as large as I felt I could. Contrasting these rocks with the white water, I next drew in the small shape, which represented a headland a few hundred yards up the coast. This headland, which was as big as the one I was standing on, I nevertheless drew as a comparatively small shape to retain the sense of distance.

The sharp horizon and offshore rocks provide a balance of darks on the left. Without these darks, the painting would have been too heavily weighted at the right and bottom. Using several variations of cool gray blues and greens, I made the white water within the surf action appear flat as it receded.

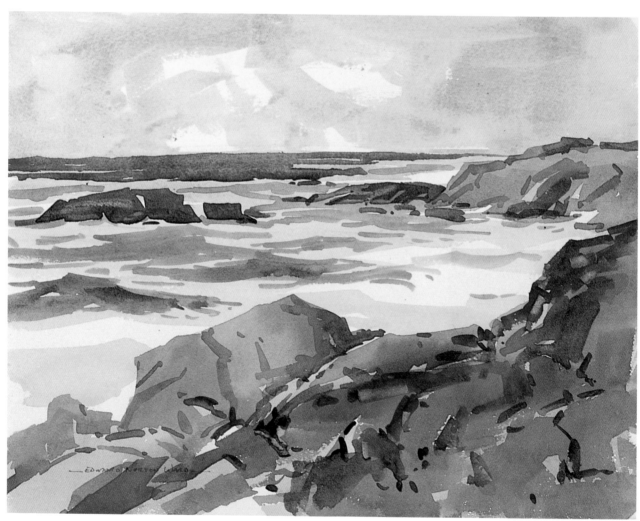

Shadows on the Water

In this painting, I used the light value of the surf, keeping it as simple as possible to emphasize the distance you feel when looking up or down the coast on a bright, clear morning.

WEATHER HAS always been a major concern to the mariner, and it can be a major theme in a marine painting. Wind, rain, and fog are common weather conditions along the coast. Along with the weather goes heavy seas and muted greens. If you find shelter, there is nothing more thrilling than watching the surf in the grip of a major storm.

Early one morning, after such a storm had passed through during the night, I was out looking at the storm-driven seas. From the back of my car I was able to quickly record essentials of an effect of light falling on gray green water. *Stormy Seas* is the result. As the storm cleared, sunlight broke through small separations in the clouds, and I was able to get an even better flow of light by painting in the shadows of rocks on the inshore surface.

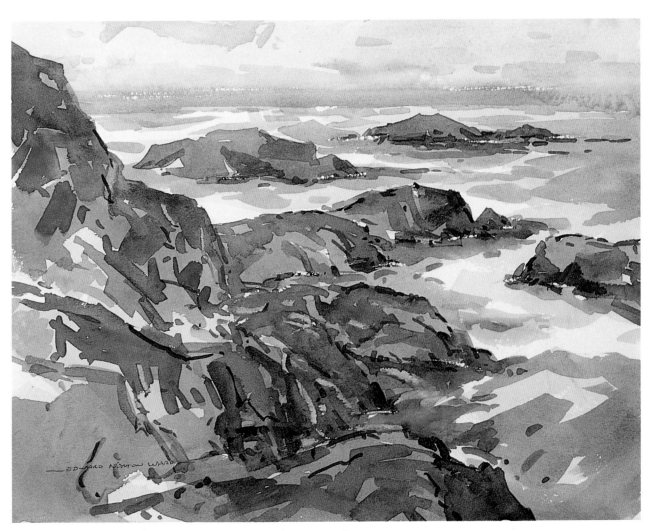

Stormy Seas

To give the illusion of light, I had to design lots of rocks and cliffs into this sketch. The shadows cast on the white water show where the source of light is and explain the sparkle and glare on the outer water.

S INCE LIGHT plays such an important part in painting—especially in marine painting—let's look at other ways of using it interestingly. Naturally, the sky reflects off the surface of the water, and whatever bright colors are in the sky will show up on the surface. If you look at *Light on the Sea*, you'll notice how the offshore rocks break up the surface of the water as they trail through the water toward Soberanes Point. This half light of the sky is typical along our coast, and it eliminated almost all detail in the rocks.

To emphasize the reflective surface of the water, I drew it as a major negative shape. The irregular path of the protruding rocks gives the viewer a little adventure in getting to the distant headland and creates diversion from the placidity of the sea. The foreground bluff and offshore rocks give scale to the overall scene, again emphasizing the distance to the far point.

With the exception of a few carefully placed whites at the base of some of the offshore rocks, I used one large wash of light yellow gray over the sky, background headland, water surface, and offshore rocks. I then painted a second warm wash over the foreground bluff; this was my only variation of color and value.

When the initial washes were dry, I painted the headlands and offshore rocks in a cooler, darker value than the sky, with a slight hint of blue violet to contrast with the yellow gray of the sky and water. To suggest the disturbance the offshore rocks created in the water, I added a few strokes of cooler blue of the same value. Finally, I painted in warmer and darker washes over the foreground blue and the nearest offshore rock. Using dark accents, I was able to suggest dark coastal pines. This final touch of color completed my sketch.

On a clear day there is little atmosphere to break up the light. Sharp contrasts appear where shadows are cast on the white water. These shadows, which are actually darker than they appear, can be exaggerated to make the light seem brighter.

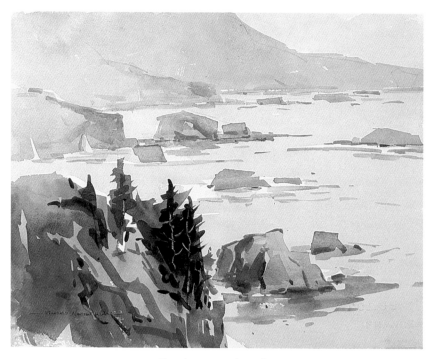

Light on the Sea

An aerial view reveals the surface of the sea in all of its variations. I drew the surface as a major negative shape, with rocks forming a path into the distance.

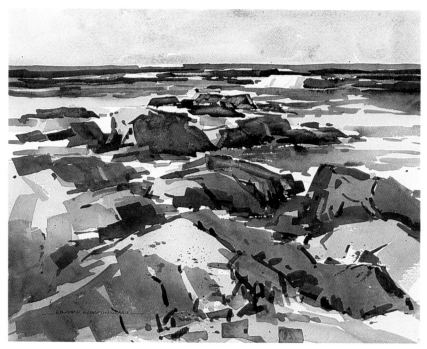

Asilomar Coast

The rocky points going out into the white water characterize this part of the coast near my studio. In low, bright sunlight, the rocks stand out as dark shapes massed together with their cast shadows.

Also, as I have shown in *Asilomar Coast*, the deep water offshore appears as dark shades of blue and green. The horizon stands out razor-sharp against the sky. By showing the light and shadows on the big foreground rocks, I was able to explain the light and shadows on the white water farther out. A small stroke of light gray on the shadow side of the breaking wave continues this light-on-the-water concept into the background.

This chapter has only touched on the design possibilities of coastal subjects. By going out and looking at the sea, you will find an endless source of challenging subjects to paint. In *Lobos Rocks*, you see the white water interlocking with the dark rocks. I was able to give a swirling direction to the white water by introducing shadow forms and a few strokes of varying shades of green. On the coast, this scene exists in endless variation. As long as you bring your imagination with you and remain open to the fluctuations of the sea, the light, and the air, you will always find a new view—and be able to make just one more quick sketch before the sun goes down.

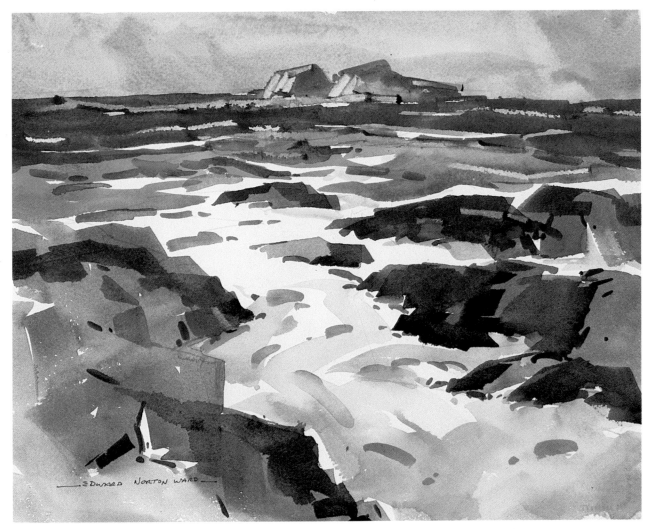

Lobos Rocks

I tried to use the white water as a large negative shape in this sketch. The dark rocks on each side of the white shape take the eye over the deep water to the offshore rocks on the horizon.

Harbors: The Charm of a Busy Dock

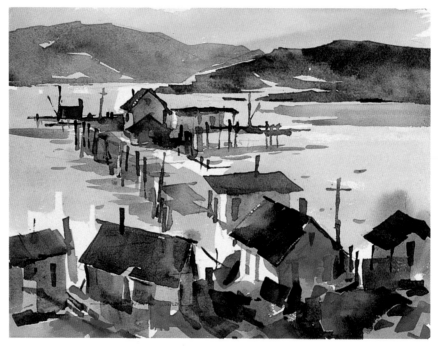

Wharf at Bodega Bay

I, like many artists, cannot resist the lure
of a fishing harbor. There are so many good subjects
available that one could paint there a lifetime.

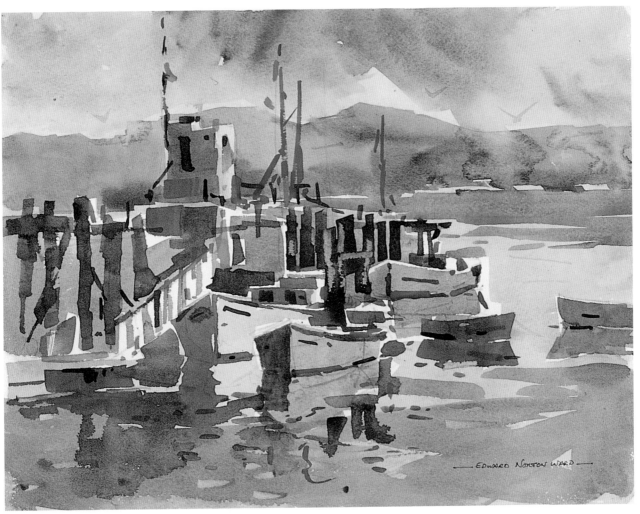

Rainsqualls Coming In
With so many good painting subjects around the docks, the artist has
to be careful not to waste time chasing ideas instead of painting.

WHEN YOU FIND yourself in a busy fishing port, your only problem with regard to a subject is how to select one from the many available. Just too many good subjects vie for your attention here. You can easily become overwhelmed by ideas. Ideas for harbor scenes generally include the following categories: fishing boats, docks, or the water itself. The artist has to decide which he will feature. Once you decide, everything else has to be subordinated. You have to apply all you know to selecting, simplifying, and emphasizing your chosen subject.

To help yourself choose a subject, begin, as I usually do in outdoor settings, by first strolling around and simply observing the scene. Let yourself absorb the full flavor of the location. Effervescent with the life of the sea, the harbor conveys its lively mood almost immediately, impelling you to make countless sketches right away. Don't give in to that first awareness of possibilities for sketches. Wait.

WHEN I FIRST arrive at the docks, I like to relax and prepare myself by looking around. I am not intent on finding something to paint right away. Instead, I let the painting opportunities present themselves naturally. *The Inner Channel at Albion* is an example of how my receptivity brought me an unexpected idea. I wasn't interested in painting a typical harbor subject that morning. I wanted something different. I watched the fog beginning to burn off and was caught up in this mysterious atmosphere. Glancing upchannel, I suddenly found my subject. There were no boats in the water, hardly any docks, just a few pilings. What held my attention was the reflection off the water as it wound its way into the distance. A perfect subject, I thought, just waiting for an artist!

As usual, I was carrying my sketchbook and recording my first impressions in small sketches. As I sketch, I begin to see exactly what part of the scene interests me. Using the thumbnail sketch is a way of thinking for me. Sometimes I catch myself speaking, just as if I were addressing a workshop class. By preparing myself with several of these quick thumbnail sketches, I was able to decide on a subject for a watercolor sketch and devote all my attention to that scene, ignoring everything else in the vicinity.

These thumbnail sketches show the fishing boats that I thought would be the best subject. I also singled out docks as the main theme of two other sketches. The surface of the water interested me as well and, too, an old boat hull I found abandoned in a nearby boatyard.

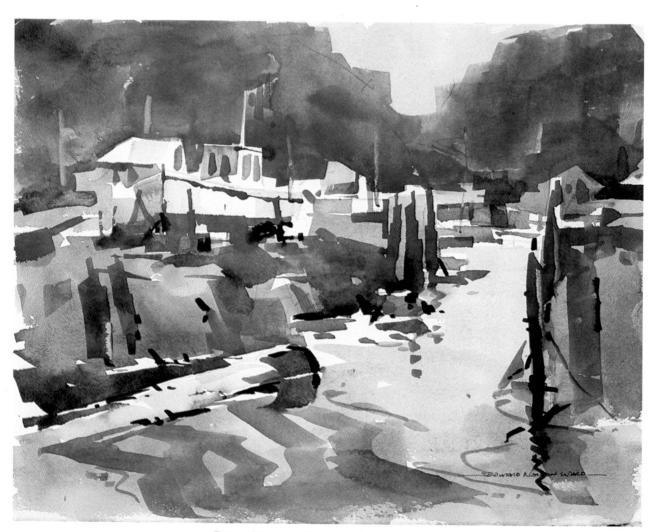

The Inner Channel at Albion

The half light of the coastal fog created an even light that bathed everything in a soft glow. Once I had defined the shape of the water channel, it was only necessary to add the simple shapes of the land and a few old pilings for defining darks.

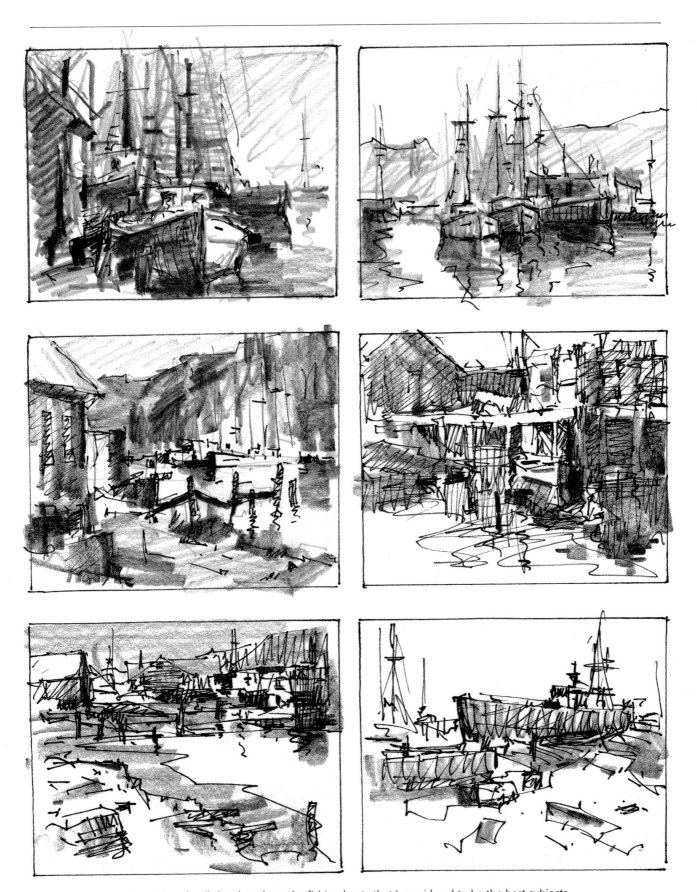

These thumbnail sketches show the fishing boats that I considered to be the best subjects.

WHEN I CHOOSE fishing boats as my subject, I like to present them as a mass of several boats grouped together rather than as a portrait of just one boat. I find it difficult to design a scene around just one boat. While drawing in my design, I try to present my first impression of the shape of the massed boats near the center area of the picture space. When I paint, that mass is more important to me than the individual boats.

In *Salmon Boats*, a group of several boats form a light shape. You have to look closely to see the individual boats on their own.

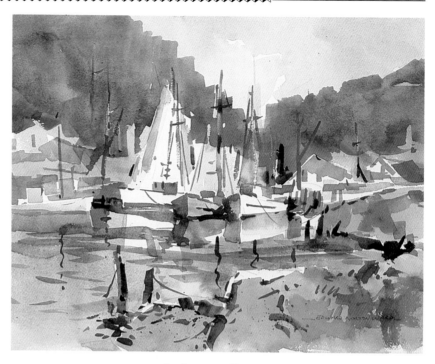

Salmon Boats

A mass of several boats gives the artist the chance to introduce an interesting shape into the design. Once that shape has been placed, then impressionistic brushwork can be used to suggest the crowding together of the boats, as the lines and spots of color do here.

EXERCISE

If you live near a body of water, chances are you can find some backwater where somebody has moored a few boats. A few rowboats, duck-hunting boats, or pleasure boats are all you need.

For this exercise, draw both the boat and its reflection as one simple shape. Later, you will indicate the waterline with paint. There is no need to draw the boat shapes perfectly. Just draw them in as simple shapes. In "Simplifying Shapes" in Chapter 5, we saw how just a few lines could define a boat.

As you draw the second or third boat and their reflections, place them on the watercolor paper in such a way that they overlap the shape of the first boat. Also, place one of the boats slightly forward of the others.

Outline the overall shape of the massed boats and their reflections with a broad, neutral middle-value wash of watercolor. Leave the composite shape of the boats as white paper. Within this shape, paint the smaller shapes of color and value just as you see them. Don't worry too much about getting these smaller shapes accurately. Try to paint spots of color and value at about the right position relative to each other.

Paint in the waterlines where you see them as a roughly indicated line. Show where the bow of each boat is either as the edge of a shape or a line of color. Where you notice details, such as ropes, pulleys, windows, etc., just put down dots of paint of the appropriate color. Watch how the individual boats take shape through passages of value, color, and white paper.

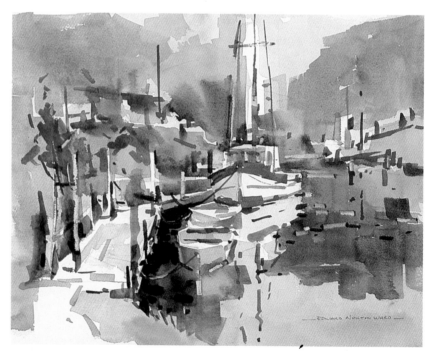

Back Channel Docks

To make boats my main theme, I subordinated everything but the floating dock, which I used as a plane to lead the eye back to the boats. I rendered the fisherman's shack, the reflections in the water, and the background hills and trees in soft-edged brushwork, some wet into wet.

At first, I saw masts, rigging, overlapping hulls, and cabins as one shape. As I painted, I kept this shape dominant. Later, during the finish, I used a few impressionistic strokes for the red waterlines and the shadowed sides of the hulls and cabins to give some definition to each individual boat—just enough to retain the first impression of massed boats.

I like to paint the harbors in northern California. There, the fishing ports are in the tidewaters of the coastal rivers. I am always finding little backwaters, where some fisherman has found shelter for his boat. Such unexpected scenes can be made into charming sketches. Beside one of these rivers on the Mendocino coast, I found the scene for *Back Channel Docks*. The fisherman who owned the boat told me that he had to go out on the high tide because the river's channel wasn't deep enough at the lower tides.

The boats really *are* the picture. I set them against part of the floating dock. This dock serves to lead the eye to the larger boat. Value contrasts are strongest where dock and boats meet. I kept my edges hard around the dock and the boats to hold the viewer's gaze there. I left everything else out of the sketch or greatly underplayed it with soft-edged brushwork. Just a few wet-into-wet strokes defined the fisherman's shack. Enough crisp shapes in the distance lure the eye even deeper into the picture.

Usually one sees boats in a harbor tied up at docks, just back from fishing excursions. Several boats tie up alongside one another when the harbor is full. Grouping several boats at dock into larger shapes, I like to show some of the dock, pilings, sheds, and fish hoists merging into the shape defined by the boats. This gives some truth to the painting and provides a sense of scale for the boats and docks. One can find negative shapes amidst the masts, hanging nets, and edges of the sheds on the dock. In *Drying the Nets*, I included the dock's influence without having it overwhelm the design.

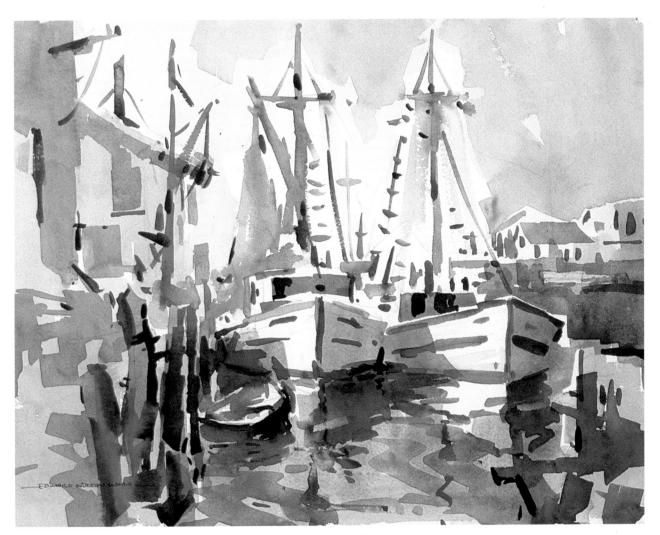

Drying the Nets

These fishing boats, tied up to the dock, have finished their work for the day. Their proximity to the wharf, the fish hoist, and the nets hanging from the mast let us know that these are real working boats.

THE DOCKS give the harbor much of its charm. Their seemingly haphazard placement is actually where their owners felt they were needed to best perform their functions. With time, there comes change—old docks are modified, buildings are demolished, or new structures are added. An ever-changing environment, the fishing harbor always presents a challenge and a flourishing source of painting subjects.

When you first look, a fishing dock seems to be a mass of buildings, pilings, and boats all merged into one large shape. You can contrast this shape against the water's surface as a dominant theme for your painting. While on our voyage aboard *Seacomber*, we put in at Thorn Bay, Alaska. As usual, the first thing I wanted to do was to go ashore and see what the little town had to offer to an artist. Returning from seeing the local sights, I found the subject for *Morning at Thorn Bay*. Our boat was tied up at the end of the dock, which extended out into the bay. The warm-colored buildings and surface of the dock contrasted with the cool colors of the bay and distant hills. I painted this sketch at the top of the walk leading down to the dock. For me, it is a favorite memory of that trip.

When I started this sketch, I was trying to demonstrate to my wife, Johanna, how a busy subject like a fishing dock should be massed together into one large warm shape. As I painted in the large cool washes for the sky and water, I left the wharf and buildings as white paper. Where the shore of the background hills meets the water, I left a band of dry paper. I painted a warm wash of light red over most of the wharf shape, except where I wanted some of the accidental white passages to appear. Without waiting for the first washes to dry, I painted the background hills in contrasting cool and warm colors and started putting down smaller shapes—the red buildings and nets on the docks—and other incidental colors where I found them.

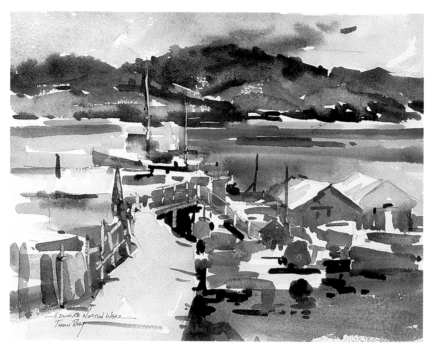

Morning at Thorn Bay

As I painted in large washes for the sky and water, I left the wharf and buildings as white paper. A band of dry paper was left where the shore of the background hills meets the water.

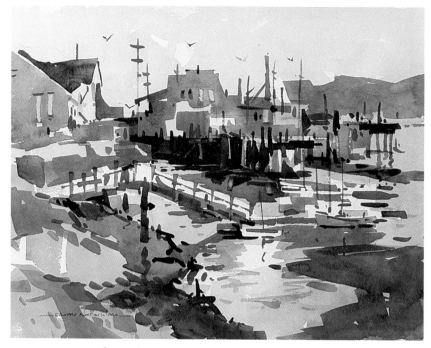

Old Canneries, Moss Landing

The soft gray daylight created a pattern of shapes of different values. Trying to keep the large shape of the dock dominant, I painted the foreground boats as a simple passage of white extending back to the dock.

Just as I painted the *Seacomber*'s distinct shape, touching in final darks around the dock and in the foreground water, feeling very caught up in the process, my wife tapped me on the shoulder. As I looked at her, she quietly said to me, "You're done."

On a gray day, you can see the docks as one large shape contrasted against the lighter value of the water's surface. Diffused, overcast light will broadly illuminate and reflect from the water's surface. On such a day I found and sketched the painting *Old Canneries, Moss Landing*.

On bright, sunny days, the water takes on the darker values of blue, green, and violet, and the opposite effect takes place. In this light the sun-bleached wood of the dock seems almost white. I forced this white-against-dark contrast in *Fish Buyer's Dock*, giving the subject a nice, crisp feeling.

As with other subjects, if you squint your eyes while looking at the harbor, all the little shapes of the docks and buildings merge together into one larger shape of the same value. This big form is exactly what you are looking for and the key to simplifying busy dock subjects. Once the large shape is identified, you can determine its value against the background.

When the docks themselves are the subject, boats should be included sparingly, as mere suggestions. In *Along the Waterfront* the boats contributed a patchwork of white paper and color that continued up into the light buildings on the dock. Since they were not the main subject, I tried to hide them in impressionistic brushwork. A single stroke for a bow, a change of value to suggest the side of a hull or cabin, a few dots for cabin windows were all I needed to suggest several boats rocking at the dock.

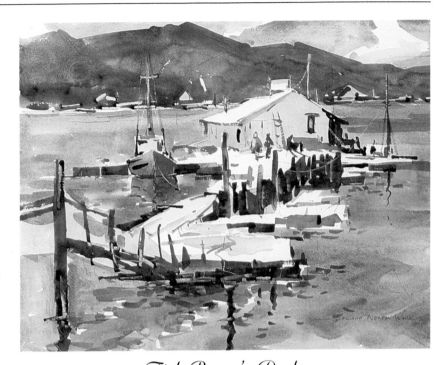

Fish Buyer's Dock
The bright sunlight on the bleached wood of the dock created a large white mass that I could play off against the dark pilings and water.

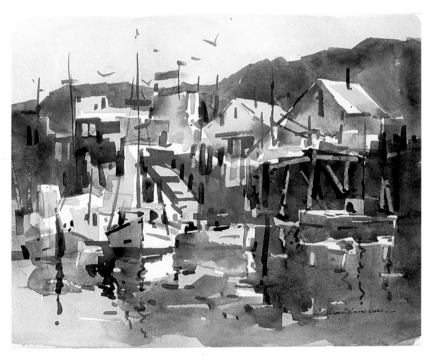

Along the Waterfront
Several boats tied together were represented as the continuation of a passage connecting the buildings on the dock. By means of their strong edges, buildings gained definition against the dark background hills. Accents of color indicated a clutter of "boats" on the waterfront, and lines suggested masts, bowlines, and waterlines.

THE GEAR fishermen use often lies around the dock or hangs from the rigging of boats. You have to learn how to quickly render this seeming confusion of "stuff" with impressionistic brushwork. Simply look at the subject, find a dark accent, use a touch of color where the detail appears in the scene. The brushwork can be very impressionistic—just a color, a line, a shape.

In *Harbor Relics* I painted a sketch of a pile of discarded junk—old fish boxes, a skiff, oil drums, worn-out netting. Behind them, in the distance, I put a dock covered with hoists and sheds. To paint most of these items, I used loose strokes of about the right size, value, and color suggestive of whatever the objects were. Some of the colors or shapes I didn't even identify. I merely put something down that would read the right value or color. Using suggestion helps a painter instantly capture the essence of a scene. Contrasts of brushwork and color add interest without distraction

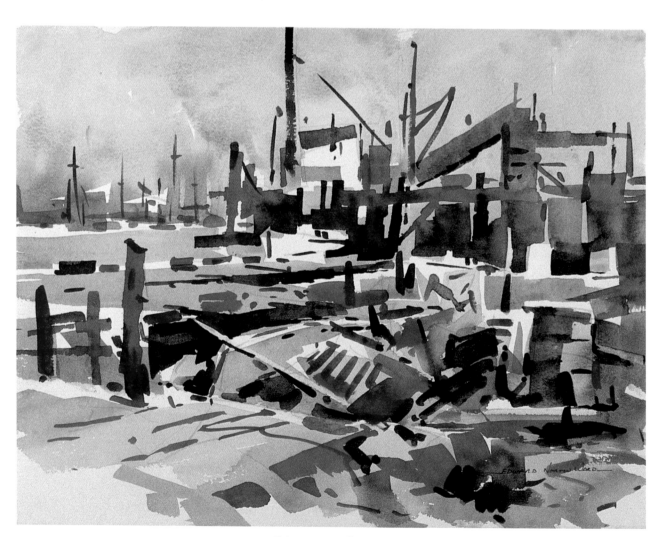

Harbor Relics

You can suggest a lot of detail by just putting down an impressionistic stroke of color and then painting a contrasting stroke of color or value over it.

EVEN THOUGH the boats are not in the water, I like to find subjects to paint in old boatyards. I recommend that you have a look there yourself. When you are rummaging around a boatyard full of boats, pay particular attention to the relationships among the boats. Here is an artist's delight of planes, each compelling the eye to follow it deeper into space. The side of one boat will pull your eye forward to the stern of another boat. The planes of the cabins will direct your eye up to the masts and riggings. Since water is not that evident in a boatyard, I exaggerate the effect of these planes and create an aerial illusion.

In for Repairs was painted one afternoon in Wrangall, Alaska. I tried to give the effect of height by using the plane of the ways and the masts of the boats to pull the eye up to the work sheds.

Finding a single boat out of the water in some isolated inlet can also lead to an interesting sketch. North of San Francisco, on the way to Point Reyes and Drake's Bay, the little town of Inverness sits at the edge of the water. A primary industry of oyster cultivation exists near Inverness, and one sees small boats up on the shore at every convenient inlet from the bay. The setting of the little boat in *In for the Season* was almost a ready-made design. A darker background of trees and buildings set off the white sunlit side of the boat. The small stream leads the eye back past the boat on the right, and the buildings pull the eye back around the light side of the boat of the foreground.

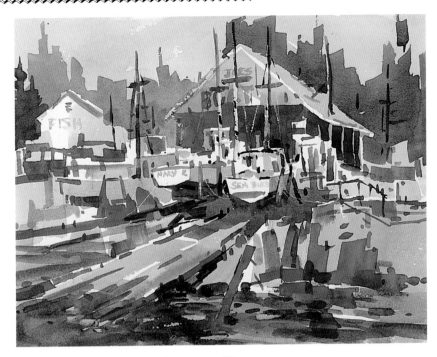

In for Repairs

The ways coming out of the water took the boats up to the work sheds above eye level. I painted the two main boats so that their sides, sterns, and bottoms were well defined. Thus, I was able to use the planes that make up the structure of the boats to draw the eye into the painting and give a greater illusion of height.

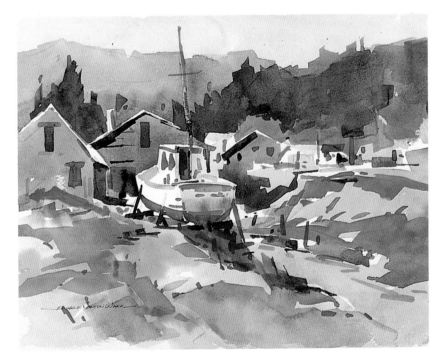

In for the Season

I worked the design around my main theme, the small boat, connecting the white paper of its sunlit side to the white passages threading through the background. In finishing, I arbitrarily touched the red color of the boat into the strong green of the foreground. This gave the green more punch and introduced subtle red passages to lead the eye from the foreground back to the area of the boat.

OFTEN, WHEN I am sketching on the docks, I come upon a scene that attracts me but am unsure exactly why. Many times it is the quality of the water's surface, which can be an exciting subject in itself. A subtle subject and not one you'll be aware of immediately, if you let the idea of water linger in your imagination, your appreciation for it as a subject will increase.

Water has certain qualities that have intrigued artists and laymen alike for a long time. Light playing on its surface can be almost hypnotizing. Interesting reflections not quite in sharp focus join their upright source to form startling color masses the artist soon learns to use. When I first started *Harbor Reflections*, I knew the boat rocking at the end of the dock had strong design possibilities, but I was also interested in the water in the distance. Until I painted the reflection of the boat's hull, contrasting the shadow side with the sunlit stern, I didn't realize that the water both in the foreground and in the background was somehow bonded as a single subject. The colorful reflections on the water were a bonus I could exploit in my painting. I decided to exaggerate both the color of the reflections and the value contrast.

The water's color itself may make an interesting subject for painting. When the light is low, the water can look deep and mysterious. Pure, rich color can be used to emphasize this depth. In *At Dock, Noyo Harbor*, I surrounded the deep blue of the water's surface color with light-colored buildings and docks and the strong white of distant boats. Looking across the water to the docks and boats on the other side, one is struck by the deep rich-colored water.

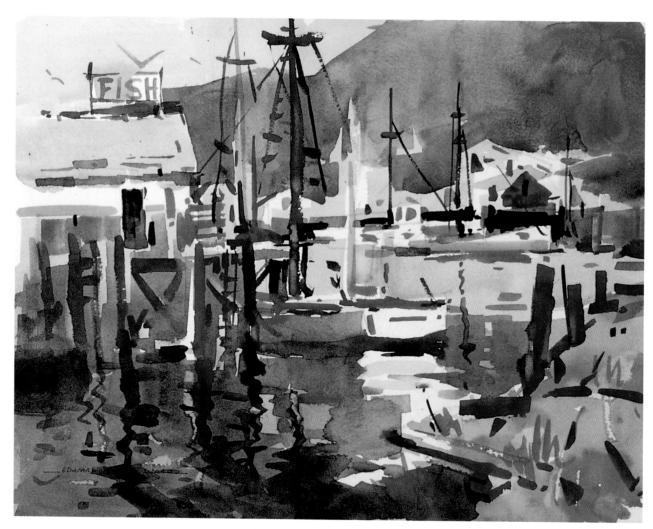

Harbor Reflections

There is a strong relationship between the foreground water and its dark reflections and the light background water. Where the dark water and light water come together, I was able to introduce some interesting color created by the local color of the boat and its reflections.

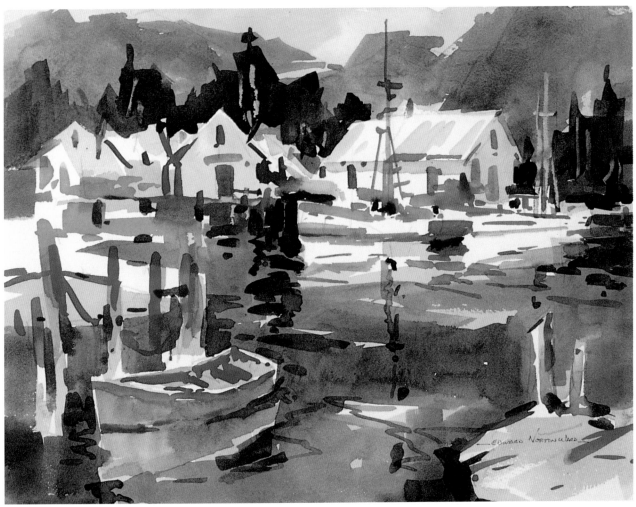

At Dock, Noyo Harbor

I painted the water with several glazes of rich blues, violets, and greens, surrounding its shape with light shapes. By letting some of the underpainting of the previous washes show through after each successive glaze, I was able to suggest the reflections off the surface of the deep water without losing the illusion of depth created by the rich dark colors.

EXERCISE

The negative shape of the water's surface is defined by the shoreline, the docks, and boats. If you cannot get to a harbor or other body of water, use a colored photograph for this exercise.

Paint a watercolor sketch where the water's negative shape is drawn in as a large major shape slightly offcenter of the paper. While painting, leave the water's surface as white paper. Concentrate on painting the smaller shapes, values, and colors that make up the edge of the water instead of its surface. If there are any breaks in the surface caused by rocks,

pilings, or boats, quickly suggest them with a few strokes. Don't make them too obvious or interesting or you'll destroy the overall emphasis of the water's negative shape.

Look over your sketch. Do the edges of the water create an interesting shape? Is the negative shape of the water's surface still the major shape of the sketch? When you base a painting on a negative shape, you must be sure that it remains the dominant subject of the painting even though you have given the viewer a lot to look at elsewhere.

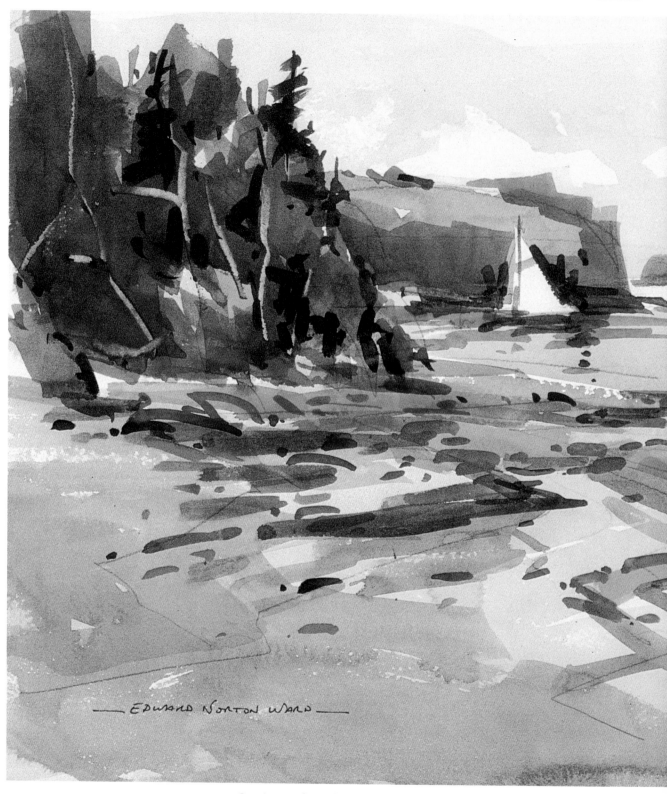

Sailing Off Inverness

Every painting, no matter how much trouble you may have had in
its execution, has some good qualities hidden in it. Don't destroy
apparent failures until you have let them age a bit. You may be
surprised at what you had accomplished. A result different
from what you expected is not necessarily a failure.

Conclusion

We have covered a lot of ground, and I hope that what I have written will be of some value to you the next time you are out looking for something to paint. Now it is up to you. Skills are gained and kept sharp by continually working with them. Nothing is better for rapid advancement than working and painting on a regular schedule.

Don't be too hard on yourself when evaluating your paintings and sketches. Rather than despair over an apparent failure, look it over from another perspective: "If I painted this sketch again, what would I change?" Some of your paintings may appear as failures, but they really are not. They probably didn't turn out as you expected, and you may be disappointed with the strange result, but wait a few days before making a final decision. Actually, you may have exceeded your own ability. Later, when you see the work with a fresh eye and have forgotten the trials the painting put you through, it might look pretty good. This happens to all of us.

If you do produce a dud, don't worry so much about it. We all fail regularly. If you are not failing occasionally, you are not taking any chances or exploring new ideas and subjects. You are probably playing it safe and just repeating what you already know. You have to take chances to advance your skills as a painter. Sometimes you have to paint on the edge of disaster, and then wonderful things might happen. But, without risk, in painting as in life, nothing much of value is ever accomplished. Remember: Every good painter I know puts as much work in the trash as he puts in frames.

In any case, your daring may elevate your skills to a higher plateau. You may find new ways of strengthening your design or emphasizing the main theme of your sketch. You may have gained more insight into the use of light and color relationships. Hidden ideas in your initial sketch may suddenly become apparent. Thus, failures can be successes if an idea leads you to explore further.

Remember that the real value of all outdoor sketching shows up back in the studio, where you can analyze your results and plan those large gallery-quality paintings.

Suggested Reading

Carlson, John F. *Landscape Painting*. New York: Dover Publications, 1974.

Gruppé, Emile A. *Gruppé on Painting*. Edited by Charles Movalli and John Lavin. New York: Watson–Guptill Publications, 1976.

————. *Gruppé on Color*. Edited by Charles Movalli and John Lavin. New York: Watson–Guptill Publications, 1979.

Hill, Tom. *Color for the Watercolor Painter*. New York: Watson–Guptill Publications, 1975, 1982.

Millard, David. *The Joy of Watercolor*. New York: Watson–Guptill Publications, 1983.

Reid, Charles. *Flower Painting in Watercolor*. New York: Watson–Guptill Publications, 1979.

————. *Pulling Your Paintings Together*. New York: Watson–Guptill Publications, 1985.

Wyeth, Betsy James. *Wyeth at Kuerners*. Boston: Houghton Mifflin Company, 1976.

Index

Edited by Grace McVeigh
Designed by Bob Fillie
Graphic production by Hector Campbell